4th
Edition

# History in Stone at the Nebraska State Capitol

# Lee Lawrie's
# Prairie Deco

4th Edition

## HISTORY IN STONE AT THE NEBRASKA STATE CAPITOL

# LEE LAWRIE'S
# PRAIRIE DECO

Nebraska Statehood
150th
Anniversary
Edition

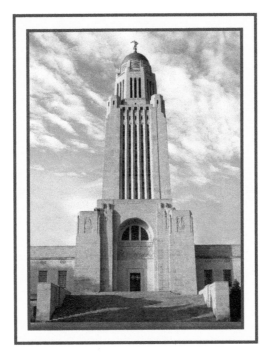

June 5, 20

To Mari-Love,
I HOPE IN YOUR
TRAVELS, SOME DAY
YOU GET TO SEE
ALL OF THIS MAG-
NIFICENT ART!

BEST REGARDS!

GREGORY PAUL HARM, M.A.

LeeLawrie.com
c/o Concierge Marketing
4822 South 133rd Street
Omaha, NE 68137

Hardcover ISBN: 978-0-9839030-9-3
Paperback ISBN: 978-0-9839030-6-2
Mobi ISBN: 978-0-9839030-7-9
EPUB ISBN: 978-0-9839030-8-6

Library of Congress Cataloging Number: 2017946338
Library of Congress Cataloging-in-Publication data on file with the publisher.

Design, Production, and Marketing by Concierge Marketing and Book Publishing

Printed in the USA

10 9 8 7 6 5 4 3 2 1

This book is dedicated to all admirers of Art Deco, but primarily to Mrs. Jean Ely, Chris, Bill, and Peter Lawrie—Lee Lawrie's grandchildren, who have each personally contributed their memories, photos, assistance, and goodwill to this project each and every time I reached out to them.

I'd also like to dedicate this to the people of Nebraska, and especially to its students of all ages. I sincerely hope *Prairie Deco* fosters their interest in the Nebraska State Capitol and reiterates the themes that Goodhue, Alexander, and Lawrie had carved into its walls—to educate about the Native American Heritage of the state and the development of the American democracy, which governs their state and our nation.

# CONTENTS

# PROLOGUE

ON OCTOBER 16, 1877, A DECADE AFTER NEBRASKA became a state, and a little more than a decade after America's Civil War ended, in a small village a few miles south and west of Berlin called Rixdorf, in the land then known as Prussia, a boy was born who would later shape the face of American art and architecture. The boy's name was Hugo Belling, but he is slightly better known to the world as Lee Oskar Lawrie, (1877-1963). And because no one else has bothered to do so yet, I will call him America's Machine-Age Michelangelo. He created literally hundreds of works over a career that lasted nearly seventy years, yet history has all but forgotten about him.

It's easy to overlook the obvious. Many Nebraskans who grew up in the capital city of Lincoln, like I did, come from families who have lived there for generations, and may have never taken the time to set foot in the State Capitol—just like lifelong New Yorkers who've never visited the Empire State Building. Often times, we fail to notice things that are right in front of us.

The Nebraska State Capitol is one of my favorite places in the city, and I have always felt some hazy, perhaps mystical connection with the building. Maybe it's because I love Art Deco. Or maybe it's because I've always had a fascination with all things Native American, and the building meets those needs. I've always felt a reverence for it.

Despite the fact that it's the tallest building in town and can be seen from nearly twenty miles away, many people know very little about this magnificent structure. Sure, like many other kids in town, I toured the Capitol as a Cub Scout and always thought it was a pretty neat place, but even as a kid I had assumed that most cities of comparable size around the country must surely contain comparable buildings.

However, as an adult, I have learned that no other city in the U.S. has anything quite like the Nebraska State Capitol. While New York City has the Chrysler Building, the Empire State Building, and Rockefeller Center—all of which are monuments to Modernism and the Art Deco period, and all of which were completed only *after* Nebraska's Capitol was well under construction—none of them can match the complexity of the Capitol in ground-breaking innovation, thematic content, architectural sculpture, and frankly, the importance of heritage and history on the American character. More importantly, it's a public building, built and paid for by the people.

What most Nebraskans don't realize is that not only does their Capitol hold the largest collection of Lawrie's work in the world, but also how this nearly anonymous man's work has created an undiscovered national network that, once recognized, could serve as a link between the other cities, churches, and communities throughout the U.S. in the variety of states in which his work is found.

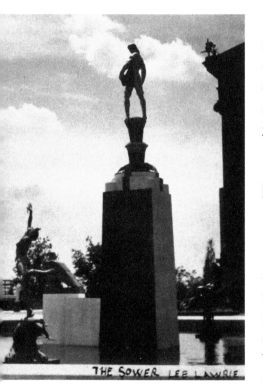

THE SOWER LEE LAWRIE

While most Nebraskans immediately recognize the *Sower* as an icon representing all things Nebraskan, very few of them have ever even heard of Lawrie. Fewer still are aware of the impact Lawrie had on architectural sculpture nationwide, nor the scope of his contribution to Modernism or the art form that we now commonly and retroactively refer to as Art Deco. He's just not a household name in Nebraska—or anywhere else for that matter.

This photo by E. Quigley shows a model of the *Sower* at a 1933 public sculpture exhibition in Philadelphia.

*Photo courtesy of the Library of Congress.*

For example, in February 2007, the American Institute of Architects and Harris Interactive conducted a poll of nearly 2,000 people to identify the public's 150 favorite works of architecture in America. The Nebraska State Capitol Building placed at number sixty-seven on this list. Seven out of these 150 works have a uniquely common thread: the U.S. Capitol, the White House, the Cathedral of St. John the Divine, Rockefeller Center in New York City, the Nebraska State Capitol Building, the Los Angeles Central Public Library, and the freestanding statue of George Washington at the National Cathedral in Washington, DC, all contain architectural sculpture created by the hands and mind of Lee Lawrie. Although Lawrie is not even mentioned, his presence at so many of these buildings ranks second only to Frank Lloyd Wright, who created nine works that placed on the list.

Like many other Lincolnites, I grew up virtually in the shadow of the Capitol, living in South Lincoln, attending Lincoln High, just about a mile down the hill east of the Capitol and the University

of Nebraska at Lincoln. In the late 1930s, my Mom worked for the State of Nebraska in the still newly finished Capitol for the Nebraska Surplus Commodities Division, which distributed surplus crops to schools during the waning years of the Depression. In 1939, she met my father who had grown up in Lincoln, witnessing the Capitol being built.

My Dad once told me that while he was in college, either on a dare or a bet, he had driven a Model T up to the top of the north stairway of the Capitol. So, there is a little more of my family history connected with the building. My father passed away several years ago, so now this dark family secret can at last be revealed.

Ever since I was a kid, I'd held some special feeling, perhaps a reverence, for the Capitol. Its cathedral-like interior evokes a feeling of sanctity—perhaps because of the overwhelming beauty and grace of the whole structure. When you're inside it, you feel that perhaps a hushed tone is in order; it simply invokes feelings of serenity. I toured it as a child, dined in its cafeteria, ran amok in its halls as a rowdy junior high school kid, and worked two internships there as a middle-aged college student. To me it was a place of majesty, dignity, and awe. It was like a prestigious and cosmopolitan art museum; except, unlike a museum, its art is on display year-round, twenty-four hours a day.

It wasn't until nearly a decade after I had graduated from the university and moved away that I began to realize the unique significance of this building, and more specifically, the importance of just who Lee Lawrie was.

In 2000, while accompanying my wife on a business trip to New York City, I was free to wander the metropolis, admiring and photographing many Art Deco buildings in the city while she was attending seminars. Having always been an admirer of Art Deco art and architecture, there are few places on the planet that hold so many brilliant examples of the style as New York City, and so I was as happy as a clam.

As I toured Rockefeller Center and saw the beautiful bas-relief sculpture of *Wisdom* on the 30 Rockefeller Plaza and the great statue of *Atlas*, I realized that a great deal of this beautiful work was done by the same artist that did the sculpture on the Capitol, way out west in Nebraska. No two works of art anywhere seem to evoke a stronger sense of the spirit of Art Deco than the dynamic duo of *Wisdom* and the *Atlas*. Upon viewing his Moses- or God-like figure of *Wisdom* on the front of "30 Rock," I was immediately awestruck. I fell in love with this new discovery of his—new to me anyway. Everything about Rockefeller Center intrigued me.

Incidentally, originally, the design of *Wisdom* was supposed to represent God. But at Rockefeller's direction, the image was de-deified, making him more secular, even though the biblical verse, "*Wisdom* and knowledge shall be the stability of thy times," was retained.

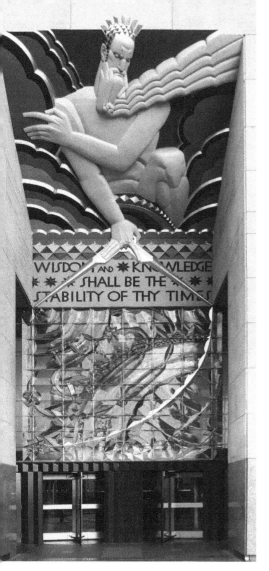

Scholars have suggested that Lawrie may have ripped off William Blake's 1794 painting, *Ancient of Days*, which pictures Blake's mythical figure, Urizen, known as the embodiment of conventional wisdom and law, in the clouds, leaning forward with giant calipers in his hands as he measures out his creation. But while Lawrie may have stolen the concept of the image, he truly made it his own. Many books about Art Deco have identified Lawrie's *Wisdom* as being among the most emblematic images of the genre. While I had seen pictures of the *Atlas* for many years, I had never seen a picture of *Wisdom*, surrounded by *Sound* and *Light*. I was helplessly overpowered by it.

Not only are these three polychrome works overwhelming, but Lawrie also worked with the Corning Glass Company to create the band of 240 individually-sculpted, amber-colored glass blocks that create the seventy-foot long window that stretches nearly the width of the facade.

Sample image of *Ancient of Days* by William Blake.

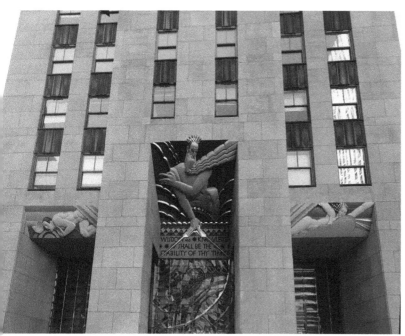

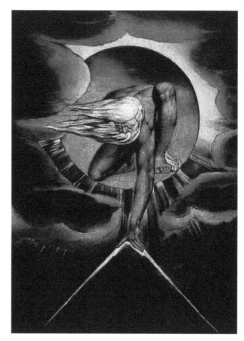

Even more interesting is the fact that the assembly of glass blocks contains no duplicate shapes—each is unique. They display the geometric pattern that lets their soft amber morning light filter into the lobby of this magnificent building. Immediately below *Wisdom*, the blocks form a compass over the sun in the background.

The crown-like pattern for the texture of his head; the angular sweep of his beard—suggesting a strong wind, the absence of which would have let his beard drape down to his waist; the lines of his powerful hands—both of which appear to be abnormally long, with his index finger as long as his middle finger; and the whole pattern of his compass, calibrating out an arc, each of these elements screams Art Deco!

Flanking *Wisdom* are two futuristic, at least by 1930s' standards, murals–*Light* and *Sound*. *Light* represents the fledgling motion picture industry and television, while *Sound* represents radio during its golden age.

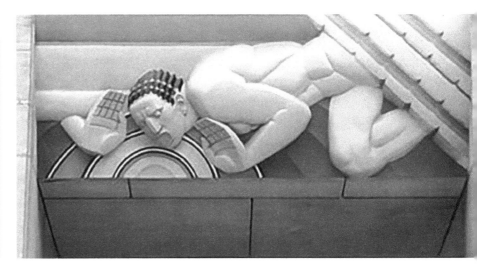

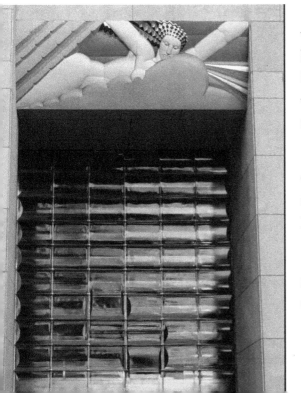

These icons were chosen to communicate the fact that this was, after all, the home of the Radio Corporation of America, better known simply as RCA. Although radio was then in its heyday, television was barely out of its embryonic state—when words like cable and plasma had entirely different meanings than they do today.

When I first learned that Lawrie had created these, I was flabbergasted. My first thought was, "Wait a minute—so the same guy who created these *also* did the sculpture on the Nebraska State Capitol?"

And then I thought, "How on earth did Nebraska of all places get the same sculptor who created this amazing art for its state capitol?"

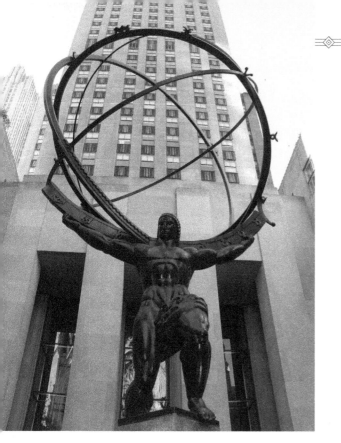

The *Atlas* at Rockefeller Center. Most people recognize it, but can't name the artist who created it. Rene Chambellan assisted Lawrie on this famous New York icon.

And at that very moment, armed with this new curiosity, this book was conceived.

The magnitude of distinct designs Lawrie created in his lifetime is astounding. How could just one person come up with so many different distinct designs? And ones that advanced the world of design so dramatically?

To me, it was truly astounding that one of the five most significant buildings in the Art Deco era was illustrated by Lawrie. Not only was I amazed at the power suggested by this imagery, what really struck me was the significance of how important Lawrie must have been in his day and age. And finally, how fortunate Nebraska was to have landed him for the work on the most important building in the state.

Most people recognize the image of the *Atlas* and thousands of people walk by it every day, but the average passerby can't name its creator. It was Lawrie—the same sculptor who created the *Sower* statue in Nebraska, but who also remains practically anonymous nearly everywhere that his works are found.

In Greek mythology, Iapetus was the father of Atlas. But at Rockefeller Center, his father was Lawrie. Standing over forty-two feet tall, the bronze statue of *Atlas*, with his sphere of rings depicting the twelve signs of the zodiac, is one of the trademarks associated with Rockefeller Center. Since I first published this book, I've learned that Rene Chambellan assisted with the design as well as the casting.

But because Rockefeller Center was completed several years after the Nebraska Capitol was done, naturally, none of the information or buzz around the 1932 completion of the Capitol could have predicted that he would go on to do this spectacular work at Rockefeller Center. That connectivity flowed only toward the future, and not to the past.

## Deeper and Deeper...

The more I studied Lawrie, the more I learned just how ubiquitous his work was and what national treasures his works truly are. During the first year or two of my research, the deeper I dug, the more dots there were nationwide that needed connecting.

In New York City, Lawrie's sculptures grace at least a half-dozen remarkable Gothic churches, but his work lies in communities scattered all over the nation. His major works can also be found at the National Academy of Sciences building in Washington, DC, the Los Angeles Public Library, Yale, Rockefeller Chapel in Chicago, the U.S. Military Academy at West Point; these works were all accomplished during his association with Goodhue, who incidentally died in 1924—barely three years after construction of the Nebraska Capitol began. They even collaborated on projects in Hawaii and Cuba. In the nearly thirty years Lawrie and Goodhue spent working together, they collaborated on over a hundred buildings nationwide.

Over the years, several scholars have undertaken research into various themes associated with Lawrie's work, examined his work at Nebraska, and perhaps a couple have recognized that he created works in several other areas in the country. But no one has ever taken the time to connect the dots to illustrate his significance to Art History in America—until now.

As I began my study of Lawrie, one of the first discoveries I made was how little information there was published about him. For example, when you search Amazon.com, the last book published solely about Lawrie's work was a monograph from 1955 by the University of Georgia Press—and it has long been out of print. The last publication before that was J.H. Jansen's folio of some of his works, *Sculpture: Lee Lawrie*, published in 1936. Moreover, take a walk in any bookstore, commercial booksellers, or even academic bookstores, and look through books on sculpture or American art history; his name is conspicuously absent from the indexes in these works.

Nebraska was still a young frontier state in the 1920s; thus, probably more concerned with building its first roads and bringing electricity to farms than caring about the world of art. So, it begged the question, "How in the world did Nebraska (of all places) manage to land one of the top sculptors of the twentieth century to decorate its Capitol?" As we will learn later, he was part of a package deal.

I suppose it would be safe to call it a quest for more knowledge, which allows me to seek out, and to venture to document some of the most remarkable art of the twentieth century that remains not merely forgotten; but also—almost completely unknown.

Back in grad school, the late attorney, Dale Hardin, my legal theory professor (who LBJ twice directly appointed to head the former Interstate Commerce Commission, and was twice confirmed by the Senate), began his class by pointing out that when you look at the history of law, and especially that of lawsuits, the events recorded in the legal case reporter books all actually happened to real people who were aggrieved in a host of ways.

Inasmuch as Hollywood can crank out prequels whenever they want to invent a fictional back-story to sell more tickets, in many ways, this book can serve as a prequel that will help to explain how buildings such as Rockefeller Center came to use the same unique cadre of artists that were used on the Nebraska State Capitol.

Finally, I wish to stress that this is not a revisionist history, but rather a retelling of events as recounted in newspaper articles, architectural trade journals, and a wealth of information provided by Lawrie's archives and even personal family letters given me to by some of his descendants themselves.

The chief distinction here is that unlike the worlds of young *Indiana Jones* or any of the *Star Wars* prequels, these lessons are drawn from the actual events that shape American government, law, politics, and art history. However, this isn't a screenplay—this is history.

Therefore, this book is a look back at the events that set the stage for the development of the Capitol. But it's also a recounting of a good deal of long buried history to help us better understand how the events of the past relate to our present-day culture, government, law, politics and society.

Over the past seventeen years spent travelling around the country retracing some of Lawrie's steps, one of the most interesting connections between Lawrie and the Nebraska State Capitol building appears in a church in Morningside Heights in New York City where Lawrie created a tomb for Goodhue.

Goodhue's Church of the Intercession is located at 155th and Broadway, a block away from the subway on Sugar Hill. In 1924, just a few weeks before he turned fifty-five years of age, Goodhue died of heart failure. Lawrie was shattered by the premature demise of his dear friend and colleague of nearly three decades.

In the church that Goodhue himself designed—and that is said to have been his favorite, according to Bob Ripley, an architect from Lincoln who possesses a deep personal knowledge of the architecture of the Capitol, gained in over twenty-five years' service as one of the Capitol's, historians, protectors, and restorers—Lawrie carved this

memorial tomb to him, featuring his life-sized figure. It was dedicated in 1929 and contains his ashes. Lawrie used Goodhue's actual death mask and a post mortem casting of his left hand to ensure the accuracy of the posthumous portrait.

In the center of this arc at the top is the image of Goodhue's largest completed commission, the Nebraska State Capitol. When the tomb was created, the building was nowhere near completion; and as time passed, the actual building was markedly different from Lawrie's rendering shown in this photograph.

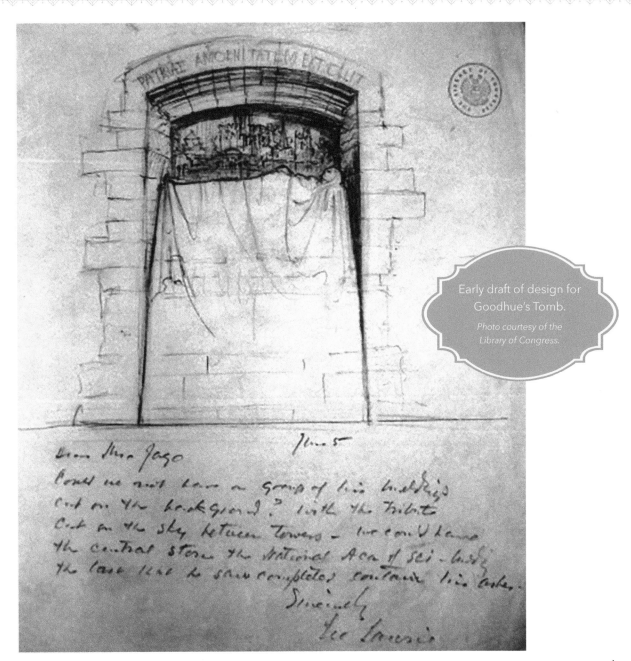

Early draft of design for Goodhue's Tomb.

*Photo courtesy of the Library of Congress.*

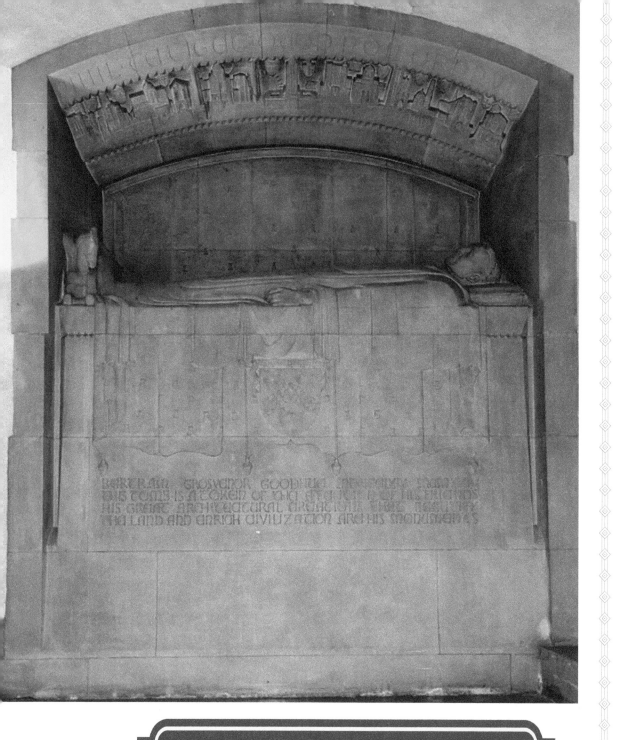

Goodhue's crypt, sculpted by Lee Lawrie reads,

"BERTRAM GROSVENOR GOODHUE MDCCCLXIX MCMXXIV. THIS TOMB IS A TOKEN OF THE AFFECTION OF HIS FRIENDS. HIS GREAT ARCHITECTURAL CREATIONS THAT BEAUTIFY THE LAND AND ENRICH CIVILIZATION ARE HIS MONUMENTS."

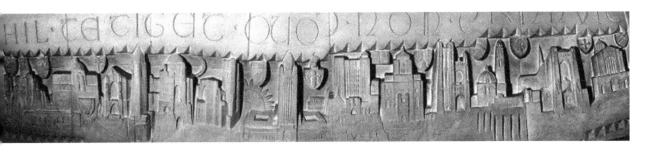

Above Goodhue's effigy appears a semicircle displaying many of his most famous buildings. The tomb of architect Bertram Grosvenor Goodhue is adorned across the top with relief carvings of buildings designed by Goodhue. The bas-relief depicts the Chapel at West Point, Rockefeller Chapel at the University of Chicago, Rice University, Caltech, the National Academy of Science Building, the Los Angeles Public Library, the Cathedral of St. John the Divine, Sterling Memorial Library at Yale, St. Vincent Ferrer, the Convocation Center designed for Madison Square Garden (never built), St. Thomas Church, and St. Bartholomew's. Below the sarcophagus bearing a reclining figure of Goodhue is a relief carving of his family crest.

It should also be noted that while Lawrie was designing the tomb, he was still working on the Nebraska Capitol, the Fidelity Mutual Life Insurance Building in Philadelphia, Bok Tower in Florida and several other projects, all simultaneously.

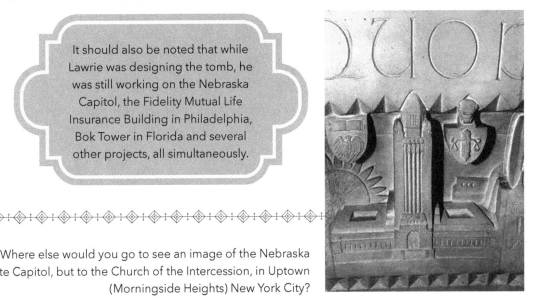

Where else would you go to see an image of the Nebraska State Capitol, but to the Church of the Intercession, in Uptown (Morningside Heights) New York City?

A detail of a proposed memorial to Goodhue from Caltech, never built.

*Photo courtesy of the Archives, California Institute of Technology.*

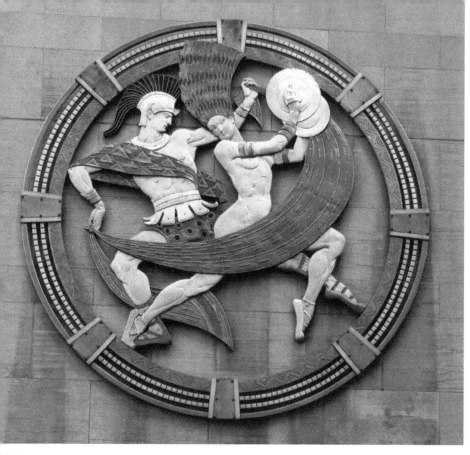

*Dance*
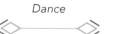

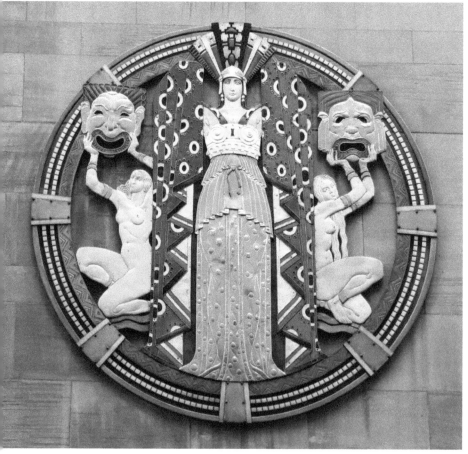

*Drama*

After learning of Lawrie's work on Rockefeller Center, imagine my surprise to learn that Hildreth Meière, who created the Guastavino Ceilings in the Rotunda, the Great Hall, the Warner Chamber and more at the Nebraska State Capitol, also worked on Rockefeller Center. Years later, I also learned that Nebraskan Hartley Burr Alexander, the thematic consultant for the Nebraska State Capitol, was also involved with creating some of the original themes about the New Frontier that were incorporated into Rockefeller Center's artistic programs.

The fact that these two nationally significant Art Deco artists worked together on the Capitol suggested to me that there was something special in the connection between this most remarkable skyscraper in Manhattan and the Nebraska State Capitol. This is what set me off on this course of research: to find out just who Lawrie was, and more significantly, what else he had created.

Hildreth Meière's *Dance*, *Drama*, and *Music* Rondels on the Fiftieth Street Facade of the south side of Radio City Music Hall. They are constructed of aluminum, brass, chrome nickel steel, and vitreous enamel, and they represent the Theater Arts.

*Music*

# More Discoveries

Since 2011, when I published the previous edition of this book, I have visited a number of sites and made some discoveries that were previously unknown or unassociated with his legacy.

Among the places containing Lawrie's work that I have explored and photographed are the Los Angeles Public Library—which was also designed by Goodhue, and features Alexander's program of sculpture as created by Lawrie, and which is the subject of my next book, currently in production—and the *Memorial Flagstaff* in Pasadena, honoring those killed and maimed in the First World War.

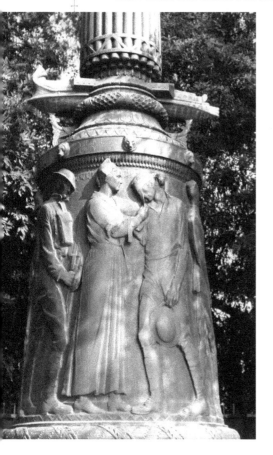

*WWI Memorial Flagstaff* in Pasadena, CA, created by Lawrie and Goodhue, dated 1923-1926.

In working on the multitude of buildings he did, the majority of them were such that he had multiple *individual* sculptures in a *cascade*. For example, on a single building—like a church or a library, where a flat plane existed for a wall—he might install ten different carvings of people. On a stairway, he might put sculpture on the walls or abutments on either side of the stairs. In other words, on nearly every building where Lawrie carved a single bas-relief there would likely be dozens more, and even the occasional freestanding statue, so each building would have a true *bouquet* of individual carvings that made up the whole commission. More than a hundred buildings across the nation may hold an exponential volume of individual pieces that no one has ever counted before.

The details of these pieces—and how they fit together—can only be fully comprehended when visiting a site like the Nebraska Capitol, where he created literally scores of individual sculptures.

The following chapters document some of the latest discoveries I've made, introduce the reader to some additional Nebraska-based examples of Lawrie's work, and hold the most poignant discovery I've made since last publishing the third edition of *Prairie Deco*!

# *Carving a Legacy*

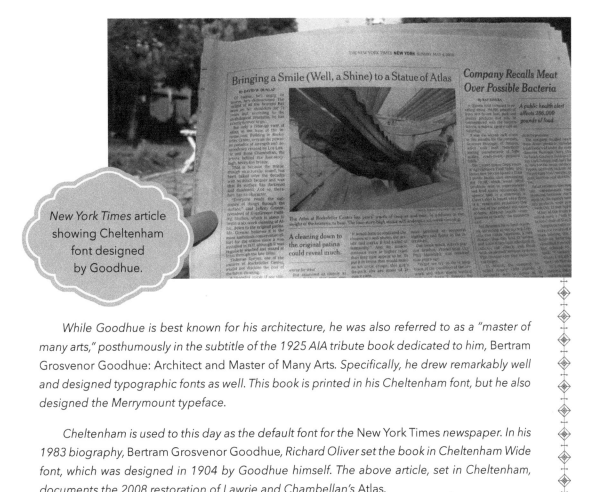

New York Times article showing Cheltenham font designed by Goodhue.

*While Goodhue is best known for his architecture, he was also referred to as a "master of many arts," posthumously in the subtitle of the 1925 AIA tribute book dedicated to him,* Bertram Grosvenor Goodhue: Architect and Master of Many Arts. *Specifically, he drew remarkably well and designed typographic fonts as well. This book is printed in his Cheltenham font, but he also designed the Merrymount typeface.*

*Cheltenham is used to this day as the default font for the* New York Times *newspaper. In his 1983 biography,* Bertram Grosvenor Goodhue, *Richard Oliver set the book in Cheltenham Wide font, which was designed in 1904 by Goodhue himself. The above article, set in Cheltenham, documents the 2008 restoration of Lawrie and Chambellan's Atlas.*

Goodhue began designing the Los Angeles Public Library at the same time he was building the Nebraska State Capitol, and in its planning, Hartley Burr Alexander was selected as the thematic consultant, choosing themes related to the light of learning and the dissemination of knowledge. Once again, Lawrie was chosen to collaborate with him and to illustrate the themes creating architectural sculpture for the building.

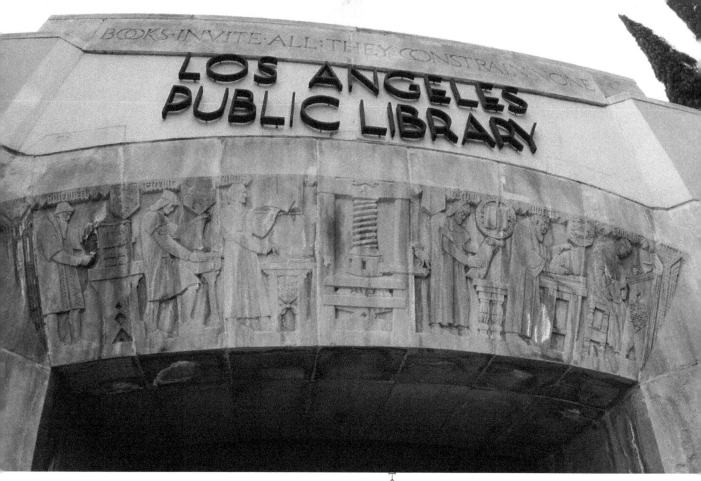

BOOKS·INVITE·ALL·THEY·CONSTRAIN·NONE

LOS ANGELES
PUBLIC LIBRARY

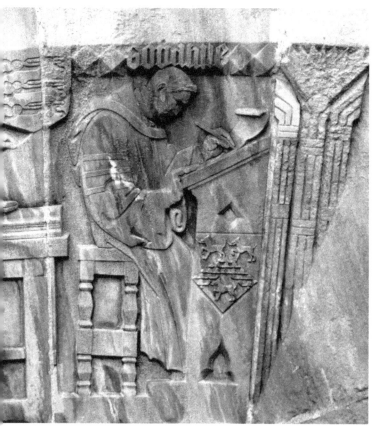

From left to right in
the arch are Gutenberg,
Elzevir, Aldus, Caxton,
Morris and Goodhue.

Alexander created a special theme, after Goodhue's death, at the south, street level entrance to the Library called the Printers' Tunnel. On it, he selected a set of both Old World and New World designers and producers of both book and the typefaces that would fill them with print.

Lawrie was selected to illustrate this series of six portraits, and the final person Alexander chose was Goodhue himself because of his skills in both typography and illustrating books.

Herewith are some examples of why Alexander ranked Goodhue among these historic giants who collectively transformed the written word, to the print and books.

Bookplate images drawn by Goodhue and featured in *Bertram Grosvenor Goodhue: Architect and Master of Many Arts*, edited by Charles Harris Whitaker, AIA Press, 1925, New York.

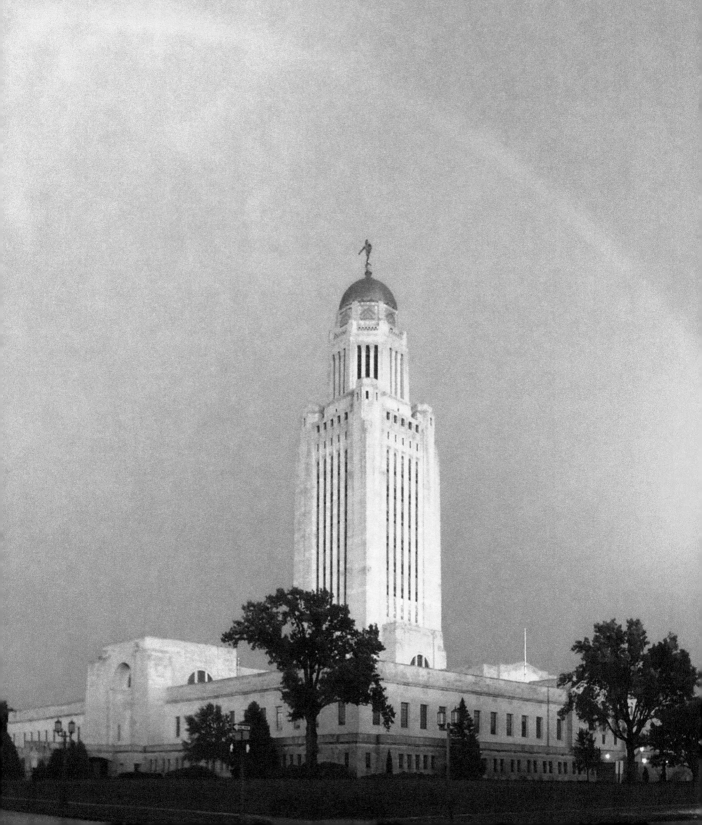

# INTRODUCTION

## Little House (of State) on the Prairie

**M**OST AMERICANS ONLY VIEW THE CAPITOL FROM ABOUT 35,000 feet up in the air. Travelers flying coast-to-coast might blink and miss it altogether. For many Americans, Nebraska is written off as being "flyover country."

But in the nation's midsection, there is a little-known historical treasure.

If people are asked about where to go to see Art Deco buildings or sculptures, many would mention the usual tourist attractions—Paris, London, New York, Los Angeles, or Miami—but one huge treasure trove rarely springs to mind: Lincoln, Nebraska.

Situated on a 720-square foot plat on high ground in the middle of town, the Nebraska State Capitol's construction was completed in 1932, which made 2017 its 85th anniversary—and the 150th anniversary of Nebraska becoming a state.

The building—and the art that decorates it—was bought and paid for by the citizens of Nebraska, and they are happy to share it with the world. The interior of the building is open during normal business hours, and, fortunately for fans of Art Deco, the exterior never closes.

The land that the Capitol sits on is 720 square feet. It is situated between K and H Streets and 14th and 16th Streets.

Thousands of people may drive by or visit the Capitol every year, and most Nebraskans will immediately recognize the statue of the *Sower* perched atop the Capitol dome; but very few can tell you *whose* sculptures decorate the interior and exterior of the building.

This book is about the historic and symbolic sculptures of the Nebraska State Capitol and, especially, the nearly forgotten twentieth-century American sculptor who created them. The multitude of images carved in Indiana limestone that grace the Capitol all started in the mind and imagination of Lee Lawrie.

Before my father died - two or three months as I remember, he told me an unknown fact from his professional background of significant interest and importance. We had been talking in general about the past and were alone for a full half-day - a rarity, that added to the occasion. At mention of the Capitol at Lincoln he said - suddenly with vigor, "Annie, I'm going to tell you something!" Leaning toward me over our coffee things and looking at me, he began, "It is not known what part I had in the design of the building"! I understood at once what he meant and the full meaning of it and his modesty in it, too, and said "I'm not surprised at that Pa, but thank you for telling me." Goodhue had, I knew, returned a gold medal awarded to him with the request that my father's name be inscribed on it together with his, which I, and no doubt others had assumed was for the sculptures being an integral part of his building. But Pa told me that aside from collaborating with sketches for his sculptures on Goodhue's competition drawing his (Pa's) idea for a change in the design of the building was used. I felt honored in his entrusting me with so personal a reality selflessly held in memory of his colleague but I was saddened, too. His life was ending; and I thought that it was for that reason he had told me. What moved me deeply was that, in its telling he meant it to be private and between us and his sweetness in that touched me deeply.

A page from the memoirs of Lawrie's daughter, Anne Lawrie Wolcott. Did he deserve more credit in the design of the Nebraska Capitol itself?

It has been extensively noted that Lawrie and Goodhue worked very closely for nearly three decades, so it would be reasonable to expect that these two friends could nearly finish each other's sentences. But also, as it has been stated, Lawrie was extremely shy.

Curiously, shortly before his death, Lawrie revealed a secret to his daughter, Anne. In it, he implies that he had played a greater role in the design of the Capitol than just contributing the sculpture.

When Goodhue won the AIA's gold medal for design for the Capitol, he sent it back to them, insisting that Lawrie's name be added to the medal, so this could lend some credence to the notion that Lawrie may have helped to influence the building's design.

Read it and draw your own conclusions, because the only other party that could confirm or deny this anecdote was Goodhue, who died in 1924.

Again, this would not be the first time in history that someone took a critical secret with them to the grave.

The Nebraska State Capitol has often been recognized as one of the most beautiful buildings in the world. As important as the architecture itself is, it's the illustration that makes this building so distinctive. Lawrie's abundantly fertile imagination produced each design of the more than one hundred distinct works in the building.

The chief purpose of this book is to inventory and identify his works at the Nebraska State Capitol and to rediscover and relate the story of what each of the sculptures signifies. These magnificent stories of Native American and Western Heritage, silently told using pictures and symbolism, have largely lost their historical importance over the decades.

It's kind of like remembering the lyrics to an old song; we may remember or recognize the melody, but can't recall the words. People may have passed by the Capitol for years. They know what the building looks like, but don't recall what all the words or pictures on it actually mean. Call it sensory overload, but a principle purpose of the sculpture is to educate us.

While a picture may be worth a thousand words, to cite singer/song-writer Elvis Costello's lyric about pictures, he once posed the musical question, "But what's the use of looking when you don't know what they mean?"

This book is meant to generate recognition of the importance of Lawrie's place in American art history by providing a common element whereby communities all across the country can recognize, appreciate, and claim as their own the colossal contribution that Lawrie made through his work: to honor both God and his adopted country. Art and history buffs worldwide are encouraged to learn of this magnificent work and make the pilgrimage to Lincoln to experience it in its original space.

Lawrie's work is best viewed firsthand where it is found, and where its scale and scope can be appreciated more fully than from the images in this book. Just as when viewing a Van Gogh, one simply can't grasp its magnificence until standing a foot and a half from it and seeing each element that went into its creation, with daubs of paint in layers and blobs almost a half-inch-thick. Each stroke of pigment builds part of an effort at illustrating in two dimensions, yet constructing a thickened three-dimensional texture in the process.

The significance of a Van Gogh painting can't be conveyed through photographs alone. You really have to see one up close to realize the significance of its creation.

When this book was first written, the Smithsonian Institute's website listed just over eighty various works of sculpture that Lawrie designed around the country. But these are just a few of Lawrie's creations.

Only four or five were mentioned from the Nebraska Capitol, yet it is the largest commissioned project he worked on in his life. There are over one hundred works and details, representing more of his work in a single place than anywhere else in the world.

Over the winter and spring of 2010-2011, I added more than a score of Lawrie's unlisted works to the Smithsonian's Catalog of American Paintings and Sculpture; yet still scores remain out there undocumented.

Although 2017 was the 85th anniversary of the building's dedication, Lawrie's work on the Capitol actually continued until 1934 when he completed the last piece of sculpture, *The Establishment of the Tribunate of the People*. A *New York Times* clipping dated November 22, 1934, marked the occasion of the completion of the carving, but attributed the "greatest job of carving" to the people of Nebraska, who carved down the Legislature to just a single house—now famous as the nation's only Unicameral.

In November 2009, I was able to help promote an effort supported by Nebraska Governor Dave Heineman to proclaim November 22, 2009 as Lee Lawrie Day to commemorate the occasion.

This may be as close as most coast-to-coast travelers ever get to the *Sower*.

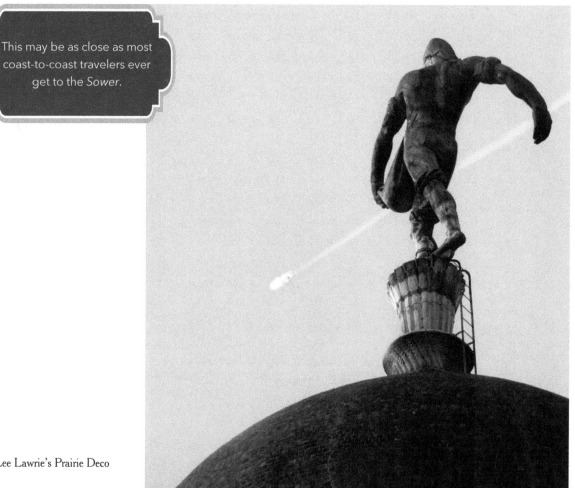

# Part I

Lee Lawrie Was Never Born

# 1

# WHO WAS HUGO?

Lee Lawrie was never born.

HUGO BELLING WAS BORN IN THE LITTLE BURG OF RIXDORF, Prussia, a few miles southwest of Berlin in 1877 to Louise Belling, a single mother. She chose to migrate to America, accompanied by her sister, Rosalie, and her eight-year-old daughter, Charlotte, Hugo's cousin. Together, the four of them arrived in New York City aboard the German steamship the *Australia* on February 20, 1881, just after little Hugo's fourth birthday. As an adult, Lawrie recalled that it was snowing that day, and that his mother had lent her scarf to a sailor standing watch. They settled in Chicago where Louise worked as a seamstress and a housekeeper.

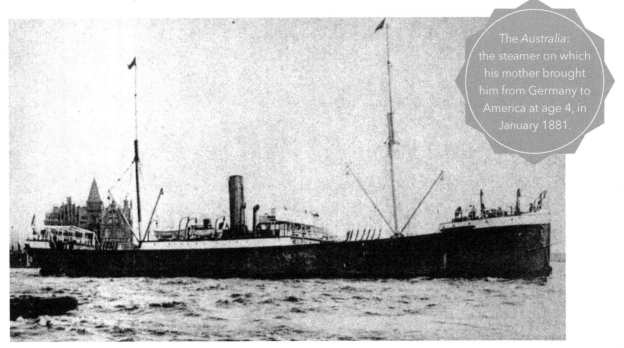

The *Australia*: the steamer on which his mother brought him from Germany to America at age 4, in January 1881.

# *Carving a Legacy*

*Tracing Lawrie's ancestry has been challenging. Prussians have a mythic reputation for being highly efficient and remarkably detail-oriented. Therefore, since he was born in Rixdorf, Prussia, (now known as the Neukölln district of Berlin) I assumed that getting some genealogical data on him, such as a birth certificate or a marriage license for his mother, would be a snap. It wasn't; it was Kafka-esque and fruitless.*

*From 2009 through 2011, through the miracle of the Internet, I was able to contact the Bezirksamt Neukölln von Berlin Amt für Bürgerdienste Archiv im Standesamt (loosely translated to the Neukölln of Berlin Office for Civil Service Archives) to request vital statistics data for Lawrie and his mother.*

*Not knowing the German language, I was able to use Google Translate to request a copy of Hugo's birth certificate. After multiple attempts—and persistence, the office informed me it was unable to locate any birth certificate for Hugo Belling. Thus, we may never know who his father was or what happened to him.*

*When Lawrie's mother remarried in 1883, she was listed as Miss Louise Belling, so perhaps that was her maiden name, or maybe she had never married Lawrie's father. Since then, the archives have begun digitalizing the handwritten logs of nineteenth-century birth records, so maybe, one day, these records will turn up.*

No doubt, in the days before welfare or public assistance of any kind, it was hard for Louise to provide for Hugo on her own. When she couldn't, he spent time in and out of orphanages. On December 18th, 1883, Miss Louise Belling married a Chicago pharmacist named Charles Lowry, but it didn't last long, and they parted company.

Around this time, young Hugo decided to change his name to Lee Oskar Lawrie; the name he would use throughout his life. The name served him well, but later in life, he was forced to try to find his roots.

In the 1940s, when Lawrie was serving as the chairman of the United States Commission on Fine Arts, his American citizenship was questioned by federal immigration authorities. He spent a couple of years during the Second World War trying to establish his citizenship by attempting to trace his adoption by his step-father. It wasn't until 1944 that he achieved naturalization, despite the fact that he had registered for the draft in World War I. But that's getting ahead of the story.

Little is known about Lawrie's early life, other than that he attended schools in Baltimore, as well as Chicago. The young Lawrie spent time living both with his mother, and in orphanages.

In later life, he recalled telling the other orphans that he still had a mother. This made them angry and jealous and they judged him haughty and arrogant. Some of the other orphans often beat this pride out of him. It was perhaps these episodes that contributed to his adult shyness and aversion to receiving attention, which in turn, may explain how he escaped the limelight for his enormous body of work.

Seeking better employment opportunities, Lawrie's mother moved them to Baltimore. But times were tough there as well and during some rough patches, Lawrie ended up spending time in the St. Vincent de Paul orphanage. Some articles about his youth reported that he not only developed an interest in drawing but realized he could use his talent to his advantage.

While living at a boarding school in Baltimore, Lawrie had the job of sweeping the sidewalk in front of the building. Instead, he laid his broom against the door, scurried off and began drawing passersby as they walked past. He would then try to sell his drawings to the people he had just drawn. In this way, he earned a little cash for food and lodging.

Because he was born into a hard-scrabble life, Lawrie learned to work at an early age. He worked as a telegram delivery boy—a job he never cared for—sold newspapers, and worked in a store.

Eventually, Lawrie and his mother moved back to Chicago. He never attended school beyond adolescence, and in 1890, at around age fourteen, he got a job as a lithographer's apprentice, inking plates for printing. In this job, he revealed a talent for drawing and soon he was producing drawings of frothy mugs of lager for beer ads.

## "Boy Wanted"

In 1891, Lawrie got his first real break when he answered a classified ad that said, "Boy Wanted." This ad was the inspiration for the title of Lawrie's never-published autobiography.

The job, as it turned out, was for a boy to help out around the studio of Henry Richard Park, a prominent Chicago sculptor. Lawrie's job was to keep the clay models moist, run errands, and answer the door. When he was first hired, he slept on a cot in the basement of the studio. He lived on bread, coffee, and cheese, and earned two dollars per week. He spent his evenings studying sculpture by modeling clay. The sculptors who worked there would then critique his creations, and advise him on technique and form.

Before long, Lawrie was allowed to begin studio work and was given minor sculptures to do. This also earned him a room in the Park household and a seat at their dinner table.

After just one year of working for Park, Lawrie had sufficient enough skill to land a job assisting master sculptors, enlarging small sculpture into full-sized plaster statuary for the forthcoming Chicago Columbian Exposition of 1893, commemorating Columbus's landing in America four hundred years prior.

The 1893 Chicago Columbian Exposition was a World's Fair, staged at the dawning of the Electrical Age. This was the Fair that introduced the Ferris Wheel to the world, and the Exposition's temporary buildings came to be known as the White City because of the "staff" (stucco-like plaster materials) used to construct them.

While Lawrie began learning sculpture at age fourteen in Park's studio, one of his other teachers was Philip Martiny. Because the Fair was global in nature, it attracted the most prominent sculptors of the day, and young Lawrie apprenticed under many of them over the next few years. By and by, Lawrie's experience working under Park would also lead to opportunities to study under the other great nineteenth-century master sculptors: A. Phimister Proctor, Charles Lopez, William Partridge, and W. Clark Noble.

Around 1894, Lawrie moved to New York City and studied under Beaux-Arts sculptor Augustus Saint-Gaudens (1848-1907) who was known as the "American Michelangelo." His famous works include a statue of Admiral Farragut at New York City's Madison Square (1881), a statue of Diana from 1892, and a twenty-dollar gold piece.

# *Carving a Legacy*

In 2006, when I visited the Library of Congress's Manuscripts Division, I located pieces of Lawrie's never-completed autobiography.

In it, he discussed a statue he made of a priest, Father J.P. "Mackincrow," but for nearly a decade, I was unable to find any information on this priest, whatsoever. Late one evening in early 2016, it occurred to me to take another stab at locating some information on this work.

Finally, it dawned on me, that, maybe, if I changed the spelling and Googled it, I might find some useful information–anything. Whether it was fate or fortune, I plugged in "McIncro" and instantly got a hit; it turns out the proper spelling was "McIncrow." There was a postcard on eBay showing the statue.

FATHER McINCROW MONUMENT, ST. MARY'S CEMETERY, AMSTERDAM, N. Y.

I bought it.

But I wasn't sure that the statue was still there. Many of Lawrie's works have been sold for scrap over the years, due to people's lack of awareness of his legacy.

Next, I got in touch with some people in the offices of St. Mary's parish in Amsterdam, New York, who generously sent me some photographs of the statue.

In his early adulthood, Lawrie was seeking commissions and approached the sculptor James E. Kelley, who had a reputation for helping young sculptors. Kelley didn't have any work for Lawrie, but told him about a job that he might be able to get–creating a memorial for a popular priest who had recently passed away in Amsterdam, New York.

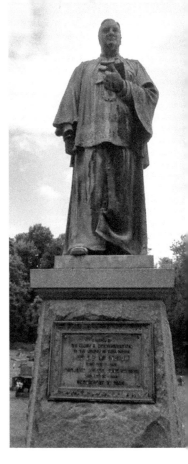

Lawrie contacted the congregants and was soon hired to create the statue. He rented a store near the church, and, for the next three weeks, he started working up a half-sized model of it for the approval of the congregants. He was provided with photographs of the deceased, and interviewed his surviving friends, but their descriptions of his features proved inconsistent at best. Once the congregants viewed his model, they were unanimously disappointed, so it was back to the drawing board.

In frustration, Lawrie spoke to a Mr. Hennesey, who had the contract to create the granite base on which the statue was to be mounted. Lawrie told him that he felt he had to resign the job, because he was unable to create a work that was satisfactory to the parishioners. However, Hennesey told him that he had an idea for a plan that would help Lawrie satisfy the patrons.

It was unusual to say the least. Hennesey consulted with the parish officials, and got permission to open the grave, in the presence of a third observer and let Lawrie directly study the corpse. Lawrie stated that he had to force himself to look at the corpse, but noted that it hadn't looked too horrible, and he was quickly able to observe the features of the deceased well enough to obtain a decent likeness of him.

Following this ordeal, Lawrie was able to complete the statue, enlarge it to life-sized, have it cast, and erected in the cemetery.

When Ms. Elizabeth Barker sent me the photographs, I was thrilled, and she consented to let me use them. However, I was somewhat surprised by the date on the pedestal—1897. Lawrie had just begun apprenticing as a sculptor in 1892—at the age of fourteen—for the 1893 Chicago Columbian Exposition, but roughly five or six years later, he was able to create a statue of this magnitude.

More important than the fact that Lawrie was able to execute the statue unsupervised, is that it is the earliest clearly documented example of his work. It is, perhaps, the first piece of sculpture that he ever created. While Lawrie began working with Goodhue in 1895, no documentation exists of his other, own work that was made before this. His allegorical bas-reliefs on Goodhue's Deborah Sayles Memorial Library in Pawtucket, Rhode Island, dating to 1900—when Lawrie was about twenty years old—are generally credited as his first work.

But this is the real deal. In 2016, I added this latest discovery to the Smithsonian's Catalog of American Painting and Sculpture. No one had ever previously documented its existence, much less identified it as such a culturally significant work of art.

One thing is for certain, there is a great deal more of Lawrie's work out there to be discovered and documented. Nothing gives me more joy than discovering a "new" piece of his work.

# Lawrie Meets Goodhue

In 1895, at age eighteen, Lawrie saw a church that would change his life. It was All Saints' Church in Ashmont, Massachusetts, and he found it stunning. The building was designed by the firm of Cram, Goodhue, and Ferguson and built in 1891-1895. Its Gothic style so intrigued Lawrie that he found his way to the firm's office and inquired whether he might be able to sculpt for them. Immediately before joining Goodhue's firm in 1895, Lawrie had been studying under the master sculptor Henry Hudson Kitson who was then very active on the Boston sculptural scene. After meeting Goodhue, Lawrie got the job.

As noted before, one of Lawrie's earliest independent commissions came in 1900 when he was chosen to design panels for the Dorothy Sayles Memorial Public Library in Pawtucket, Rhode Island.

This library was designed by Goodhue, and Lawrie designed panels for the exterior of the building, depicting Greek figures and mythological heroes of the ancient world.

In 1904, Lawrie designed a sculpture titled South Dakota, depicting a Native American maiden for the St. Louis World's Fair—or Louisiana Purchase Exposition— that celebrated the centennial of the Louisiana Purchase.

Around 1908, when Goodhue was still working with Ralph Adams Cram, he and Lawrie worked together on a series of works at the United States Military Academy in West Point, New York.

During his early twenties, Lawrie entered Yale and graduated with a Bachelor of Fine Arts degree in 1910. He had begun teaching at the Yale School of Art two years earlier in 1908—yes, two years before his graduation—and taught there until 1918. He also taught at Harvard School of Architecture from 1910 to 1912.

Perhaps it was at Yale where Lawrie acquired the taste for Modernism in his style. At the end of the nineteenth-century, most of the active sculptors were European emigrants, like Lawrie. According to art and architecture historian Eric Scott McCready, men such as Franz Metzner, Ivan Mestrovic, Ulrich Ellerhusen and Alfred Bottiau all used modern style that eventually influenced the work of Karl Bitter, Paul Manship, John Gregory, Lawrie and others.

McCready's doctoral dissertation was on the Nebraska Capitol and its place in Modernism in architecture. McCready mostly attributes the styles of Ellerhusen and Bottiau

as having pioneered the style similar to that of Bitter and Lawrie. In 1932, Lawrie received an honorary Master of Fine Arts from Yale. Later in life, Washington College granted him an honorary Doctorate, although he never actually invoked the title Doctor Lawrie.

In the years from 1912 to 1920, Lawrie created sculptures for churches designed by Goodhue and other architects. One of their most famous works during this period is the St. Thomas Episcopal Church on Fifth Avenue in New York City. Lawrie designed the reredos—the giant wooden screen behind the altar—that consist of more than sixty-three figures, both ecclesiastic as well as secular. The reredos stands some eighty feet tall and forty feet wide. The church also contains an illustration of St. George slaying the dragon as well as a relief showing World War I doughboys, airplanes, and tanks. Goodhue and Lawrie's next major collaboration would be the Nebraska State Capitol.

Lawrie is an outstanding role model for immigrants seeking the American Dream. A German-American immigrant, Lawrie came to this country as a poor child with almost nothing. He would grow up to become one of the most prolific and innovative artists this country has ever known. Lawrie managed—through sheer talent, industry, and gumption— to become one of the most ubiquitous American artists of the twentieth-century. His handiwork was exhibited at four World's Fairs: Chicago's 1893 Columbian Exposition; St. Louis in 1904, commemorating the centennial anniversary of Lewis and Clark's expedition; Chicago's 1933 Century of Progress; and he even served as a sculptural advisor at the 1939 New York World's Fair.

Many people work twenty-five or thirty years, get the gold watch and the pat on the back, and then spend their remaining days winding down. Not Lawrie. With a career that began at age fourteen, and spanning nearly seventy years, he worked daily until eight days before his death in January of 1963.

One account I read from Lawrie's archives indicated that once he had moved to Locust Lane farm in Talbot County, Maryland, he had decided to raise some chickens. However, it was also said that all of the chickens there died of old age. This image is taken from his scrapbook at the Goodhue Archives, Avery Architectural Library, at Columbia University in New York.

**BANTAMS FOR SALE**

Lively foragers.

Feed bills not high.

Eggs small but of fine quality.

These beautiful chickens make desirable pets for children.

**$3.00** A PAIR

**LOCUST LANE FARM**

Phone 1335-W-3

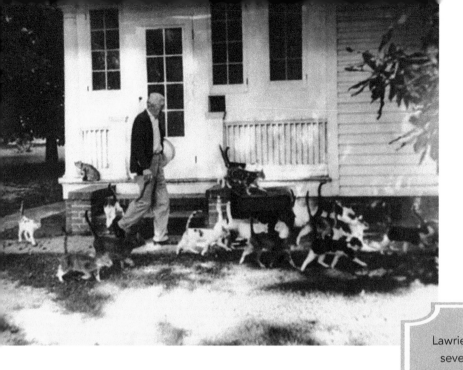

Lawrie at his Locust Lane Farm, with several dozen kitties. He was still working at age eighty-five, when they took him to the hospital one last time. Photo courtesy of the Library of Congress, Lawrie's archives.

## Dean of American Architectural Sculptors

In looking at Lawrie's art at the Nebraska State Capitol, one might wonder not only how he fit into the overall scheme, but also who he was. Where did he learn his craft? What else did he do? What was his life like?

Lee Lawrie was one of the most prolific architectural sculptors the world has ever (not) known, and his work can be found throughout the United States. Every day, thousands of people walk by his *Atlas* at the Rockefeller Center in New York City, yet few know of the genius who was behind this creation. In fact, Lawrie designed and installed more than a dozen sculptures and relief sculptures in and around Rockefeller Center alone.

Lawrie created the polychrome reliefs of *Wisdom*, *Light*, and *Sound*, which top a spectacular wall of sculpted, amber-colored glass blocks that grace the front of 30 Rockefeller Plaza. In 2006, these images were featured in the opening credits of the NBC sitcom *30 Rock*; however, there was no mention whatsoever of Lawrie as the artist of these works. Of course, they've always been there, therefore they're easily overlooked.

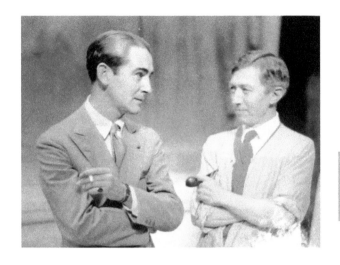

Lawrie was a humble, modest, and extremely shy individual who felt that his art should speak for itself—not draw attention to the artist. For nearly three decades, he worked closely with the Nebraska Capitol's architect, Bertram Grosvenor Goodhue. He created engaged architectural sculpture on nearly all of Goodhue's buildings. "Engaged sculpture" means that it is integral to the building, a part of it, rather than something standing independently and distinct from the building, or an afterthought, added onto it later.

In his never-published autobiography entitled *Boy Wanted*, (The title came from the newspaper help-wanted ad that Lawrie answered, resulting in his first job in sculpture.) Lawrie stated that he worked on all of Goodhue's buildings except one, over those three decades. Sadly, while both geniuses noted this exception, neither man specified which building it was. (However, I believe my childhood friend, Kelly McKeen of San Diego, has correctly solved this mystery—I *suspect* it is the Museum of Man at Balboa Park, but this hypothesis is yet unproven.)

In 1922 at a celebratory dinner in his office, Goodhue was introducing and recognizing the individual architects in his firm. When it came time to recognize Lawrie, Goodhue described him as "one of the quietest, to my mind the ablest, and assuredly the shyest sculptor in the world." Then, as an aside, Goodhue said, "Please drag Mr. Lawrie forward."

Continuing, and demonstrating the scope of their collaboration, he said, "With but a single exception, not a building of ours of which sculpture is a part, but the sculpture is from his hands, whether it be state capitol, college, library, school, house, or church."

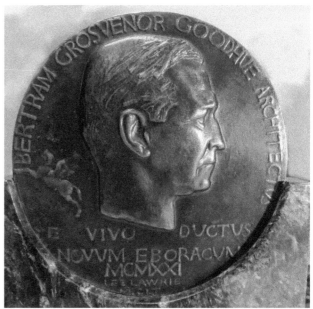

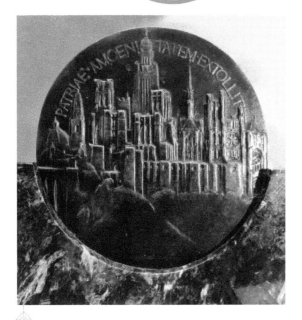

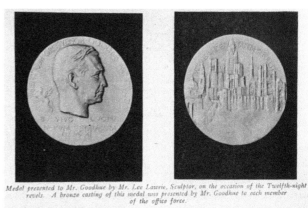

*Medal presented to Mr. Goodhue by Mr. Lee Lawrie, Sculptor, on the occasion of the Twelfth-night revels. A bronze casting of this medal was presented by Mr. Goodhue to each member of the office force.*

*Photo courtesy of* Pencil Points: A Drafting Room Journal, *January 1922.*

It was also at this party that Lawrie presented Goodhue with the medal bearing his image.

It was also at this *Twelfth Night* Celebration where Lawrie first revealed his medal honoring Goodhue, presenting the first one to the honoree and then giving one each to the rest of the staff.

In the early 1920s, Joseph Kiselewski spent four years working alongside Lawrie in his studios as his sculptural assistant. When writing Lawrie's obituary, this eyewitness to living and working with Lawrie, Kiselewski states that he was a superb designer with a powerful and unlimited imagination, and that his drive pushed him on without rest.

Kiselewski also noted that Lawrie possessed the most tremendous amount of energy he'd ever seen in a man. He remembered that Lawrie often had several commissions

going at one time, employing up to ten men at a time in his studio to complete the many projects of his work. He also noted that Lawrie could draw as easily as most people could speak. He paid little attention to a forty-hour week, had no time for a social life, and frequently worked seven days a week until exhaustion stopped him, often skipping meals, and generally fueled by little more than lots of coffee and cigarettes.

Joseph Kiselewski, one of Lawrie's studio assistants.

*Photo courtesy of Smithsonian Institute, Peter A. Juley & Son Collection.*

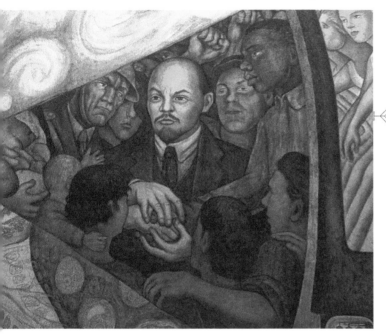

Rivera's mural that was demolished from Rockefeller Center's archives.

*Photo courtesy of Jaontiveros.*

It's funny how popular culture can focus on one artist in a particular era, and completely ignore another. The 2002 film biography *Frida* about the early-twentieth-century Mexican painter Frida Kahlo, celebrated her art and that of her husband, Diego Rivera. He was the renowned 1930s Communist painter and muralist who was chosen to create a mural in Rockefeller Center in the RCA Building for the Rockefeller family.

Most people know the story of how Rivera designed the mural with figures of Lenin and Trotsky in the grouping. And many people have also heard of Nelson Rockefeller's orders to destroy the mural with sledgehammers because it was contrary to the wishes of the Rockefeller family. Apparently, no one ever told Rockefeller that Rivera and Trotsky were buddies.

Yet, almost no one knows anything about this man Lawrie, whose work is found less than fifty feet away from the site of Rivera's original mural. Often times, just doing the job you were hired to do doesn't bring you fame as easily as causing a scene does, so maybe that's why we know Diego Rivera a little better.

Lawrie was born literally in the horse and buggy days. During his lifetime, he witnessed dramatic changes in the world. Lawrie saw the country transform from an agricultural society to an industrial, urbanized, and sub-urbanized one. He saw electricity replace kerosene and gas lighting and witnessed the birth of radio and television. He saw transportation grow from animal-powered to machine-powered with the advancement of the automobile, planes, and the birth of the space-age. He saw warfare transform from equestrian cavalries to the industrialized carnage of World War I. He even lived long enough to witness the dawn of atomic warfare and the Cold War. But along this road, everything that he saw fueled his imagination and was manifested in his art.

His patriotic images commemorate the nation's war dead dating back to the Revolutionary War, at battlefields such as Gettysburg, at the WWI Memorial Flagstaff in Pasadena, California, and the Soldiers' and Sailors' Memorial Bridge in Harrisburg, Pennsylvania. His monuments also stand guard at the American Battlefield Cemetery, in Brittany, France, over the graves of 4,909 American war dead; most of whom perished fighting in WWI during the 1944's Brittany and Normandy campaigns, following D-Day. In addition to memorial statues, Lawrie also designed various medals including the American Defense Medal awarded to war veterans.

In 1956, *American Artist Magazine* dubbed him the "Dean of American Architectural Sculptors." During his lifetime, Lawrie also served as a consultant in sculpture for a multitude of projects, including the American Battle Monuments Commission in the 1950s. He was also a sculptor-member of the seven-man National Commission on Fine Arts as well as a member of the American Academy of Arts and Letters. He was honored in 1933 as an academician at the National Academy of Design. He was an honorary member of the American Institute of Architects, who awarded him two gold medals: the first in 1921 for his Nebraska work and again in 1927. Lawrie also received the Medal of Honor from the Architectural League of New York and the Medal of Honor in Sculpture from the National Sculpture Society. In 1931 and 1932 he was honored as a Fellow with the Council of the American Geographical Society. In 1937, Lawrie also won the American Numismatic Society's prestigious J. Sanford Saltus Award, for Outstanding Achievement in the Art of the Medal. He received nearly all of these honors during the

very period of his career when he was working on the art for Nebraska. Wherever his flair for design came from, few have rivaled this level of recognition—and yet he left such a tiny footprint in history.

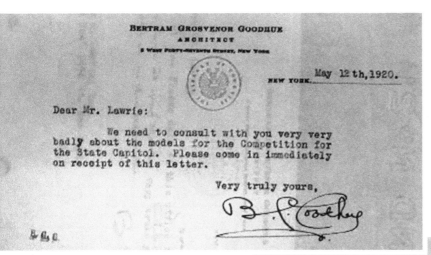

Early letter from Goodhue to Lawrie: Perhaps the first indication of the two starting to collaborate on the Capitol.

Letter from Goodhue to Lawrie, regarding drawings for sculpture at the Capitol. Both images were photographed at the Goodhue Archives. Avery Architecture Library at Columbia University.

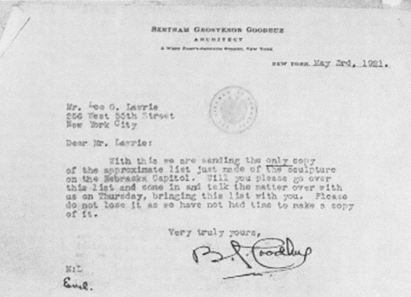

Isn't it ironic that this man, who created so many memorials to others, is honored by this simple headstone? Lawrie's grave in Easton, Maryland, not far from his Locust Lane Farm.

*Photo courtesy of Alexandra Witze.*

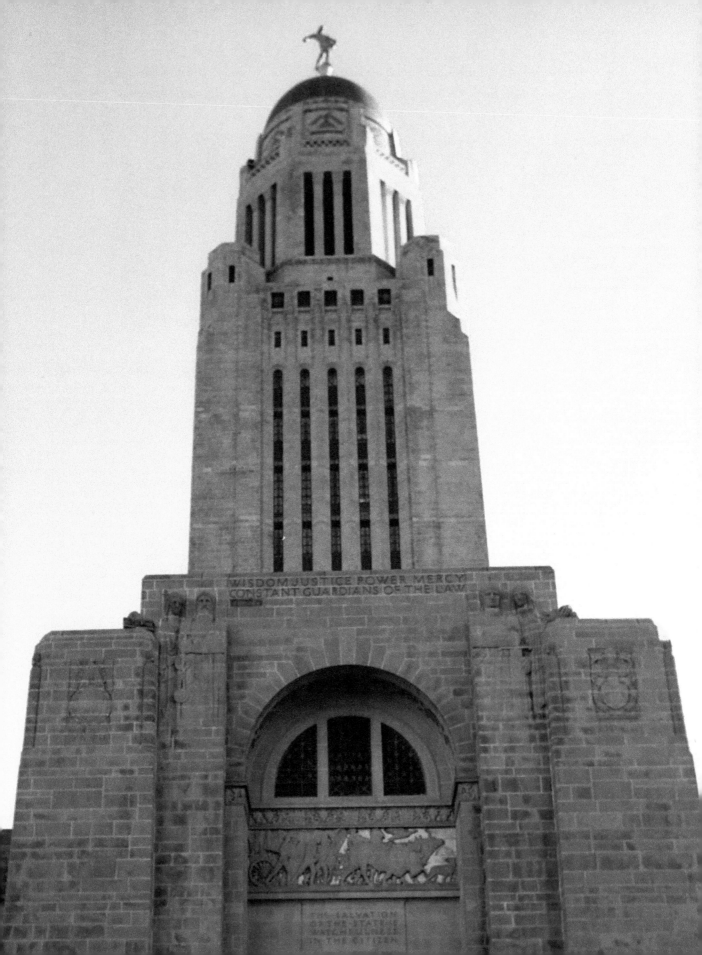

# THE PHILOSOPHY OF LAWRIE

Author's Note: The following passages are taken from speeches, articles and letters written by Lee Lawrie. His words are worth reading firsthand, rather than through any clumsy effort on my part to interpret what he meant. His character comes through in his own voice, far more clearly than I could ever attempt to describe it.

IN HIS INTRODUCTION FROM A 1936 PORTFOLIO OF HIS works, Lawrie speaks of his motive and the purpose of his works:

Sculpture for buildings serves to accent the architecture, and sometimes also to characterize the building for which it is made…The sculpture…aims to do both. It consists of details and parts from a series of work done for a number of buildings, and the same, few, simple rules were applied to it all. None of it employs the forms that are brought to mind by the term "architectural decoration," those symbols of past ages whose forgotten meanings render them useless except for the purpose of accenting the architecture they adorn. It seems like a waste of effort when sculpture aims only to "decorate."

If the sculpture is to reflect ideas that will tell the passerby the kind of building it marks, pertinent subjects must be found for all the surfaces provided for it. Good subjects make one feel that the work needs to be done, and that feeling causes it to take shape readily. Unconsciously, then, the sculptor returns to the principles that guided the primitives, who were not too knowing, but were intent upon bringing out an idea or a story.

After the subject is determined, the next consideration is the design, which is a simple arrangement that may be comprehended at a glance. Then

comes the modelling, which must have no unnecessary detail that would complicate the design and obscure the idea–no capricious touches to divert the beholder's attention from the sculpture's meaning. The design and modeling being kept simple–the meaning is clear.

In looking through an illustrated history of sculpture, one reaches the conclusion that there is no new way of designing and modeling, for there is ample evidence that every arrangement has been done as well as every manner. There are two reasons why this is so: the human figure with which all sculptures have been mainly engrossed, has certain bounds which cannot be disregarded without resulting in the production of a monstrosity; the other is that the carving of stone and the casting of metal are the same today as they were in the earliest times, and hold the sculptor to certain principles that are handed down as traditions, from which he could not escape if he would.

If newness is the desire, it must be achieved in the idea that the sculpture presents. Almost the same modeling can be used to make a frieze of corn, wheat, or any native plant in making the acanthus. The same rendering that produces Athena may be used to make a personification of a modern city. By bringing the native subject forward, interest and vitality will be added to modern sculpture, and the citizen will feel a relationship to it.

It is not meant that the acanthus will not always be considered a beautiful ornament, nor that so long as civilization lasts, traditional symbolism will not be venerated and used. A greater respect for it would surely be indicated, however, by its being used more sparingly and appropriately.

Also, it is not meant that a sculptor cannot be a creator. Although no new ways of designing and modeling are available, the personal characteristics that stamp each sculptor's work, when applied to an original theme and architectural problem, make it a creation. What will be done when the sculptors have full play with the tremendous and dramatic themes that are to be recorded of our age and scene can only be imagined. The opportunity for this expression will no doubt bring forth works equal to those of the great monuments of the past.

–Lee Lawrie, 1936.

Lawrie in his thirties.

*Photo courtesy of the Library of Congress.*

In another work, Lawrie states,

> The problems of present-day architectural sculpture are more practical than artistic. The sculptor is like one of the fiddlers in an orchestra. Sculptors who work on buildings know this. I think there is more opportunity for artistic thought in meeting the resistances that a modern building puts out than in purely aesthetic sculpture. You have to confine yourself to the architectural language and stick within its medium, but I don't think these limitations prevent anyone from using what imagination and skill he has.
>
> On buildings, the sculptor's object is not to make an outstanding detail as much as it is his job to help complete the building. There will always be gallery sculpture, but architectural sculpture has a different purpose. The sculptures of Babylon, Egypt, Greece and even of the Middle Ages were made almost entirely for and on buildings. The art museum is a recent invention—it was unknown in Rembrandt's time and sculpture in the early days was done for a reason.

Lawrie also taught us that his murals were often carved in place as part of the structural, load-bearing walls, and as such, they personified architecture; being integral and specifically *not* supplemental afterthoughts. Additionally, he points out that there has to be a stylizing or "a conventionalization" that organic forms, such as human or plant undergo whereby their appearance stiffens when carved in stone. This is addressed, he suggests, by keeping the shapes fluid. Additionally, he distills the shapes down to their very essence, where fewer lines become more pronounced in the carved image. An additional benefit of this is that as the sun travels across the sky, its rays on the works vary constantly from day to day and season to season, therefore each line, shape and shadow depends on the light to convey their meaning.

Lawrie also pointed out that the purpose of mural art in Gothic style churches remained unchanged until the dawn of the twentieth-century. By incorporating steel into construction, skyscraper construction was suddenly occurring. This, in turn he suggested, freed such artisans from the conventions of the past and presented them with new architectural problems. This was beneficial in that it led to creative solutions, many of which had not yet evolved in the 1930s. To see how he attacked these problems, we can look not only at the Nebraska Capitol Tower, but also his high altitude works on Bok Tower in Florida and the Louisiana State Capitol, all of which extended Lawrie's visions heavenward.

He took sculpture to places it had never been before. He designed looking directly into the eye of the future; presenting it with something totally and completely new and of a nearly incomprehensible volume.

# PART II

## The Creators of
## Stone Storybooks

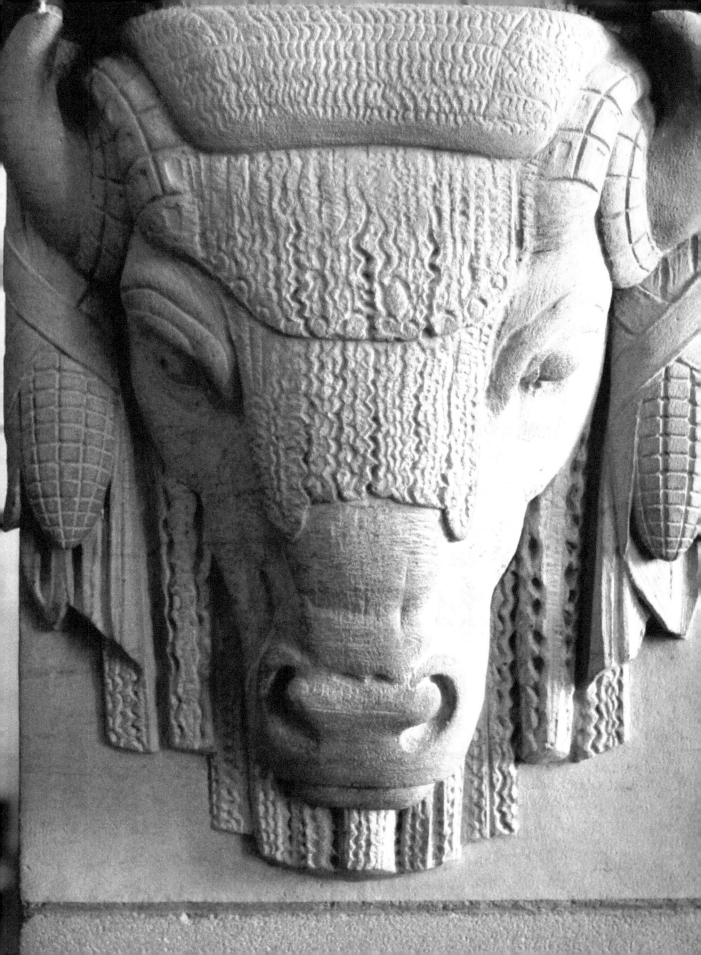

# 3

# A MASTER OF LOGISTICS

ONE OF THE AMAZING THINGS ABOUT LAWRIE IS THAT HE performed these logistical feats, and some of the largest examples of project management, some eighty years before the development of computers, fax machines, e-mail, or smart phones, and at least thirty years before air travel would replace rail service.

Yet Lawrie managed to complete many projects simultaneously—and nationwide—using only those primitive tools of communication available in the early 1900s.

While he was working on the sculpture for Nebraska, he also had ongoing projects at the Los Angeles Public Library, Rockefeller Chapel in Chicago, the Fidelity Mutual Life Insurance Building in Philadelphia, the Education and Finance Buildings in Harrisburg, Pennsylvania, and Bok Tower in Florida. He was multi-tasking like crazy long before the term reached our vernacular.

Most of Lawrie's creations on the multitude of buildings where his work can be found were carved by workers in Eduardo Ardolino's company, which sometimes employed as many as thirty-six stone carvers at a time.

Master Stonecarver
Eddie Ardolino.

*Photo courtesy of
Mary Francis Dougherty.*

One of two bison heads on the Governor's reception room fireplace. The bison represents the regionalism of the prairie. Note its geometric zigzag treatment of its fur, complemented by the grid surface of the corn. It's prairie meets Art Deco.

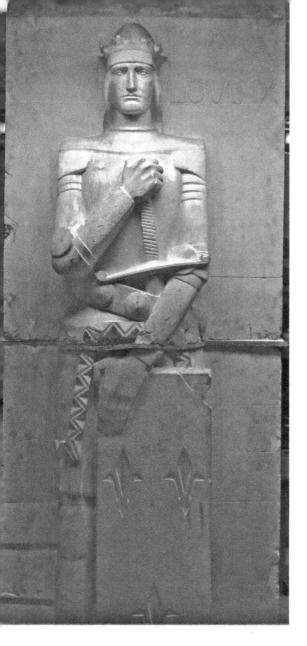

Lawrie's archives are packed with folders that contain scores of letters and telegrams to and from Goodhue and Alexander, most of them yellowed with age. Whenever Goodhue wanted to get together with Lawrie in his office, they would have to set it up by mail, or telegram, and maybe confirm the meeting with a local phone call if they were both in New York at the same time. Just imagine what Lawrie might have accomplished had he lived in the twenty-first century!

Lawrie operated out of a studio at 1923 Lexington Avenue in Harlem in New York City and often employed crews of carvers and sculptors to execute his works. He would create his models first in clay, followed by maquettes out of plaster, built up over wood lath foundations. The maquettes would then be shipped to the job site for carvers to use to enlarge into the stone bas-reliefs and figures used on the Capitol.

The lion's share of the actual carving at the Nebraska Capitol, both on the interior and exterior, was done by Alessandro Beretta. In carving the *History of Law* panels, then known as *The Development of the Law*, Beretta would spend up to ten weeks on each panel, working from the maquettes, and using from seventy to one hundred different tools, including pneumatic chisels, inside temporary wooden sheds erected to help protect him from the often-harsh Nebraska elements. As of 1931, Beretta had been sculpting for twenty-six years and was forty-seven years old. He noted that where possible, the faces were done as historically accurate portraits, and were the hardest parts to carve.

Because Lawrie was able to rely on Ardolino's men to get the carving work done, it freed him to focus on the creative task of building the maquettes. Ardolino had gained

Lawrie's full trust and confidence over their collaborative work on previous buildings: Saint Thomas's Episcopal and Saint Vincent Ferrer's churches in New York and the Harkness Quadrangle Buildings at Yale. Ardolino had also done carving for several of the other prominent architects of the day, such as McKim, Mead & White, John Russell Pope, Cross & Cross, and James Gamble Rogers, among others. The caliber of Ardolino's clients speaks to the strength of his reputation.

Today, we worry whether the UPS guy will deliver our order on time, but we have the luxury of checking the tracking number online to locate our package. In Lawrie's day, he would have to ship his maquettes from New York to Nebraska and then wait until letters or telegrams arrived to let him know the goods had reached their destination. This process could take days or weeks from start to finish, and all Lawrie could do was wait and hope his shipments didn't end up lost and sitting in some small-town depot in Illinois, Ohio, or Utah.

On a 2006 visit to Manhattan, I found that Lawrie's 1923 Lexington Avenue studio is long gone. It's been replaced by a rather bland mid-century-era apartment building, clad with a space age, *Jetsonian* aqua and turquoise siding crisscrossed with aluminum trim.

In 2010, I had the pleasure of interviewing ninety-three-year-old Richard Mays, who was raised in New York City and whose parents had once owned the garage that Lawrie had converted into his studio. He recalled that when he was a small boy, he would accompany his parents to Lawrie's Studio when they collected the rent.

While I had known for years that Lawrie's studio was in a converted garage, Mays asked me how large I thought it would have been. I responded that I assumed it was probably about the size of a modern quick-lube joint or a muffler shop. Mays said that the building was actually a three-story structure, built as a parking garage with room enough for as many as two or three hundred cars!

Lawrie's Harlem studio where he and his crews created nearly all of his sculpture, from around 1920 through 1940.

He remembered that in the early 1900s and 1920s, automobiles were so new and expensive that people didn't care to leave their cars parked on the street at night, for fear of damage or vandalism. He also noted that in those days, Harlem was a community of mostly European immigrants, with the Irish, Germans, and Poles living there, and it was mostly a middle-class neighborhood. So, the Mays's garage provided shelter for these immigrants' prized automobiles, where they were safe and easily accessible.

He also recalled that on any given day, a dozen to fifteen men at a time would be working there. While we may envision some artisan laboring away in a tiny loft studio, Lawrie's shop was more on the order of an art factory. He created a tremendous volume of work there in Harlem. Mays went on to say that his parents lost the garage during the Depression, and Lawrie eventually had to find another site for his studio.

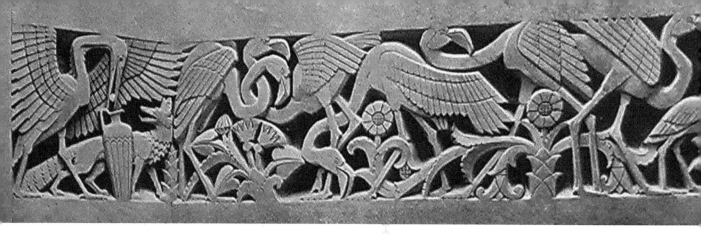

These images illustrate examples of *additional* sculpture that Lawrie created elsewhere around the nation, all generated *at the very same time* he was sculpting for the Nebraska State Capitol.

Detail of flamingos, Bok Tower, 1929, Lake Wales, Florida.

*Colossal Eagles* atop the pylons to the Soldiers' and Sailors' Memorial Bridge, 1930, Harrisburg, Pennsylvania.

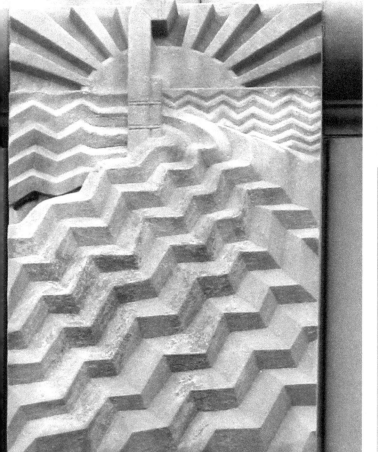

*U-Boat* from the Soldiers' and Sailors' Memorial Bridge, Harrisburg, Pennsylvania.
*Photo courtesy of S.B. Hacker.*

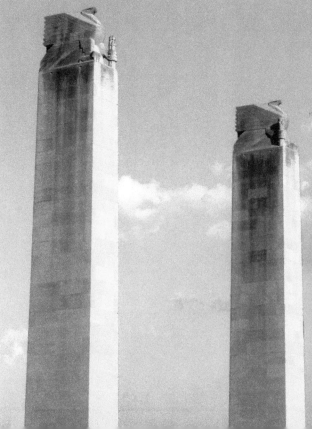

Pelicans on the Louisiana State Capitol Tower, 1932, Baton Rouge, Louisiana.

Lawrie's *Civilization* and *Sphinxes* at the Los Angeles Public Library, c. 1926.

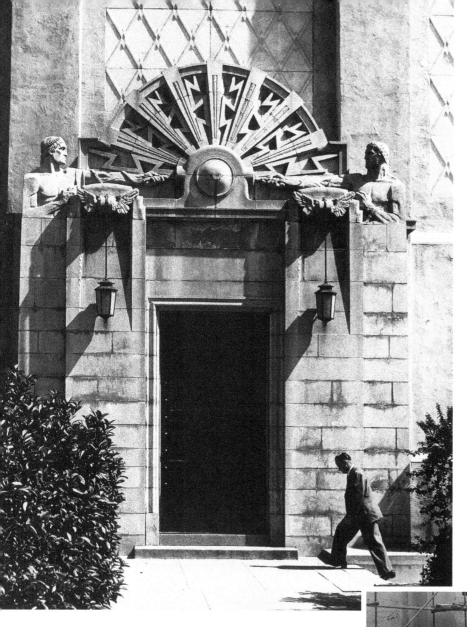

Entrance to the High-Volts Building at Caltech, 1925. Sadly, this work was demolished around 1960, when the building was renovated.

*Photo courtesy of Archives,
California Institute of Technology.*

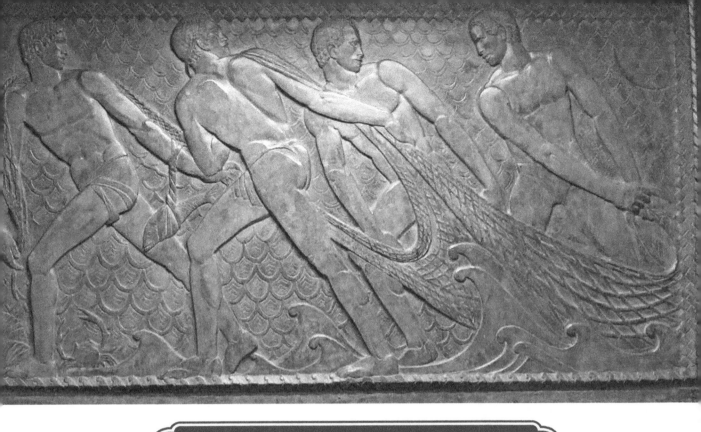

*The Seiners*, 1924. This bas-relief was recently restored by the Bank of Hawaii. It was originally installed in Goodhue's 1926 Bank of Hawaii Building in Honolulu. That building was demolished around 1970, but fortunately this and another bronze panel, *The Canoe Builders*, were saved before the building was razed.

Photo courtesy of Bank of Hawaii.

Spandrel representing North America Fidelity Mutual Life Insurance Building, 1927 (now the Perelman Building) in Philadelphia, Pennsylvania.

# *Carving a Legacy*

In 2015, my wife and I traveled to New York City, where we branched out to explore additional examples of Lawrie's work. First, we visited the Dime Savings Bank in Brooklyn, where Lawrie created a tympanum, featuring time, with a youth rising for the day and lacing up his sandals and, opposite him, an old man with a long, flowing beard, like Father Time, who represented old age. These two figures surround the clock in between them. This work dates to around 1930.

Woodlawn Cemetery in the Bronx was our next stop, where we photographed the Harkness Mausoleum, 1925, resting place to Edward Harkness and his wife Mary, inside and out. Its interior is covered with carved columns, figures of angels, and round pieces at the apex of each rib of its vaulted ceiling. The floor design (bottom left) represents time with hourglasses and twenty-four figures, which symbolize the hours in a day.

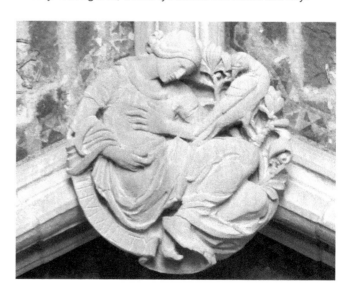

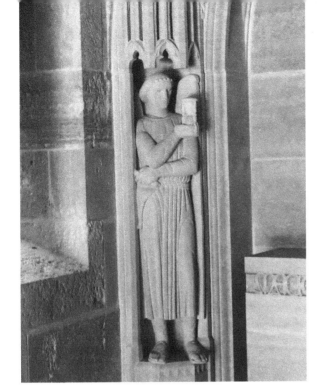

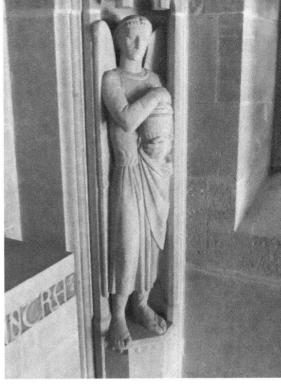

Edward Stephen Harkness was the son of Stephen V. Harkness, a nineteenth-century investor and mogul in John D. Rockefeller's Standard Oil, who became its second largest stockholder. Edward was heir to his father's fortune and spent his lifetime as a philanthropist. He was a benefactor to many causes, including being the founder of the Commonwealth Fund and funding much of the construction at Yale, including Harkness Tower, which is covered with sculpture of famous Yale grads—done by Lawrie.

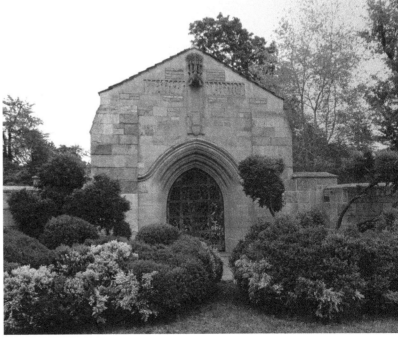

Also at Woodlawn is the tomb of Isidor and Ida Straus, who perished on the Titanic. Isidor was the owner of Macy's, and their story was included in the 1997 movie Titanic. Mrs. Straus would not board a lifeboat without her husband, so they voluntarily went down with the ship. In front of their mausoleum is a nearly fifteen-feet long replica of an ancient Egyptian funeral barge, with oars extending out of its sides, that Lawrie carved to commemorate the Strauses.

Like the Harkness Mausoleum, the Straus Tomb, 1928, was also designed by architect James Gamble Rogers, with whom Lawrie had worked on many buildings at Yale.

Photos courtesy of Larry Atkins.

*Lawrie also likely has work at Caltech, where Goodhue designed the campus, then known as the Throop Institute. The only work formally attributed to Lawrie at Caltech are the hieroglyphics sculpted into the entrance of the Hale Solar Observatory, 1923, just a few blocks away from the campus. While a national landmark, it is now part of a private estate, and is no longer open to the public.*

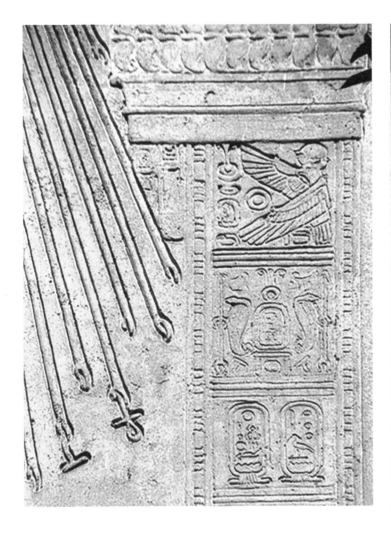

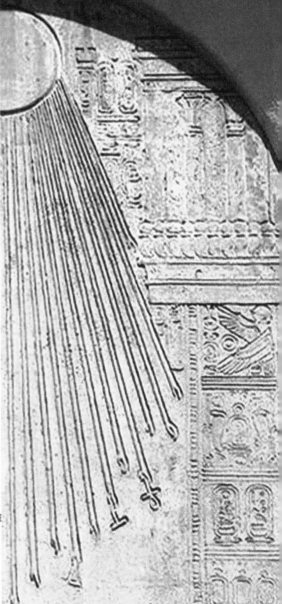

*Photos courtesy of Larry Atkins.*

*Portrait from Architecture Magazine, 1931.*

# 4

# GOODHUE AND HIS TEAM OF DREAMERS

## Goodhue

GOODHUE WAS BORN IN POMFRET, CONNECTICUT, IN 1869. HE studied at, but never graduated from, Trinity College. Nevertheless, he could draw exceptionally well. In the 1880s when Goodhue was learning his craft, there were two paths into the profession of architecture: education or apprenticeship, and great architects emerged from both trails. Being of modest means, Goodhue couldn't afford college, so he apprenticed.

While many of the leading architects of the day attended the École des Beaux-Arts (or School of Fine Arts) in Paris, Goodhue hadn't. Consequently, he often felt somewhat marginalized from the inner circle of architects who had.

In 1884, when Goodhue was about fifteen, he started an apprenticeship as an office boy at Renwick, Aspinwall & Russell in New York City. After just two years, he had earned a reputation as a distinguished draftsman.

In May 1891, Goodhue went to Boston to collaborate on St. Matthew's Church in Dallas with Ralph Adams Cram and Charles Francis Wentworth, which featured his winning design. By June of that year, at the age of twenty-two, he joined the firm as a partner. The firm continued to grow and ultimately became known as Cram, Goodhue, and Ferguson.

Goodhue was a man of unique vision, seeing beyond the present and into the future. As an adult, his travels took him to Europe, the Middle East, and Mexico. In these exotic lands, he saw the complex examples of architecture that had been formed over

millennia. He would ultimately incorporate these images into his architectural vocabulary. Before long, the young Goodhue was designing churches, posh residential homes, public libraries, and several buildings at West Point. As noted earlier, Goodhue and Lawrie worked together for nearly three decades. Goodhue designed literally scores of Gothic churches, primarily in the Northeast and upper Midwest, but he and Lawrie also worked together on many public buildings.

In the decade following the completion of the Capitol, one of Goodhue's protégés would have a significant impact on the world of architecture—a young architect named Raymond Hood, who went on to design several nationally famous skyscrapers and ultimately his masterpiece, Rockefeller Center.

According to Richard Oliver, Goodhue's biographer, Rockefeller Center was the "true child" of the Nebraska Capitol Building, whose North Portal "almost single-handedly defined Art Deco sculpture." Goodhue used a total design concept in his buildings by coordinating the painting, sculpture, and architecture.

However, in a 1988 interview, long-time Capitol authority Bob Ripley noted that by the time Goodhue created the Capitol, he had been sketching similar towers on his buildings for fifteen or twenty years before he got the chance to use the design on the Nebraska Capitol.

My old friend and noted Chicago architect, Kim Clawson, first told me that perhaps some of the elements for Goodhue's palette, which straddled both the old and the new, came from the following influences: Lars Sonck's Kallio Church, Eliel Saarinen's Helsinki Railroad Terminal, and Istanbul's Hagia Sophia.

Lars Sonck's 1909 Kallio Church may have inspired the Tower.

Still others suggest that Goodhue was influenced by Eliel Saarinen's Helsinki Railroad Terminal, built in 1919.

The North Portal may have a hint of Istanbul's Hagia Sophia which dates to medieval times.

While many Nebraskans are aware that Goodhue was the architect who designed the Capitol building, few realize that the team he assembled to collaborate in its design consisted of some of the greatest artistic minds of the day.

Similarly, very few Nebraskans truly grasp how prominent Goodhue was on the national scene—and how fortunate Nebraska was to have landed this genius in a city so far removed from the cultural Meccas of the day.

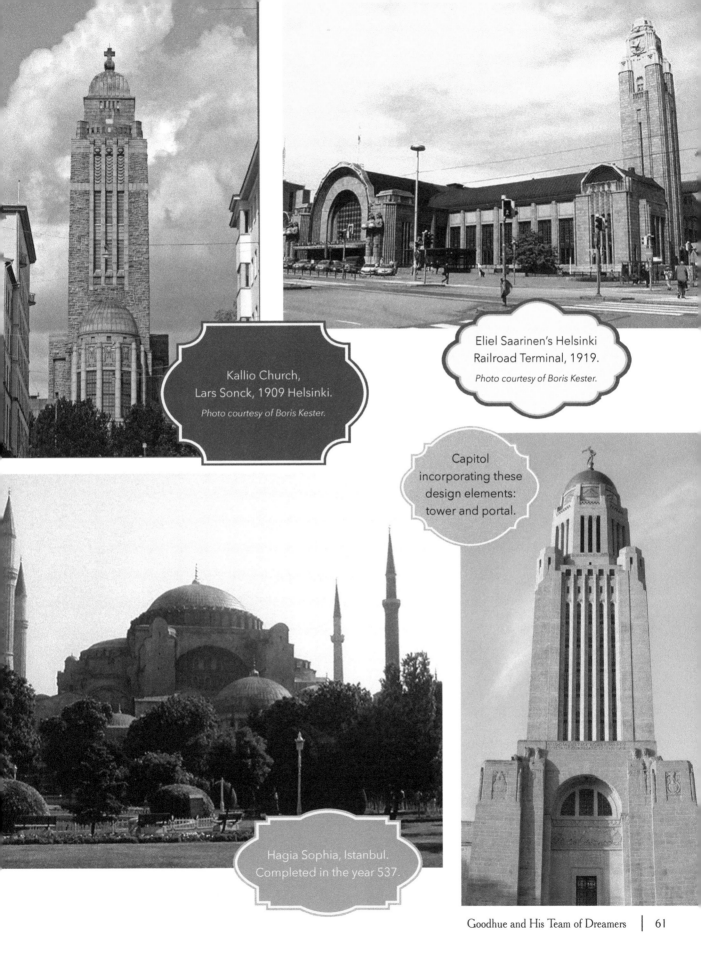

Kallio Church,
Lars Sonck, 1909 Helsinki.
*Photo courtesy of Boris Kester.*

Eliel Saarinen's Helsinki
Railroad Terminal, 1919.
*Photo courtesy of Boris Kester.*

Capitol
incorporating these
design elements:
tower and portal.

Hagia Sophia, Istanbul.
Completed in the year 537.

Bertram Grosvenor Goodhue. The portrait to the right was a model Lawrie had created for his tomb, but it was never used.

This 1914 drawing of "A Battle Memorial" was done by James Perry Wilson, when he graduated from Columbia University's School of Architecture. Wilson was hired by Goodhue, and his drawing likely had at least *some* influence on Goodhue's ultimate design of the Capitol. University Archives, Rare Book & Manuscript Library, Columbia University in the City of New York.

Second Medal.     A BATTLE MEMORIAL.     J. P. WIL

Portrait of Goodhue from the book of Nebraska's Memorial Capitol, 1926.

# *Carving a Legacy*

July 19, 2016

## Another Slice of History Stares at the Wrecking Ball— Goodhue's Studio's Last Days

### 1912 Time Capsule slated for the dump.

*I routinely Google the terms "Lee Lawrie" and "Goodhue" to see if anything new has been published about either man. I've been primarily researching Lawrie since 2000.*

*Late one night in September of 2014, I came across a link through one of Yale University's sites, where I discovered some long-lost photos that revealed day-to-day scenes of Goodhue's architects actually working in his New York Studio, where all of his buildings built between 1912 and 1924 were conceived and designed.*

*Goodhue opened this office, located at 2 West 47th Street, in 1912 and spent the rest of his life working out of this studio. After Goodhue died, his surviving architects formed a new firm—Mayers, Murray & Phillip, which occupied the space until 1940 when that firm dissolved. The photos were credited to someone named R.O. Blechman, with whom I was completely unfamiliar.*

*Through Googling a little more, I discovered that Mr. Blechman is actually an internationally famous cartoonist, animator, illustrator and filmmaker whose work has appeared in the* New York Times *as well as* The New Yorker. *Through his website, I found his contact information. (Most octogenarians are taking it easy and don't have websites, but*

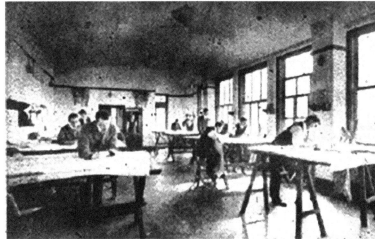

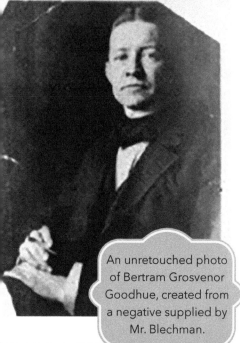

Mr. Blechman is an extraordinarily prolific and interesting fellow—as well as an appreciator of great architecture.) I emailed him a few times, and then finally got up the nerve to call him to request his permission to use copies of his photos in my books.

The first thing I was curious about was how he acquired the photos of architects working in Goodhue's studio. Mr. Blechman told me that he had obtained the photos from the widow of one of the architects that worked in this office with Goodhue

I also learned that Mr. Blechman had spent twenty-seven years in his office that he had rented in Manhattan's Diamond District. When he was first shopping for office space in Manhattan, the real estate agent told Blechman that the space had not been touched since it was abandoned by an architectural firm sometime around 1940. The agent suggested that the space had been occupied "by the famous English architect, Sir Francis Goodhue."

An unretouched photo of Bertram Grosvenor Goodhue, created from a negative supplied by Mr. Blechman.

Century-plus-old images of Goodhue's original reception room, from the May 1913 issue of *Architecture*, courtesy of Hanleywood.

But the agent had the name wrong. It had been the studio of Bertram Grosvenor Goodhue; the space had sat vacant and virtually untouched for decades.

More delightful still, after visiting with Blechman for a while, I realized that he was quite familiar with Lawrie and many of his works in Manhattan.

*In a not-yet-published article, Blechman noted, through a series of odd coincidences, how he met architectural critic, David Garrard Lowe, who was an authority on Goodhue. Blechman then attended a lecture to learn more about this mysterious figure.*

*In an associated odd coincidence, after Blechman moved in, there were a few pieces of decorative hardware missing around the office. He was fortunate enough to find the firm that had actually supplied the office with its original hardware. Moreover, in what Blechman describes as another accident of fate, an art director visited the studio, who had an octogenarian aunt whose husband came to the studio with pictures of the original offices, including the* Twelfth Night *photos.*

*In the January 1922 edition of* Pencil Points: A Drafting Room Journal, *Goodhue stated that every piece of sculpture on every building that Goodhue and Associates had designed, had been done by the hand of Lee Lawrie. The edition also includes a photo from a* Twelfth Night *party held in that very studio.*

*This is the very space where Goodhue and his associates designed the Nebraska State Capitol as well as dozens of other nationally famous buildings, and also the Pasadena War Memorial Flagpole, numerous buildings at West Point, and doubtlessly more buildings than this.*

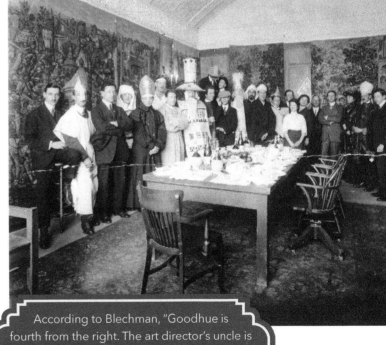

According to Blechman, "Goodhue is fourth from the right. The art director's uncle is the dapper gentleman, far left." This image was originally published in the January 1922 edition of *Pencil Points*.

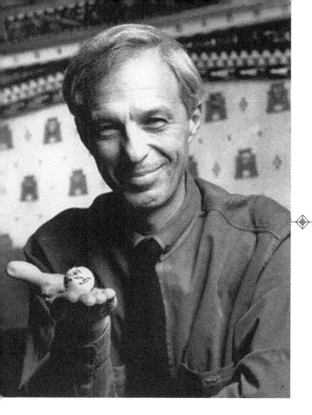

But more importantly by far, Blechman explained to me that he had occupied Goodhue's former studios at 2 West 47th Street in Manhattan for decades. His company, The Ink Tank operated out of this studio.

R.O. Blechman in his studio, holding a ping pong ball, with his art company, the Ink Tank's logo on it. Note Goodhue's original fireplace in the background.

Although I didn't recall ever hearing of Blechman before, I was familiar with one of his major contributions to American Culture–a 1967, Clio-winning animated commercial for Alka-Seltzer featuring a wiggly-lined drawing of a stomach, seated on a chair, lamenting about how tough it was to be a stomach, when its human owner subjected it to such a harsh diet. It's hilarious. The voiceover was done by a pre-Young Frankenstein actor, Gene Wilder.

Around 1976, when Mr. Blechman was first offered the space to rent, the agent advised him that they could modernize it: lower the ceilings, re-drywall it, etc. Frankly, (and thankfully,) this prospect horrified Mr. Blechman, who informed the agent that renovations were not necessary, that he would take the space in its then-current condition.

Blechman in his studio reviewing artwork with his associate, Tessa Davis, undated.

*Photo courtesy of Mr. Blechman.*

*During my conversations with Mr. Blechman, I inquired whether he had been back to his old studio in the years since he had retired and moved upstate. He responded that he had not returned and had a sense or a suspicion that after he left, the space was probably carved up, and altered to a degree in which nothing that he had enjoyed would still be there. It is like when you turn a favorite possession over to someone else, revisit it later, and realize that they have neglected it, remodeled it, or somehow instilled some similar form of abuse upon it. Suffice it to say, that he worried that revisiting the space would probably shatter his memories of the grandeur that once filled the space where he had devoted almost half of his nearly six-decades-long career.*

*Fast forward a couple of weeks: A friend of mine since childhood, Hot Jazz impresario, Russ Dantzler, had lived in Manhattan since 1987. Russ has a great respect for distinguished architecture, the history of the city, and a unique connection that only a few Nebraskans can claim: his father was an engineer at the Nebraska State Capitol for years, involved with the building's operations. He has a rather pedigreed interest in the Capitol as well as in Goodhue.*

*Around that same time in the autumn of 2014, Mr. Blechman sent me an email with "Sad News" in the subject line. It was an announcement, an article stating that a new hotel was going to be erected on the space where the studio stood, at 2 West 47th Street in the Diamond District.*

*Knowing that Russ lives in Hell's Kitchen, I figured I'd let him know about this and see whether he could find anything out about this old space that, God only knows, how badly it had been gutted since Mr. Blechman left.*

*When I mentioned to Russ that I had recently become a pen pal with Mr. Blechman, and that he had formerly occupied Goodhue's old studio, Russ's curiosity led him to go look into the matter to see what he could learn about the space. In particular, whether there was any trace of Goodhue left in the old space. Mr. Blechman told Russ that he had moved out of the studio in 2003, and held a party to commemorate the occasion.*

## An Historic Time Capsule

*Here is the opulence that greeted Russ on his first visit to the studio: the over-a-century-old space looked much like it did when both the architects left in 1940 and Blechman vacated it in 2003.*

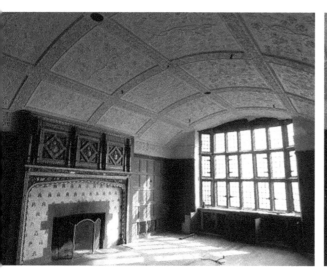

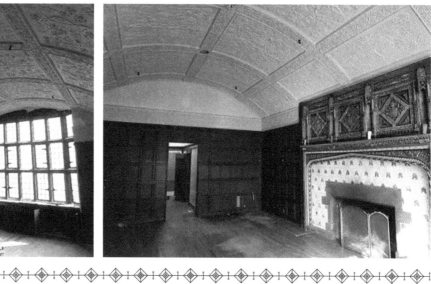

Detail of the curved plaster ceiling.

*All color photos in this section are attributed to Russ Dantzler.*

After visiting the site one Friday, Russ learned that the space had NOT been gutted, as Blechman had feared, and was, in fact, pretty much the way it was when he (Blechman) had vacated it years earlier. Fortunately for all of us, Russ was able to acquire access to the space and photographed it for posterity.

Consequently, although Mr. Blechman may have had the opportunity to go visit his old digs, and to create some final memories of his old studio, he decided that it was best to let his memories of it remain intact.

As the article referenced before has indicated, all of the tenants have already vacated the building in anticipation of its demolition. But with a little luck, Russ and R.O. will be able to explore the space again, and see it for one last time, before it ends up in debris on the ground. See also www.leelawrie.com for images of Lawrie's widespread architectural sculpture.

For more information on this space, see Christopher Gray's article about it in the New York Times from 2000.

Since discovering that this space was still extant in 2014, all former tenants have abandoned the building. Contacts to numerous academic and cultural institutions have not led to any chance that the building will survive, much less this historic office, where so many of the nation's grandest buildings were conceived.

Guliemus Wicamus, (1324-1404) aka William of Wykeham, or Winchester, was a bishop and medieval builder/architect. He built Windsor Castle.

The Coat of Arms of Ralph Adams Cram with the motto, "STOLZ UND TREU, or "Proud and Loyal."

Goodhue's Coat of Arms, "NEC ENVEDIO NEC DESPICIO"; "I Neither Envy Nor Despise."

Frank William Ferguson's Coat of Arms, "DULCIUS EX ASPERIS"; "The Sweeter Because Obtained by Hardships."

Goodhue's private bathroom contained this tile, designed by the Gusatavino brothers. The same tile was used in El Fureidis, the 1906 mansion Goodhue built for James Waldron Gillespie's residence in Montecieto, California, featured as the mansion in the movie *Scarface*. The residence also features reliefs by Lawrie on its portico.

*As of August 2016, Russ had undertaken the challenging task of contacting civic, institutional, and academic institutions to call attention to this space, before it is reduced to dust. But so far, the efforts have not yielded any concrete responses, or a willingness to preserve the space. I guess it is just obsolete, and will be lost to history.*

*In fact, if we place this space into the context of twentieth-century American Architecture, let us consider the significance of just how many major buildings Goodhue conceived, designed, and built from this very space—each of which has the potential to hold scores of Lawrie's sculpture that has not yet been identified, much less documented. It would be terrible if some of these buildings containing Lawrie's unknown works were simply razed.*

*Shouldn't this alone warrant either protecting or salvaging these artifacts?*

# Alexander

Initially, Goodhue struggled with determining which inscriptions would be suitable for the North Portal of the Nebraska State Capitol. He originally assigned the theme of the portal to be "Knowledge, Mercy and Force," but he felt that it needed more. In 1921, he wrote to Kimball and the Capitol Commission seeking their help with the inscriptions. This request from Goodhue led to the appointment of Nebraska native Dr. Hartley Burr Alexander, whose first task was to improve the inscription to its final incarnation, transforming the theme from Goodhue's line about "Knowledge, Mercy, and Force," into the title of *Wisdom, Justice, Power, and Mercy, Constant Guardians of the Law*, which graces the North Portal to this day.

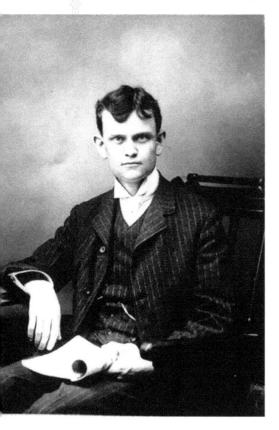

Goodhue's most significant collaborators were his thematic consultant, Dr. Alexander, and sculptor, Lawrie. Together, the team worked out Alexander's scheme of decoration, symbolism, and inscriptions— which were created to make the Capitol a living history book—to convey the true meaning of democracy and how it developed in the Western world. But it was Alexander who advanced the Capitol Commission's wish that the character of the building reflects the heritage of the state, and it was he who selected the various subjects that the artists would use to illustrate the story of the state.

Goodhue's team of artists included not only Alexander and Lawrie, but also the renowned mosaicist Hildreth Meière and nationally recognized painter Augustus Vincent Tack. Meière designed the dreamy Darwin-esque black and white illustrations of the Rotunda and the Great Hall, replete with fossils, saber-toothed tigers, dinosaurs, and other prehistoric animals. These primeval creatures dovetailed with Alexander's dreams, where the ossified trilobites and other ancient sea creatures played their part in the history of the state, becoming part of its geology. Goodhue then gave Tack the assignment of painting the vaulted ceilings of the Governor's Suite with colorful, storybook-like murals.

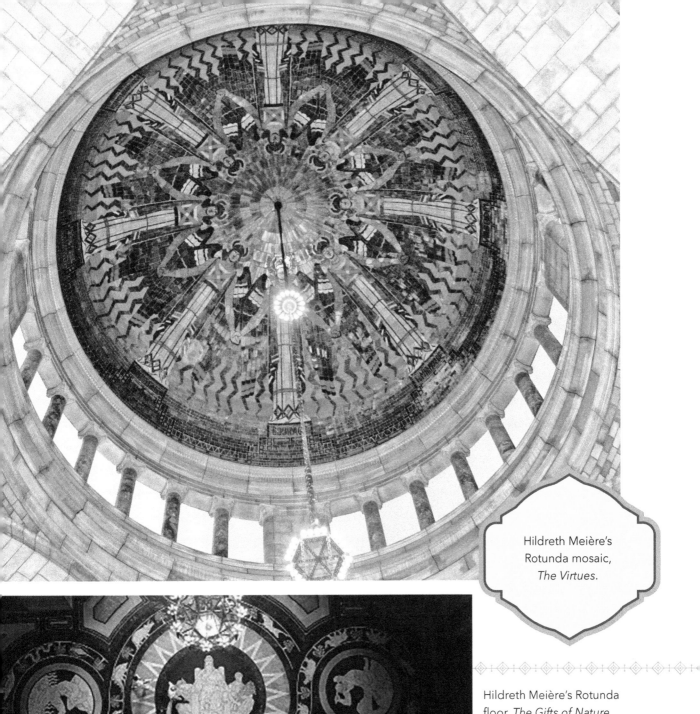

Hildreth Meière's Rotunda mosaic, *The Virtues*.

Hildreth Meière's Rotunda floor, *The Gifts of Nature*.

Not only was Alexander an authority on American Indian history and culture, he was also a Doctor of Philosophy, well-educated in both the history and philosophies of Western civilization. In his role, Alexander sought to pay homage to the heritages of both the Native Americans and the European immigrants who first populated Nebraska.

Because it was to serve as a house of state, Alexander, together with Lawrie, crafted the scheme of the building to be a sort of giant textbook. Alexander would identify the most significant characters and events in the history of political development, and Lawrie would make the sketches, mold clay or plaster into the models, and design the sculpture that would illustrate and accentuate these characters or events on the various façades, shoulders, corners, and other prominent surfaces of Goodhue's building.

The notion of the building as a storybook helps to guide the observer in a logical progression around the structure. The story develops mostly chronologically, first honoring the heritage of the Native Americans, who were once the only occupants of the state, and then the European-American settlers that entered the area in the nineteenth century.

Alexander, who served as the philosopher-king on Goodhue's team, developed the thematic content upon which Lawrie's work was based. Alexander told the story and Lawrie illustrated it in stone, bronze, and wood. Together, these two great geniuses created

Together, Lawrie and Alexander created a stone storybook of the history of law in the Western world.

a stone storybook of the history of law in the Western world. Their stone images included the concepts of the rights of Habeas Corpus in justice, suffrage, no taxation without representation, independence from colonial powers, civil liberties, freedom of speech and the press, and a host of other political milestones that have been held up as beacons to all those who live in oppressed lands.

Alexander chose the theme "The History of Law" and followed its progression from the earliest Hebrew or Mosaic law, into the Greek and Roman era, through the Middle Ages, past the Pilgrim and Colonial times, to the Civil War, and up through the admission of Nebraska into the Union as the thirty-seventh state in 1867.

The casual observer who visits the Capitol may recognize such memorable historic scenes as The Signing of the Declaration of Independence, The Drafting of the Constitution, or even The Emancipation Proclamation. But how many people among the

general public are familiar with Las Casas and his sixteenth-century struggle to obtain civil rights for the Indians of the Caribbean? Who can look at *The Tribunate of Rome* or *The Judgment of Solomon* and, without additional study, understand that the stone tattoos on the skin of the building also tell us how the system of "trial by jury" was conceived?

Alexander's poetic selections, carved by Lawrie into the limestone that clothes the building, also give voice to the prayers and songs of the Native Americans of the region. Those voices were nearly exterminated at the end of the nineteenth century. Decades before Tonto rode across the tiny silver screens of our mid-century black and white TVs, Alexander was quoting the songs of the Native Americans, immortalizing their words in stone for posterity.

> American Bison, or buffalo, were like Wal-Mart on the hoof for the Native Americans, providing Native Americans with food, clothing, shelter, tools, blankets, and even buffalo-hide boats called bullboats that allowed them to cross the abundant rivers of the Great Plains.

Naturally, Alexander called for images of buffalo to figure prominently into the scheme. Metaphorically speaking, American Bison, or buffalo, were like Wal-Mart on the hoof for the Native Americans. They provided Native Americans with food, clothing, shelter, tools, blankets, and even buffalo-hide boats called bullboats that allowed them to cross the abundant rivers of the Great Plains. The tribes of the Great Plains were dependent on buffalo and held a sacred respect and gratitude for the species. Lawrie captures the whole sanctity, beauty, and nobility of the bison in no less than a half dozen sculptures in and out of the building. The most prominent of these are four, life-sized buffalo featured on the parapets of the North Portal.

According to Bob Ripley, Alexander supplied the philosophical element that allowed Goodhue to graduate from purely the ecclesiastic form of architecture to the secular. Alexander developed the sculpture program that would encapsulate five thousand years of history and law—as well as cultural and political evolution—from the days that Moses brought down the law from Sinai, to the latter half of the nineteenth-century.

From the 1922 groundbreaking, until long after Goodhue's premature death in 1924 at age fifty-five, Alexander worked closely with Lawrie to identify the cast of historical political heroes and events that created the foundations for modern American government. And whatever figures or events Alexander identified, Lawrie would illustrate, through a collection of sculpture using wood, stone, and bronze to create nearly one hundred distinct works symbolic of both Native American and Anglo-American heritage.

Lawrie's interpretation of Alexander's *History of Law in Civilization*—alternatively named *The Development of the Law* and, in still other articles, *The Majesty of the Law*—highlights the most salient developments in Western Law. What is more, it illustrates that democracy as we know it took more than five thousand years to develop and take root in Nebraska. In the chaos of the twenty-first century, the lessons identified by Alexander and illustrated by Lawrie have never been more timely and valuable.

## "You're not getting paid to think!"

While the team of Goodhue, Alexander, and Lawrie worked in harmony on the Nebraska Capitol, Alexander's role as a chief philosopher, while serving in future projects such as the Fidelity Mutual Life Insurance Building in Philadelphia, government buildings in Harrisburg, and later at Rockefeller Center, would eventually wear thin.

While Nebraska and buildings in other communities and states benefited from Alexander's lofty eloquence, under the "time is money" pressure constraints of the construction world in the middle of the Depression in Midtown Manhattan, his wordiness may have cost him his job. Accounts vary as to whether Todd fired Alexander or Alexander left voluntarily because he felt that Todd and company were playing fast and loose with his serious scholarship, and he didn't want his name connected with something that was done in a slip shod manner.

According to Christine Roussel, author of *The Art of Rockefeller Center*, there were throngs of artists working to create the many murals and sculptures for that building. While the art that resulted is multi-dimensional in character—greatly influenced by the artists themselves—the process of overseeing the artists, however, was less harmonious. The artists, working under the time and economic pressures of the Depression, were fully accountable to project manager John R. Todd, head of Todd & Brown and the chief contractor for the Rockefeller Center. Todd oversaw the construction and installation of the art. Time was money, and Todd was all about business. Ultimately, Alexander, who was focused on the altruism of man and quite anxious to share his eloquence with those around him, left the project.

*Photo of Dr. Alexander, courtesy of the Nebraska State Historical Society.*

> Alexander's lofty eloquence was taken for granted under the "time is money" pressure constraints from the Great Depression.

Isn't it rather ironic that a philosopher, educated at Columbia and of such great reputation elsewhere, was dismissed in the greatest of all American cities—especially in one generally regarded as a true Mecca of intellectualism—for being too eloquent and philosophical?

Or perhaps Todd was the first individual to ever utter the blue-collar foreman's favorite axiom, "You're not getting paid to think!"

Doctors of Philosophy like Alexander, however, are paid to think!

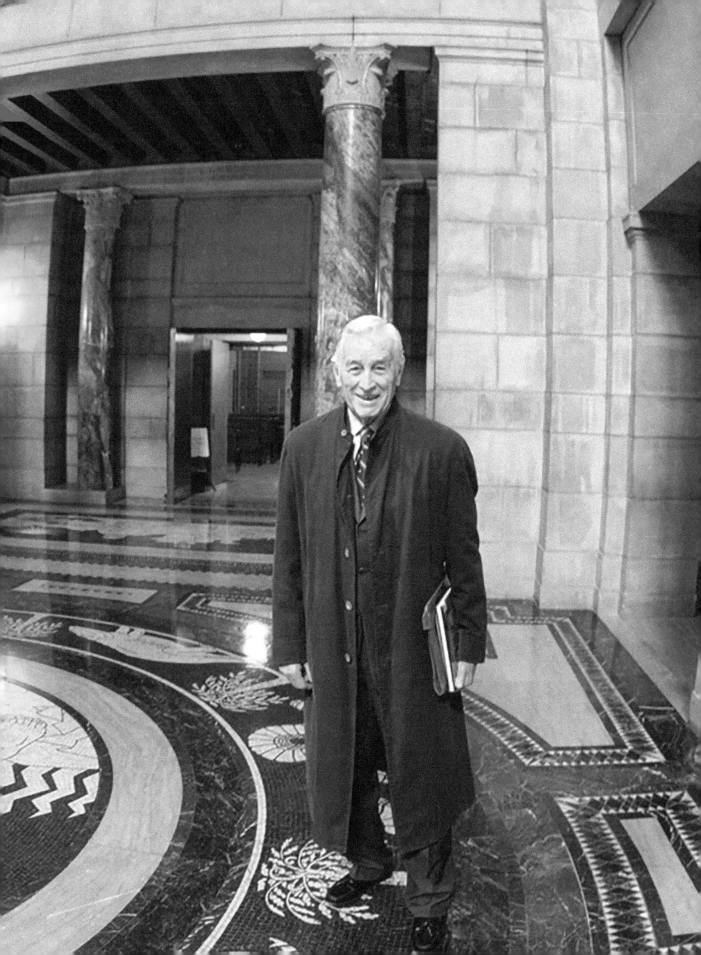

# 5

## PROFESSOR DALE GIBBS, DICK HILL, AND THE RESCUE OF LAWRIE'S MAQUETTES

### Dr. Dale Gibbs

I N THE SUMMER OF 2006, WHILE RESEARCHING THIS BOOK, I had the honor of interviewing Dr. Dale Gibbs, a retired University of Nebraska Architecture professor who taught from 1954 until 1992. Dr. Gibbs was a tall, hale, and distinguished fellow, whose good looks and posture made him look much younger than his eighty-three years. He had written a chapter celebrating Lawrie's work in a 1990's book about the Capitol, *A Harmony of the Arts*. I credit Dr. Gibbs for piquing my curiosity about Lawrie after I read his chapter in that book.

I asked Dr. Gibbs how he had come to be interested in Lawrie. He stated that he had always been an admirer of Lawrie's work in Lincoln and had been involved in various projects at the Capitol over the years.

Dr. Gibbs grew up in Lincoln. When he was a young boy, his parents gave him a camera. Decades later, he rediscovered some of the photographs he had taken of the Capitol and of First Plymouth Congregational Church in Lincoln. He chuckled and suggested that even as a young boy, he must have had some yet-unrealized interest that would lead him to his life's work as an architect.

As an adult, Dr. Gibbs maintains that he got interested in Lawrie "almost by accident." His friend, Professor Linus Burr Smith, called him one day to say that Lawrie's maquettes had been gathering dust and were getting damaged in storage. These maquettes were the models that Lawrie sculpted in his studios in New York City, and then shipped to Lincoln where his team of stone carvers would then enlarge them.

Dr. Dale Gibbs, 2009.

After the Capitol's construction was completed in 1932, the maquettes were put in storage on the third floor of Morrill Hall on the University of Nebraska campus. Dr. Gibbs gave the caveat, "Now we don't know if this is true, but one day, Smith was walking by Morrill Hall, and the third-floor windows were open, and he saw these fellas throwing pieces of stuff out the windows." Upon figuring out that the stuff flying out the windows were Lawrie's original plaster models, Smith yelled, "Stop! Stop!"

"Obviously," Dr. Gibbs continued, "they were getting these out of the building! Dwight Kirsch, the curator of Morrill Hall back then, said 'Why don't you guys take them to Architectural Hall?' So they were taken to the attic in Architectural Hall by 1946."

## Richard Hill

The maquettes remained in storage and were largely forgotten for the better part of the next two decades. According to Dr. Gibbs, around 1963, a fifth-year architecture student named Richard Hill wanted to take some summer architecture courses. Coincidentally, the architecture department was also anxious to have something done with the maquettes. Dr. Gibbs designed a project for Hill and Kaz Tada, a University staff photographer.

Hill's assignment was to find out all that he could about the maquettes, to determine what each represented, and why Lawrie chose these particular sculptures to go on the Capitol. His research resulted in a monograph that included Tada's photographs of the eighteen maquettes and preliminary descriptions of the symbolism of the characters they represented. Today, the surviving maquettes are in storage in an undisclosed location.

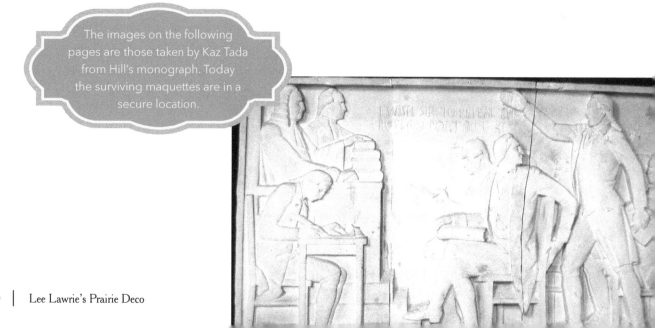

The images on the following pages are those taken by Kaz Tada from Hill's monograph. Today the surviving maquettes are in a secure location.

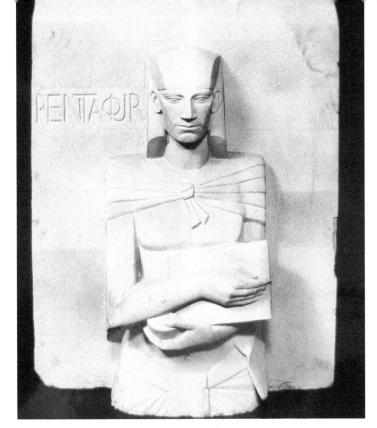

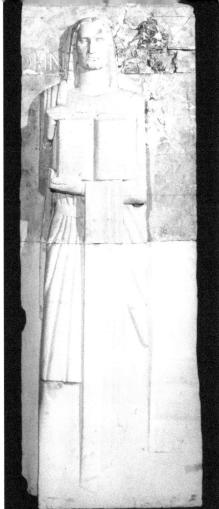

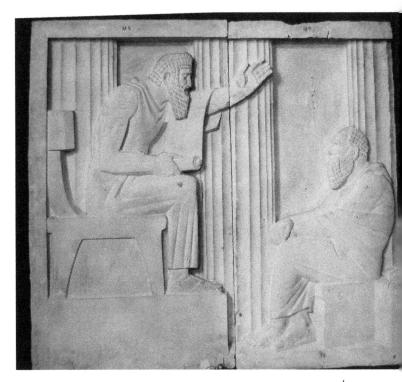

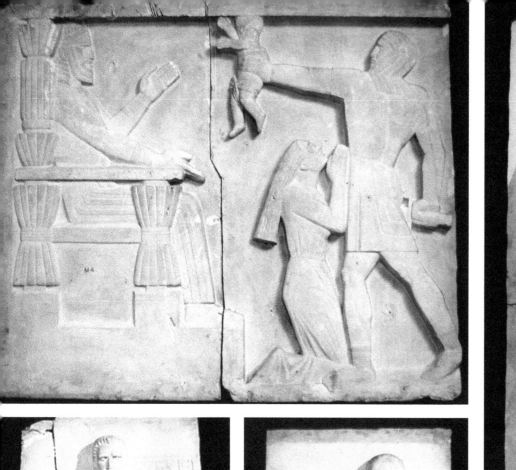

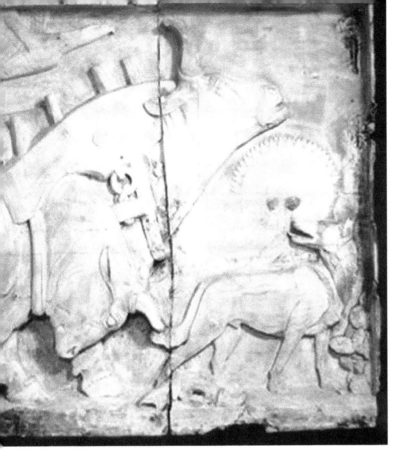

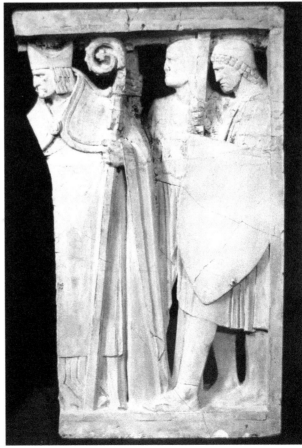

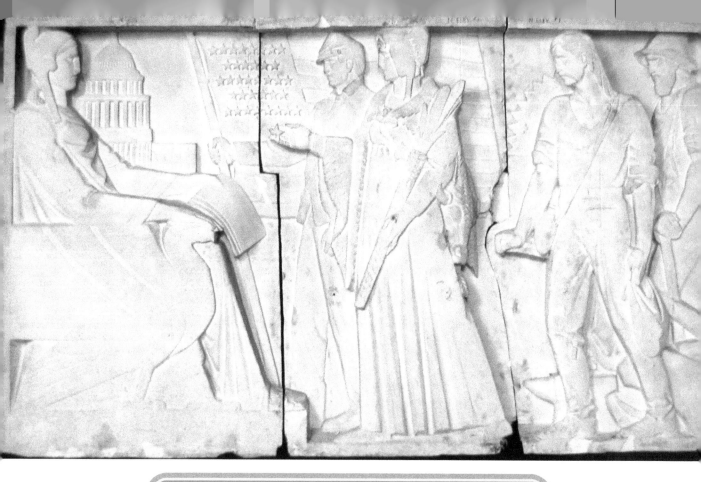

Source: Hill, Richard T., Lee Lawrie's Maquettes for
Capitol Sculpture, monograph, Spring 1965. Mr. Hill is
now retired and lives in Colorado. He has graciously shared his
work for scholastic purposes. Kaz Tada's photographs for
Hill's Monograph document show the surviving maquettes.

Hill's childhood experiences in the archaeological digs left their imprint on him and gave him a love of history and architecture. He would spend the next four decades working in both fields. So, like the author of this book, Hill's special mystical fondness for the Capitol took root in his many pre-adolescent visits there. His admiration of the art and desire to learn the curious history locked up in the stones, (not to mention a few extra hours of university credit) led Hill to coordinate the study of Lawrie's remaining maquettes.

Tada is a Seattle-born child of Japanese parents, who spent time with his family in a Wyoming Japanese internment camp during World War II. After the war, Tada made his way to Lincoln, and eventually graduated from Nebraska Wesleyan. He spent most of his career on staff at the University of Nebraska.

Years before Hill began his project, another photographer had worked in Lawrie's studios shooting images of the maquettes. In 2006, I photographed several pages of manuscripts and boxes of personal photographs that were buried in Lawrie's archives. Unfortunately, there were no captions on the majority of the photographs. There were also many large format negatives of his sculpture in these archival boxes, but they had no captions and were not attributed.

I have seen thousands of pages of Lawrie's letters, clippings, publications, and related documents, and literally hundreds of photos of his work. Based on these findings, my best guess would be to attribute these negatives to early twentieth-century photographer R.V. Smutny, who frequently shot Lawrie's works for various books and architectural journals.

I was able to create positives from these historic negatives using the modern technology of Photoshop. There were no positive images of these in Lawrie's archives. It would be a safe assumption that no one has seen them since they were first shot in the 1920s.

These images show us several of the maquettes that may well have been among those being thrown out the windows of the top floor of Morrill Hall years before. These photographs may be the only surviving evidence of their existence.

Dr. Gibbs also noted a curious aspect unique to the world of architectural sculpture. In this project, Lawrie had to subvert his will to that of Goodhue. Dr. Gibbs said that in modern architecture, sculpture is divorced from architecture, rather than being an integral part of it. Today, for example, sculptors may prepare a work to be installed as a supplement to a building, but it is usually physically separate and distinct from it.

By contrast, Lawrie believed that the art should speak for itself, and not to the ego of the sculptor. The result of his concept is manifested in the Capitol, where the art is harmonious and purposeful, not only in telling the story of the pioneer and Native American heritages, but also in recounting the story of five thousand years of law, government and politics in the Western World.

Like me, Hill had a passion for the Capitol, because of the time he spent there in his childhood. As a kid growing up in Hastings, Nebraska, Hill got to live the dream of many kids, going on archaeological digs with his grandfather, archaeologist and historian Asa (A.T.) Hill. How many kids would have been as happy to have spent their summer vacations tramping around with a real-life version of Indiana Jones?

The elder Hill was the Director of the Nebraska State Historical Society, and spent many years combing various archaeological sites in and around South Central Nebraska, looking for relics both natural and anthropological in nature. The younger Hill recalls memories of spending a few cherished weeks with him in his pre-teen years.

It was on this site that the early western explorer Zebulon Pike once camped with his expedition. A few weeks before Pike's arrival a regiment of some 300 soldiers from the army of Spain camped at this site. According to legend, this was the last time that the flag of Spain was flown in Nebraska.

He remembers riding in his grandfather's car out to campsites along the Republican River near Alma, Nebraska, (hometown of the author's mother). It was there that A.T. searched for and found evidence of one of the largest permanent Pawnee villages, dating at least to 1806.

These archeological digs gave scientists the last opportunity to document the presence of Pawnee in the area. Later this area was inundated by the rising waters of the Harlan County Reservoir, when a dam was built there shortly after the end of WW II. The flood also caused the physical relocation of the town of Republican City to higher ground. It also flooded the land on which my maternal grandfather's Willow Springs dairy farm and my mom's childhood home were located.

During his tenure at the Nebraska Historical Society in the1930s and forties, A.T. lived in an apartment in one of the old Gothic brownstones that once stood across 14th Street to the west of the Capitol.

Often, while his grandfather was at work, Dick would spend his days admiring the Capitol, looking at it from the apartment across the street, and wondering what all of the sculpture on it meant. Inside the Capitol, young Hill would roam the halls and savor the wonders and artistic riches that graced the building both inside and out. "The Capitol was my babysitter!" Hill recently joked, noting that he would spend countless hours in the building, exploring the tower, drinking in the views that span more than twenty miles in every direction.

Hill's childhood experiences in the archaeological digs left their imprint on him and gave him a love of history and architecture He would spend the next four decades working in both fields. So, like the author of this book, Hill's special mystical fondness for the Capitol took root in his many pre-adolescent visits there. His admiration of the art, and the desire to learn the curious history locked up in the stones, led Hill to coordinate the study of Lawrie's remaining maquettes.

The following negatives were found at the Library of Congress.

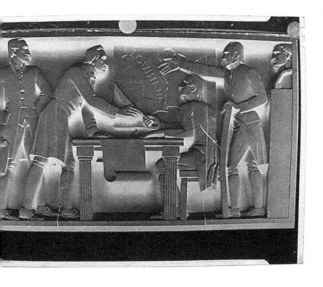 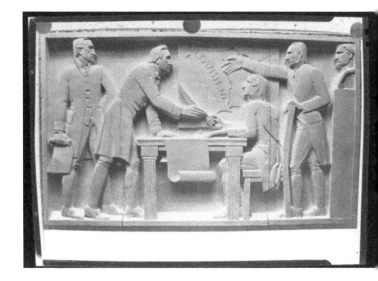

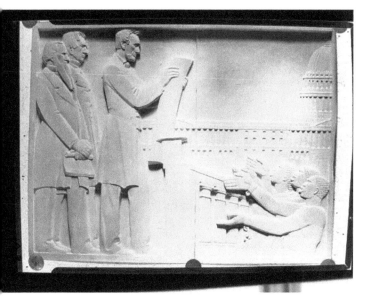

These negatives had not likely been seen since they were originally photographed and might never have been seen again, had I not reproduced them.

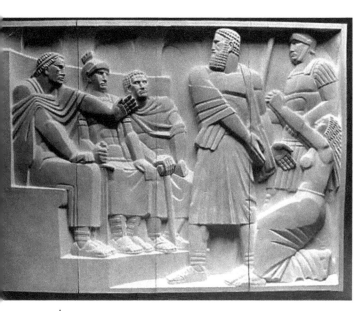

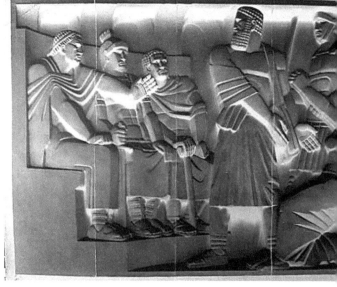

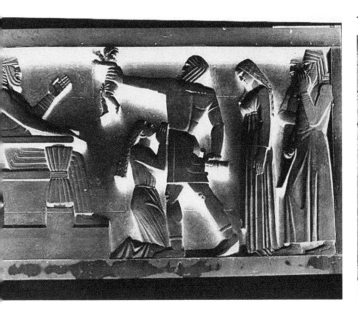

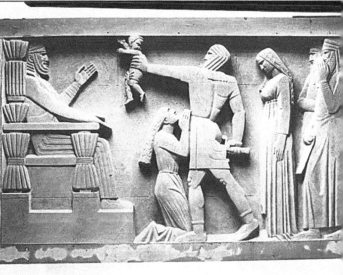

Negatives of the maquettes stored in Lawrie's Archives at the Library of Congress in Washington, DC. First made in clay, then in plaster, the maquettes were shipped via rail from Harlem to Lincoln, to the Capitol, where Ardolino's adept team of carvers shaped the stones into the sculptures precisely as Lawrie designed them.

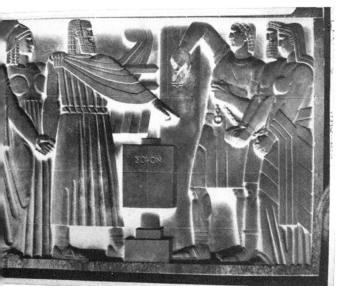

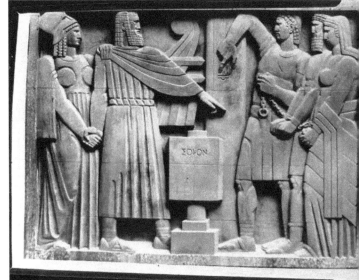

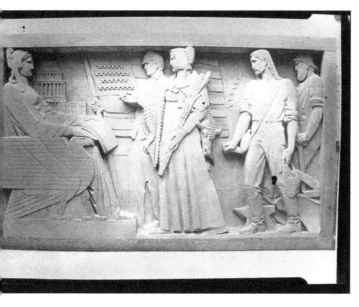

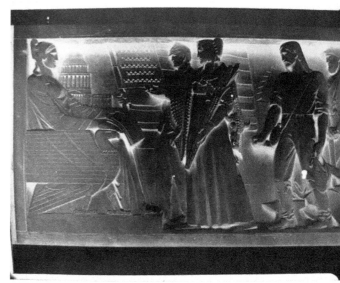

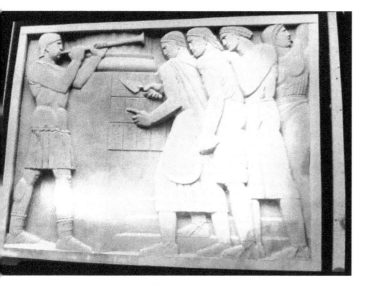

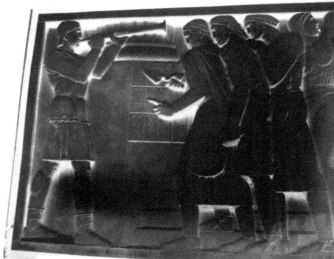

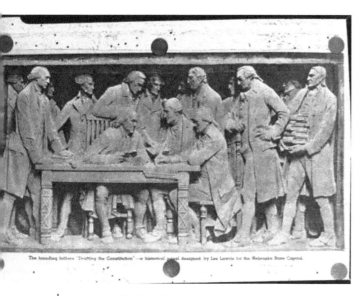

The founding fathers "Drafting the Constitution"—a historical panel designed by Lee Lawrie for the Nebraska State Capitol.

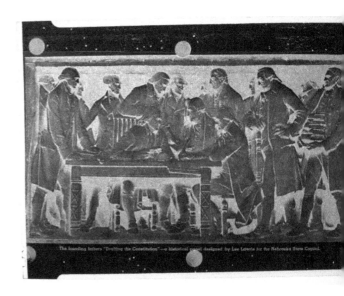

The founding fathers "Drafting the Constitution"—a historical panel designed by Lee Lawrie for the Nebraska State Capitol.

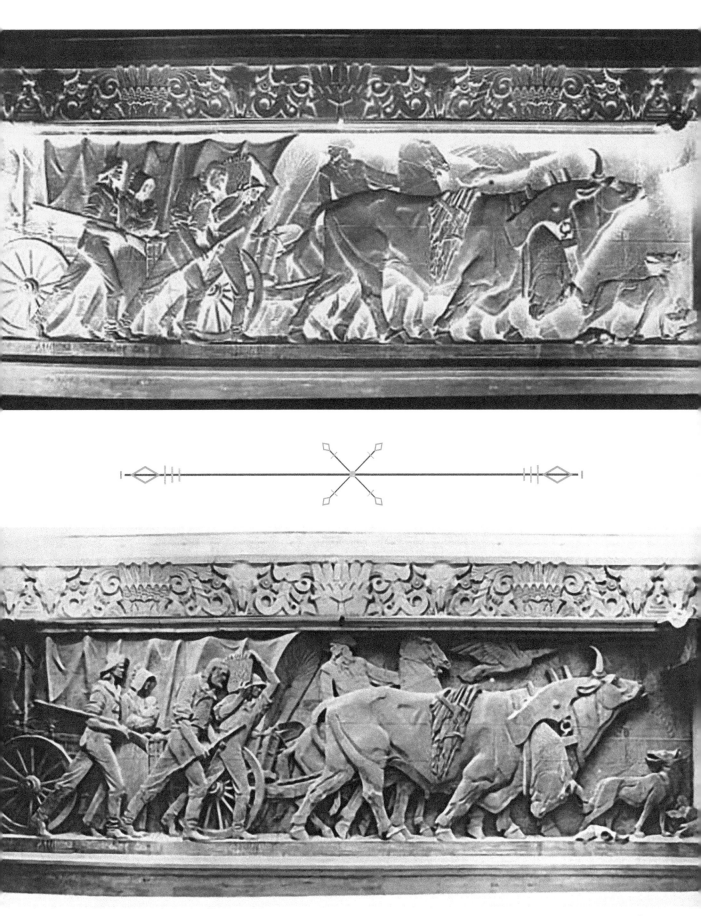

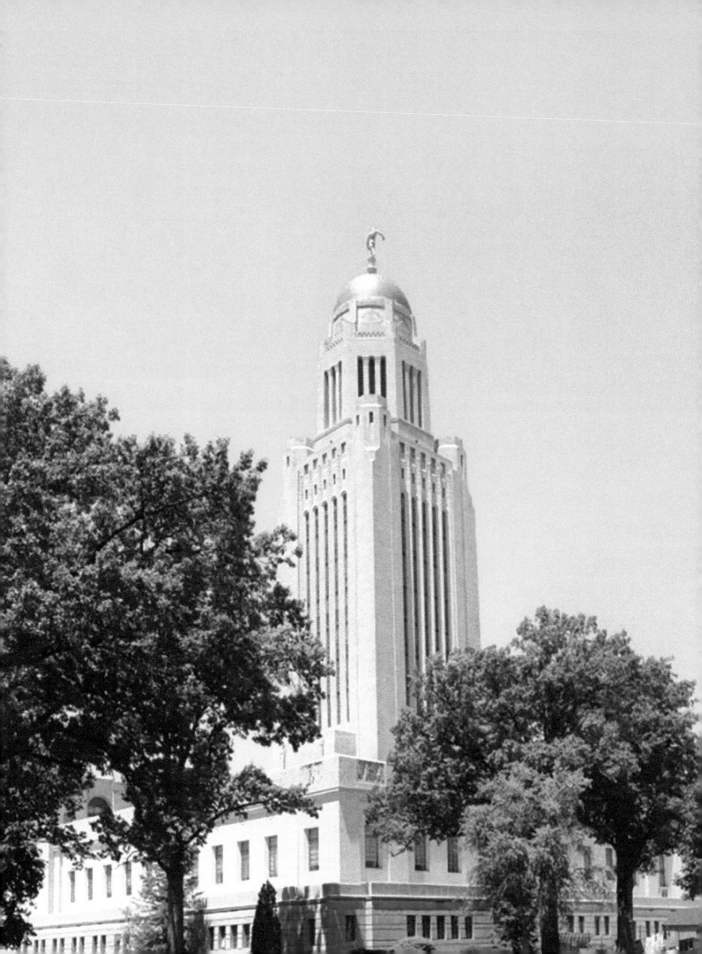

# 6

# LAWRIE'S LARGEST COMMISSION AND HOW IT CAME TO BE

WALK INTO ANY GOODHUE-DESIGNED BUILDING AROUND the country (of which there are more than a hundred) and chances are you will experience the same sensations in each one. I've been to the Capitol in Lincoln, the National Academy of Sciences in DC, St. Thomas's in NYC, and the Church of the Intercession in Spanish Harlem. They all have a bountiful magnificence about them—a sense of balance and harmony. They are stately and serene, but without pretense. They look and feel just right—almost as if they had been there since the Middle Ages.

In the 1920 architectural competition for a new capitol for Nebraska, Goodhue's winning creation would initially shock the world as a truly unique marriage of functional design with Moderne styling. It would later be hailed as one of the seven most beautiful buildings in the modern world, and in 2007, it still ranked in the upper half among the American public's favorite one hundred fifty buildings nationwide.

Oddly enough, the Nebraska Capitol Commission initially challenged Goodhue's choice of Lawrie as the sculptor for the Capitol project, which infuriated Goodhue. He blasted back at the Commission, telling them that Lawrie was the only man he would consider for the job.

In a letter to the Nebraska Capitol Commission, Goodhue scolded them, stating, "The idea of putting this on a competitive basis, precisely as you do plumbing, is preposterous… How am I to get competitive bids on the same work which, it must not be forgotten, was designed almost wholly by him?"

The Nebraska State Capitol, looking northwest, 2006.

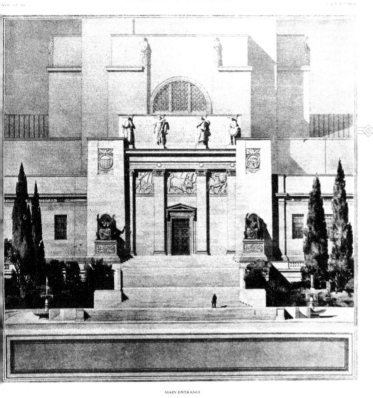

MAIN ENTRANCE

Goodhue's original drawing for the 1920 Capitol Competition featured a more traditional Beaux-Arts design for the North Portal, but, before long, the design was radically transformed.

*Photo from Architectural Review, Vol. XI, No. 3, from the author's collection.*

Goodhue explained to the Commission his long-standing association with Lawrie and assured them that Lawrie always got the work done on time—and under budget. Eventually, the Commission relented, and Lawrie was awarded the work.

Goodhue's insistence that Lawrie serve as the sculptor ensured that the design of the building would be consistent in style under his vision.

Once construction was underway, Goodhue would suffer other slings and arrows from the Commission when the State Engineer, George A. Johnson, made allegations that Goodhue was ripping off the state in "sundry and divers" ways (his spelling, not mine). The scandal brought construction to a halt and led to at least two investigations; one by the Commission, and one by the Legislature itself, which lasted several weeks. Ultimately, Goodhue was cleared, and the Legislature ruled against Johnson.

The true epicenter of Lawrie's artistic world is in Lincoln, Nebraska, at the State Capitol. In a career that spanned seventy years, from the 1890s to the 1960s, the Nebraska sculptural commission project was his largest job. It was the high point of his eighty-five-year life. Lawrie used the multitude of surfaces, corners, pylons, and balustrades of the Nebraska State Capitol as the blank slate on which he would help shape Art Deco in America. His legacy of art belongs to the state and people of Nebraska. There are very few other places in the world where a person can walk right up to and touch so many of the most beautiful sculptures on earth.

In their nearly thirty years together, Goodhue and Lawrie worked hand in hand on some of the most remarkable architecture in the early twentieth century. Up until their collaboration on the Nebraska State Capitol Building, Goodhue was primarily a Gothic architect who built libraries, churches, and cathedrals throughout New York City, all over New England, and the upper Midwest. Consequently, Lawrie's work in the first trimester of his career was largely classical and religious.

Lawrie's clay model for the North Portal shows another stage in the evolution of the Capitol's design.

## Communicating Through Sculpture

Lawrie once said that medieval sculptors carved scenes from the Gospels on churches because, before Gutenberg, the only people who could read were clerics or scribes. He said that the importance of sculpture in those dark ages was to teach the lessons of the Bible to an illiterate populace.

In that same vein, the intent of bas-relief is to communicate a story or an event with a single glance. When a person looks at an image in bas-relief, he can recognize and understand its meaning in a split second. Lawrie never said that his bas-relief works were worth a thousand words, but you get the idea.

Shortly after the end of World War I, Nebraska's old State Capitol—its second, completed in 1889—was crumbling, wearing out, and literally cracking up. The state's population was increasing rapidly, and the state leaders had outgrown the old State House.

With the recent loss of so many lives in the Great War, Nebraskans and communities all over the nation were busily planning monuments to honor those who died while defending their country. They felt that the new Capitol would serve as a monument to their sacrifice.

In 1919, the Legislature established the Nebraska Capitol Commission to hold a design competition for the building, whose members would define the building's desired requirements.

In 1920, the Commission specified that the design called for a building that would illustrate the character of the state's people. It would express respect for their traditions and history in shaping their culture. Initially, the competition was open only to architectural firms in Nebraska; but later, firms across the country were invited to compete.

Thomas Rogers Kimball. Photo from *American Architect*, October, 1931.

## It All Started with a Dream

The Commission was headed by Nebraska architect Thomas Rogers Kimball. According to former UNL architecture professor and Fellow of the American Institute of Architects Frederick C. Luebke, Kimball was "Probably the most distinguished architect in the history of the state." Kimball was up to the job and as well suited to lead it as any architect in the nation. He was local, but he was

certainly no yokel. He was different. He had studied architecture first at the University of Nebraska, then at the Massachusetts Institute of Technology (MIT), and finally in Paris at the prestigious École des Beaux-Arts; the French school then largely regarded as the world's crown jewel of turn-of-the-century architecture academies.

Kimball's portfolio of Nebraska buildings included Omaha's St. Cecilia's Cathedral, the W. Dale Clark branch of the Omaha Public Library, Omaha's Burlington Railroad Station, and its Hotel Fontenelle as well as Grand Island's Hall County Courthouse. After operating a firm in Boston for a few years, Kimball returned to Nebraska and from 1918-1920 he served as the national president of the prestigious American Institute of Architects (AIA) for the national organization, not just the Omaha Chapter.

Moreover, Kimball was well-connected to both society and the community of architects back East, in and around New York City, and one who certainly kept in touch with the stylistic and technological advances of the day. He was also a remarkably gifted artist.

Under Kimball, the competition called for designs created in collaboration with the architect, the sculptor, the painter, and the landscapist. He believed the role of each of these collaborators would give the building its unique character.

The competitors were among the finest architects in Nebraska and around the nation. The finalists included three Nebraska firms: Ellery Davis of Lincoln; John Latenser & Sons from Omaha, and brothers John and Alan McDonald, also of Omaha.

In addition to Goodhue and Associates, the national finalists consisted of Bliss & Faville of San Francisco; H. Van Buren Magonigle of New York City; John Russell Pope of New York City; Paul Philippe Cret of Philadelphia; McKim, Mead, & White of New York City; as well as Evarts Tracy and Egerton Swartout, who were both educated at Yale and had formerly worked for McKim, Mead, & White. All the finalists held national stature in the architectural community. The rules of the competition stipulated that the panel of judges, as well as the entrants, would all remain anonymous until the finish line was crossed and the winner was awarded this lucrative commission.

While many of the entries contained somewhat generic concepts—mini-clones of the U.S. Capitol with prominent early-eighteenth-century federalist styled overtones—Cret, Davis, McKim, and Goodhue all brought forth more daring designs. Amid this stiff competition, and after great consideration, Goodhue beat out the competitors and was awarded the contract for the building.

Judging the competition was a panel of three of the era's most distinguished architects: Waddy B. Wood of Washington, known for his Beaux-Arts banks, embassies, and office buildings; Willis Polk of San Francisco, also known for his Beaux-Arts expertise; and James Gamble Rogers of New York, who had also trained in both New York and Paris.

Later in the 1920s and 1930s, Lawrie would again work with James Rogers on Sterling Memorial Library, buildings at Yale, as well as the Montgomery Ward Memorial Building (and perhaps additional buildings) at Northwestern University in Chicago.

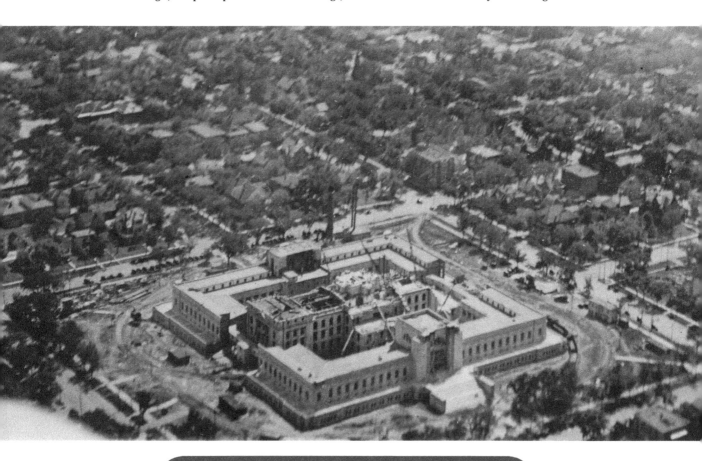

The New Capitol was built around the old one, allowing for its continued use until the horizontal structure was nearly completed. This photo was taken in 1925 during its construction. It was taken from an early airplane by Nebraska University Geology Professor E.C. Schramm, and donated by retired UNL Geology Professor William J. Wayne.

# Everything Is Grist to His Mill

Ground was broken for the new building on April 15, 1922. Because the state was fiscally conservative by nature, state officials decided that the building would be constructed on a pay-as-you-go basis, with sales taxes paying for a large portion of the cost. Additionally, not only was it to be created on the site of the existing building, but it would also be built around it—an amazing feat no matter how you look at it.

Architect Harry F. Cunningham, who stepped in to assist the firm of Goodhue and Associates after Goodhue's death in 1924, wrote in 1931 that, "All of the ornament is IN, not on, the building. Nothing has been 'tacked on' for mere decoration, nothing that is in the building could have been omitted without damage to the complete ideal. All of the ornament is significant and much is significant only to Nebraskans."

Perhaps even more significant is Cunningham's further observation that, "Nothing on the building is copied from anywhere."

Each and every element of the multitude of sculptural designs was created originally for the Capitol. They were first conceived solely in Lawrie's galactic imagination, born in sketches, molded in clay by his hands, then in plaster models which were shipped halfway across the continent, and finally carved into stone by Eduardo Ardolino's master carver Alessandro Beretta and his crews of master stone carvers.

Upon his first visit to Lincoln, less than three months after Goodhue's death, Lawrie inspected the progress of his work.

"After looking over the walls from every point of view, he said with tears in his eyes, that it met every expectation; that it bore the impress of the genius of Mr. Goodhue in every line." *The Lincoln State Journal*, Wednesday, July 9, 1924.

The same article continued that, upon this visit, "His first impression of the Nebraska landscape is that it was 'very flat.' That explained to him the desire of Mr. Goodhue to make this building take the tower form; a structure that should command a wide view, and become the dominating feature of all views around Lincoln."

When one considers how much time and Herculean effort were involved in carving all of these works—from conceptualization to each individual stone being carved in place, consuming more than twelve years to execute—it is indeed, a truly remarkable feat.

Goodhue described Lawrie's talent in a particularly poignant clipping from his scrapbook: "His genius surpasses the limits, however wide, of any particular style. Everything is grist to his mill, but always transmuted into something, that while recalling one of the historic periods, is at the same time new, modern, and undeniably his own."

# *Carving a Legacy*

Another Connection to Nebraska: Lee Lawrie's Boys Town Bas-Relief Murals.

In 2006, while researching Lawrie's work on the Nebraska State Capitol, I spent several days at the Library of Congress, pouring over folders containing hundreds of yellowed pages in Lawrie's archives. It was there that I first learned that about thirteen years after his work on the Capitol Lawrie created another significant—and massive—work in Nebraska that I never knew existed.

December 21, 2017, marks Boys Town's Centennial; this seminal date marks the founding of the orphanage in an old boarding house, but this event was just another step in a parade of humanitarian efforts put forth by Father Edward Joseph Flanagan, a young Irish-American immigrant Catholic priest.

## Father Edward Joseph Flanagan and the Founding of Boys Town

Boys Town founder, Father Edward Joseph Flanagan was born on July 13, 1885, in County Roscommon, Ireland, and immigrated to the United States in 1904. He was ordained a Catholic Priest in 1912, and a year later, was appointed as an assistant pastor in Omaha.

The effects of Nebraska's extreme swings in weather seemed to influence his early career. On Easter Sunday in April 1913, a devastating tornado wiped out one third of

Omaha and left a death toll of 155 people. Father Flanagan's initiation into serving humanity may have begun there, as he began the following day assisting local mortician, Leo Hoffman, in collecting victims' bodies for proper burial.

Over the next couple years, Father Flanagan helped minister to the victims of this same tornado, helping them find food and shelter. This path set him on a road to helping to house and feed the less fortunate.

Soon after, a drought in 1915 left many seasonal agricultural workers stranded in Omaha without food and shelter. As winter approached, Father Flanagan secured an old garage, spread straw on the floor, and created a warmer alternative than sleeping outdoors along railroad tracks, as many had been.

Next, he acquired the former Burlington Hotel, and provided shelter for fifty-seven men. In 1916, Father Flanagan secured a larger place at 13th and Capitol Streets that he called the Workingman's Hotel and sheltered up to a thousand men that winter. In April 1917, once the U.S. had entered into World War I, many of the homeless men living there enlisted. As the unemployed men vacated the hotel, they would soon be replaced by drifters and hobos. From these homeless adult men, he observed a common characteristic among them: they had all come from fractured or broken homes, where loving and caring families were nonexistent.

In December 1917, Father Flanagan borrowed ninety dollars to rent the Byron Reed building at 25th and Dodge Streets, which became his original orphanage for boys in Central Omaha, known as the "City of Little Men". It housed five boys from eight to ten years old. By June 1918, Father Flanagan's group of boys had grown to thirty-two, and he moved them into the former German-American home at 4106 South 13th Street in South Omaha. By Christmas 1918, the population had reached one hundred boys, and soon after one hundred and fifty.

On May 18, 1921, Father Flanagan received the deed to Overlook Farm. In 1921, this land was way west of Omaha, and is the present site of Boys Town, but now surrounded by suburban West Omaha, near 139th and Dodge Streets.

During the ensuing decades since its humble beginnings, schools, churches, dormitories, homes, and administrative buildings have been built in the Village of Boys Town, including the music hall and the Skip Palrang Memorial Field House, both of which feature major bas-relief works by Lee Lawrie. (Marurice "Skip" Palrang, for whom the field house was named, served for twenty-nine years, from 1943 until 1972, as their football, baseball, and basketball coach.)

Moreover, Boys Town has continued to expand its mission of saving children, healing families, and strengthening communities and now has locations across the nation in California, Florida, Iowa, Louisiana, New England, New York, Nevada, Texas, Washington, DC, in addition to the original in Nebraska.

# About The Art

At Boys Town, Lawrie created terra-cotta bas-relief murals that grace the gymnasium and the music hall.

On the exterior of the fieldhouse, now known as the Skip Palrang Memorial Fieldhouse, are figures of boys playing a variety of sports. We can assume that this is to promote sportsmanship among young boys and girls.

The Skip Palrang Memorial Fieldhouse.

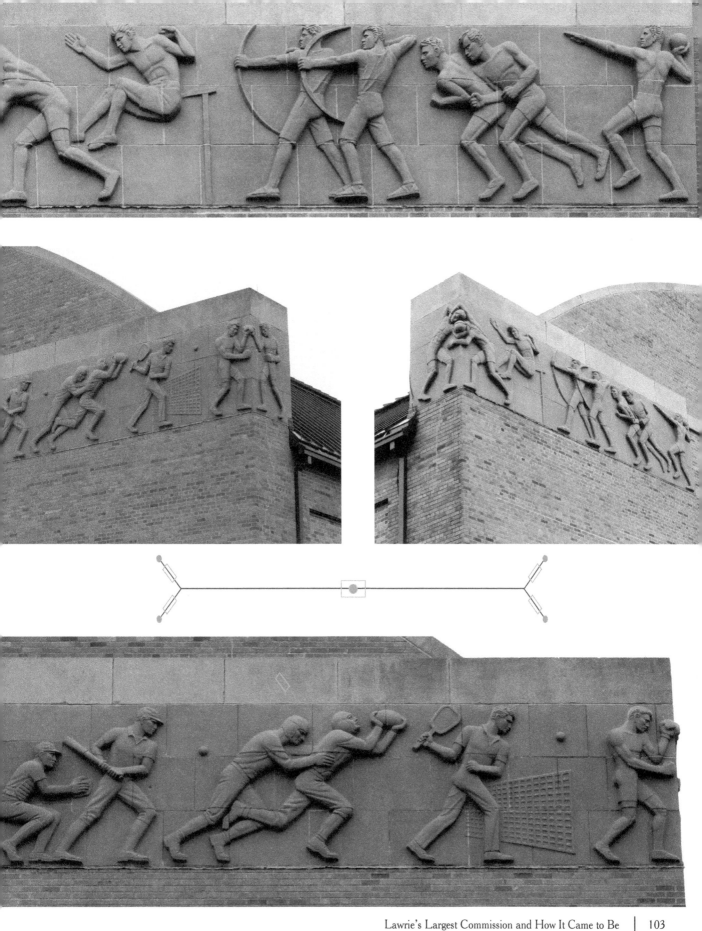

*The music hall displays a moralistic depiction, whereby a seemingly abandoned child falls into the graces of an angel and Father Flanagan, is taken in, educated, taught a trade, and coached in citizenship, which help him become a contributing member of the community.*

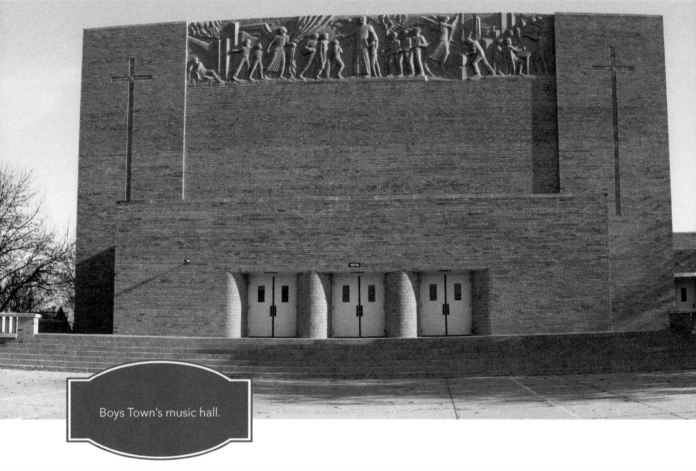

Boys Town's music hall.

Father Flanagan is pictured in the center of the panel.

*Here Lawrie describes his firsthand history of the terra-cotta murals he created for their music hall and the fieldhouse. Construction of the fieldhouse began in 1947, and was completed in 1948, designed and built by Omaha architect Leo Daly. From his never completed and unpublished autobiography,* Boy Wanted, *Lawrie recounts these observations about the Boys Town Sculpture:*

A telephone call came one day from Omaha, Nebraska. It was Leo Daly, the architect, inviting me to Boys Town, Nebraska, to discuss sculpture for a large auditorium he was designing. He thought I should meet Father Flanagan.

Mr. Daly showed me about the grounds and buildings. There was nothing about the atmosphere of the place that seemed any different from that of any boys' school. The older boys worked on the farm and in the different shops but were given enough time for study and play.

Father Flanagan had been away on one of the trips he frequently made to look into the cases of boys in either want or trouble and bring them to Boys Town if it was found advisable. This day Mr. Daly was told that he had returned with two new pupils. When word came that he was ready to see us, we went to his office.

Mr. Daly outlined what the sculpture would be. It was to tell the story of Boys Town and serve as a reminder of what its objectives are—to help boys grow into men who would lead the normal life that the right kind of man and citizen expects to have. Father Flanagan asked what the sculpture would cost. I named a price that was half what I would ordinarily charge, and without a moment's hesitation he told Mr. Daly to prepare a contract. Then he told me he hoped I would proceed with the sculpture without delay. He asked me to remain in Omaha over Sunday and come out to Boys Town Sunday evening and see the movie *Boys Town* with Spencer Tracy taking the part of himself and Mickey Rooney the Boys Town boy.

We were at Boys Town early enough to see the boys come into the large hall. Soon it was filled. We sat in a long seat in the back of the hall with Father Flanagan; his sister, a nun; his brother, a priest, who looked like him; Mr. and Mrs. Daly; their son, and his wife. One little fellow, who could not have been more than three, spied Father Flanagan and ran over and jumped into his lap. He was the youngest boy I saw there. When it was time for the movie to begin, Father Flanagan put him down and without a word he ran to the seat that was evidently his regular place in line. There were hundreds of boys in the hall. They laughed and cheered at the antics of Mickey Rooney, and Father Flanagan laughed hard too.

The large sculptured panel extends across the front of the auditorium. I made the model for it in quarter size and shipped it to the Northwestern Terra Cotta Company in Chicago, where John Sand enlarged it to fifty-one feet. While I was going over the work with him, Mr. Daly arrived from Omaha, bringing photographs of Father Flanagan for me to follow in making the central figure. I worked quite a while before Mr. Daly called out, "Stop! Stop! You've got it. Don't touch it!" This large clay panel was divided into sections and burned in enormous kilns or ovens, producing terra-cotta.

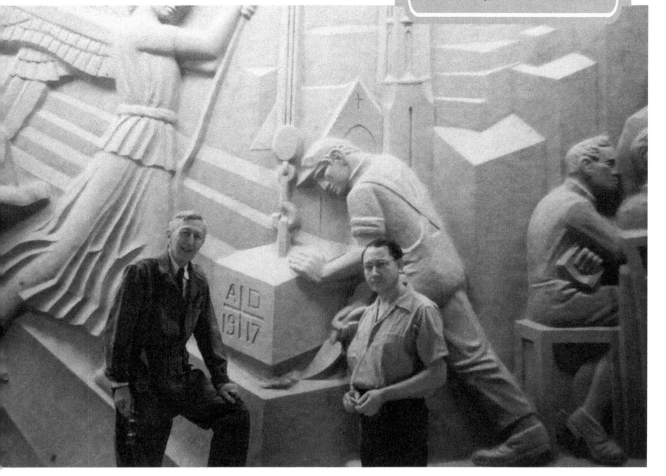

**Boys Town**

Leo Daly the Omaha architect, who was designing all the buildings for Boys Town wrote to me and asked if I would do the sculpture for the new auditorium building, the trades school and the gymnasium. My wife and I had to go to make a trip West anyway and so we went on to Omaha and saw Mr. Daly at his office and he took us out to see Father Flanagan. Father Flanagan wanted us to see the movie Boys Town in which ~Spencer Tracy~ had impersonated Father Flanagan in the film. We went Sunday night with Mr. and Mrs. Daly, Father Flanagan, his brother and sister, and sat in the rear of the hall. It was an interesting sight to see the large number of boys come in and take their seats in the large hall which they filled. There was wild cheering over the antics of Mickey Rooney who portrayed wonderfully one of the Boys Town Boys. And Father Flanagan laughed ~until~ ~heartily~ ~and tears,~ all through the picture.

At the beginning of this way as I had to go to Redfore, Iod to see about the carving of Mr. Moffett's research lab. at Ames, Ill. My wife was stooping at her sisterless in Iowa with the ~.........~ which were buried in the ~.......~ ~family's.~

While at Omaha there was a blistering hot wind that made one look for a cool shelter. We went into an air conditioned movie for relief. The picture was "Mother Wore Tights" with charming Betty Grable. We stayed there as long as we could, dreading to return to the heat outside, but upon going out the weather had changed, going down more than 50° and we were miserably cold. There were no cabs in sight, so we walked, shivering, to the hotel.

I made the working models for the 52' panel for Boys Town Auditorium and the Northwestern Terra Cotta Co. had the contract to enlarge it to full size and convert it into terra cotta. John Sand, the young sculptor member of the Terra Cotta works made an excellent enlargement xxxx of what I believe it is largest panel ever made in terra cotta.

Lee Lawrie on the left, and (presumably) the man on the right is the artist who executed the designs for him, John Sand, at the Northwestern Terra Cotta works in Chicago, as mentioned by Lawrie in the article.

*Photo from the Avery Library Archives, Columbia University, New York New York).*

While I had always recognized Father Flanagan's name, and known of him as the founder of Boys Town, I assumed that Boys Town had been there all of my life, like other buildings that, at least in our lifetimes, have always been there. This phenomenon allows us to slip into complacency and overlook that which is monumental and right in front of us—yet still unnoticed.

Unlike gallery art, such as paintings or statues, Lawrie's work is where you find it—not in one central place, where it is collected and displayed. His architectural sculpture is primarily found on buildings; thus, it can only be seen and appreciated fully by visiting these individual places, spread out over at least twenty-three states and beyond. So, having two significant Nebraska sites, where Lawrie's work is available for viewing at nearly any time, Nebraskans can gain a better appreciation of his style and the powerful symbolism packed into his works.

The intervening years between Lawrie's work on the Capitol and the Boys Town commission brought the end of the Great Depression, followed by WWII, and the Nation was returning to a peace-time economy; prosperity soon followed. By 1940, as the Great Depression wound down, Lawrie had survived it, but the lack of much new architecture over the previous years had been difficult for him, so he moved from New York City to his Locust Lane Farm in Easton, Maryland.

The Boys Town commission was a major boost for Lawrie's career, and this new work was created in a new style for Lawrie. While the art on the Capitol primarily reflects an Art Deco style, (along with styles mimicking those for the periods they represent: Assyrian, Roman, and so on) the Boys Town murals were created in a somewhat softer and more naturalistic style. In general, most of the work that he created after moving to Locust Lane had abandoned the geometric, angular features so common in Art Deco sculpture, and the work was noticeably smoother, the faces rounder, the garments more fluidly draped.

One particular feature of his new style was that instead of devoting deep definition to his figures' eyes, sharply defining the lines of their pupils, irises, and eyelids, the eyes in most of his postwar work were generally simplified, represented by little more than semi-spherical shaped "domes," void of any expression. Personally, these seem to make the figures faces appear blank, somewhat vacant. In classical works of art, many artists often attempt to capture the eyes as the "gateway to the soul." As one views these works, this detail is readily observable.

While I might lack the academic credentials to offer a more acceptable critique of the Boys Town work (at least among the more sophisticated cliques of art critics); after having studied Lawrie's work since 2000, to my knowledge, no one else has taken the time or interest to identify, isolate, and classify Lawrie's career into three distinct periods and corresponding styles.

The first, I call the Ecclesiastic. This represents the work that he did prior to World War I, consisting of classical Religious-, Greco-Roman-, and Renaissance-style realism, creating lifelike forms out of stone.

The second is the Art Deco period, created almost exclusively in the two decades between the World Wars, during which all of his work was contemporary, done in the Moderne or streamlined styles, (and quickly shunned by the architecture world after they discovered the International Style, which followed the maxim, "Form follows function," meaning that the building should be shaped according to its intended purpose. This style of architecture practically eliminated ornamentation on buildings. It also meant that demand for Lawrie's specialty, architectural sculpture, all but dried up.)

Incidentally, one of the co-founders of the International Style was Philip Johnson, who designed the University of Nebraska-Lincoln's own Sheldon Memorial Art Gallery. The other co-founder was architecture critic and historian, Henry-Russell Hitchcock. In 1932, these two introduced the style in America in an exhibition titled "Modern Architecture: International Exhibition."

Thus, in the same town, you'll find both the largest architectural sculpture commission Lawrie created in his seventy-year career, as well as a building designed by the architect, who for all intents and purposes, eliminated the use and demand for sculpture on buildings in America.

Stylistically, Lawrie's "third act" came about largely in the postwar period, whereby his work seemed to flee anything dominated by the short-lived Art Deco phase. It has been observed that Art Deco, at least in architecture, reminded people too much of the Works Progress Administration (WPA), the Depression, and the Fascists, who embraced the style.

When I first began researching this new section on Boys Town, in particular, Father Flanagan, I learned that the federal government sought his help to aid children both nationally and internationally, and following World War II, President Truman asked him to travel to Asia and Europe to help resolve the plight of children orphaned and/or displaced by the war. During this tour of Europe, Father Flanagan suffered a heart attack and died in Berlin, Germany, on May 15, 1948. It seems like an odd coincidence that Flanagan would die in Lawrie's hometown.

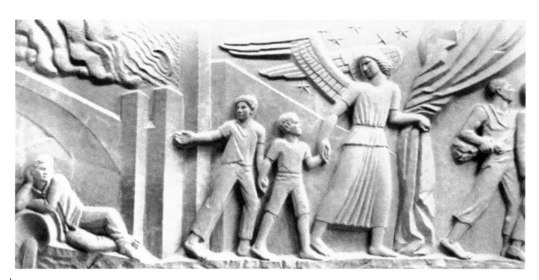

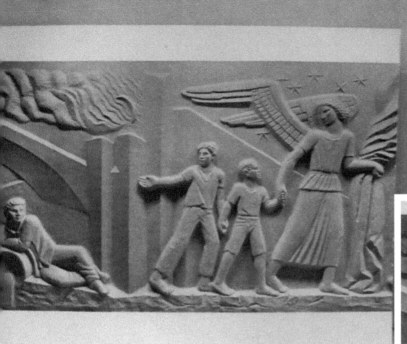

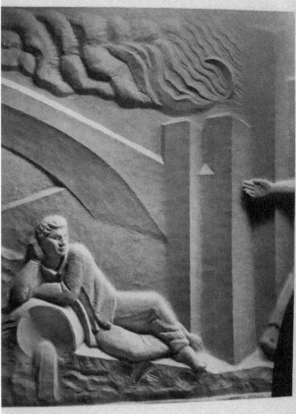

This is detail from the clay model for Lawrie's mural for the Music Hall, with a closeup of two boys encouraging a lost boy to come join them on their journey to adulthood.

*Photos from the Library of Congress's Manuscript Division*

## "He ain't heavy. He's my brother."

When one thinks of sculpture and Boys Town, most people think of the statue of an older boy carrying a younger one and the tag line, "He ain't heavy. He's my brother."

In the iconic 1921 photo taken at a Boys Town picnic, Reuben Granger carried his younger "brother," Howard Loomis. The young Loomis had been stricken by polio and consequently had to wear leg braces, which made walking very tough for him. As time went on, more and more of the boys took turns carrying Loomis to help him get around more easily. This historic photo is attributed to the Boys Town symbol, adapted in 1943.

*In what is described as "Teachable Moments" on the Boys Town website, Father Boes attributes the line to Reuben Granger. When Father Flanagan asked whether carrying Howard was hard, Granger replied, "He ain't heavy, Father. He's m' brother."*

*According to this article, in 1943, Father Flanagan was reading a copy of* Ideal Magazine, *with an illustration of an older boy carrying a younger one. It was captioned: "He ain't heavy, mister...he's my brother." Upon seeing this, it reminded him of the 1921 photo of the Granger and Loomis boys. He then contacted the magazine and obtained permission to use the image and the quote, which the magazine approved, and Boys Town "adopted them both as its new brand."*

Two of the original Boys Town boys, Ruben Granger carrying Howard Loomis. This is compassion, personified.

*Photo courtesy of Boys Town Hall of History Archives.*

*Another reference to this quote is paraphrased from the book,* The Parables of Jesus, *published in 1884, cited by United Free Church of Scotland's moderator, James Wells. According to the parable, Jesus saw a little girl carrying a relatively big baby boy. Per this parable, someone observing her struggling to carry him, asked her if she wasn't tired from lugging him, to which she replied, "No, he's not heavy; he's my brother."*

*Whether Reuben or the little girl in the parable uttered it first, it doesn't matter. What matters is the takeaway from the teachable moment, which really says it all,*

*"Seventy years later, the saying is still the best description of what our boys and girls learn at Boys Town about the importance of caring for each other and having someone care about them."*

# Part III

Prairie Deco: Regionalism Marries Art Deco

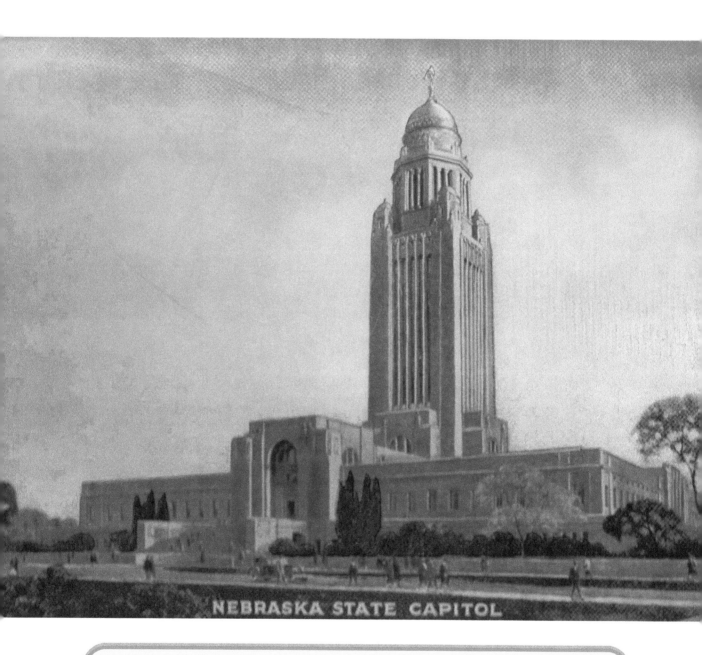

NEBRASKA STATE CAPITOL

A rendering of one of Goodhue's earlier designs of the Capitol, salvaged prior to demolition from the old Jacob North Printing Company Building in Lincoln, and given to me by Sid Conner, an architectural preservationist and fellow admirer of the Capitol.

# 7

# ARCHITECTURE IS FROZEN MUSIC

In 1948, the American Institute of Architects polled five hundred of its members to identify and recognize the twenty-five best built buildings in the world of all time.

According to the Journal of the American Institute of Architects, "The Nebraska Capitol was fourth on the list and placed ahead of such world-renowned monuments as the Parthenon in Athens, Greece, and the Cathedral of Chartres in France."

GERMAN POET JOHANN WOLFGANG VON GOETHE ONCE wrote that "architecture is frozen music."

If that's the case, then as an architectural sculptor, Lawrie was its virtuoso, accenting and punctuating buildings, carving stone "riffs" and flourishes, developing a style that was purely his own, like a visual Jimi Hendrix.

The carving of Julius Caesar and Justinian I on the upper exterior corner of one of the vestibules in the new Nebraska State Capitol, known as engaged sculpture—carving directly in the stone of the building, rather than applying it later. Also shown is the finished carving of Charlemagne. Note the scaffold-like carving sheds dangling off the side of the building. These sheds allowed Ardolino's artisans to climb into place and carve the Lawgivers *in situ*.

*Photo courtesy of the Nebraska State Historical Society.*

Consequently, Lawrie's unique style carries a distinct mood, illustrating that it's the thought or the idea behind the work that counts. It is a voice, if you will, employing a vocabulary, where figures economize and are distilled in their purest essence. Here, less becomes more, streamlining and strengthening each image.

## Art Deco Meets the Prairie

No book about the design of the Nebraska State Capitol would be complete without exploring the theme of regionalism as shown in both the architectural detail and more importantly, in the sculpture.

The Capitol's theme leans heavily upon regionalism; in this case, the imagery of the prairie, the culture of the Plains Indians, and the legacies of Western Civilization.

Nebraskans take pride in their state and its natural resources, especially its abundance of fertile soil and water, which allowed the early pioneers to settle the area and carve out a frontier society. This Wild West state was tamed and made orderly, in part based on the institutions of government the pioneers brought with them. So, the building leans heavily upon the imagery of the prairie; the culture of the Plains Indians, and the legacies of Western Civilization.

Dr. Timothy Garvey, who wrote his doctoral thesis on the regional aspect of Lawrie's work around the nation, noted that Lawrie was well versed in the importance of incorporating regional or perhaps provincial design elements into his work. Garvey notes that Lawrie assisted Goodhue in the design of buildings in the Southwest, such as the Spanish design elements at San Diego's 1915-1917 Panama-California Exposition and a Phelps Dodge company mining town built in Tyrone, New Mexico, in 1916. According to Garvey (citing Talbot Hamlin), Lawrie's sculptures served to "humanize" public architecture by making it "of, for, and by" the very people who would use the structures on which his sculptures would appear.

Following the prescribed list of images that Nebraska Native and professor of philosophy Dr. Hartley Burr Alexander identified as critical symbols for the sculpture program at the Capitol, Lawrie incorporated regionalism into the imagery of his work by drawing upon Native American and Western themes. The pictures Lawrie shaped in stone are highly rural and agrarian, acknowledging that the majority of the population of the state, and the nation, still lived on farms in those days.

In some ways, it is difficult to imagine that Lawrie, who spent decades living in New York City, would have a good grasp of this agrarian life. But in describing the *Sower*, the bronze colossus that tops the Capitol, Lawrie recalled his youth back in Illinois, watching a nineteenth-century farmer rhythmically sowing seeds in his fields.

What a contrast this city on the plains must have been to Lawrie in the 1920s from his environs in East Harlem. The subway stations were blocks away from his studios at 1923 Lexington Avenue, and no doubt the city was filled with urban racket of the day. Back then, motorcars and streetcars would have been an ever-present source of noise and distraction, especially to an artist at work. But in the days before Americans began gulping sleeping pills nightly, Lawrie usually pushed himself working so hard that sleep likely came easily to him.

As Nebraska was very much an agricultural state, Lawrie incorporates corn and beef into his palette. For more than a generation before the first transcontinental railroad was built across it, Nebraska was part of the way West. Both the Mormon and Oregon Trails followed significant stretches alongside the Platte River across the prairie, snaking westward. And as the pioneers would make their way across the state in Conestoga wagons, heading toward Scottsbluff and Chimney Rock, these great landmarks signaled they were finally within days of the Rocky Mountains ahead and communicating to them that they had traveled at last, or at least, halfway west.

Eventually the wagon ruts gave way to a complex network of railways; and ultimately after World War I, the Lincoln Highway led a great system of early highways that were well traveled until succeeded by the Interstate Highway System. The Interstate system was developed after Eisenhower saw the value and strategic importance of the German Autobahn, and wanted the same type of modern superhighway system in America: in order to get people and goods around the country better. If you drive Interstate 80 across the state, you retrace their routes in many areas. You see the Platte River Valley in all its glory, and traverse westward through farm country, until you reach the Sandhills and the foothills of the Rockies, along the same paths as the pioneers. This was the land where the buffalo actually roamed and the deer and the antelope once played; and both of whose images find their way into Lawrie's work on the Capitol.

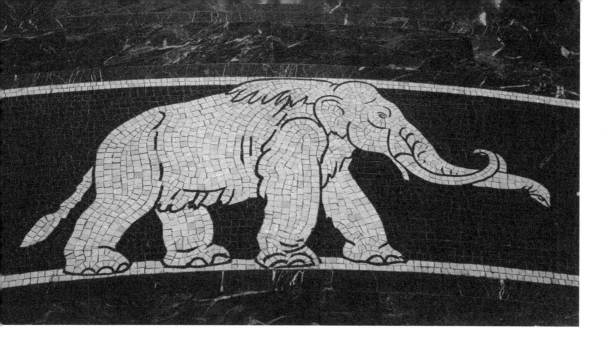

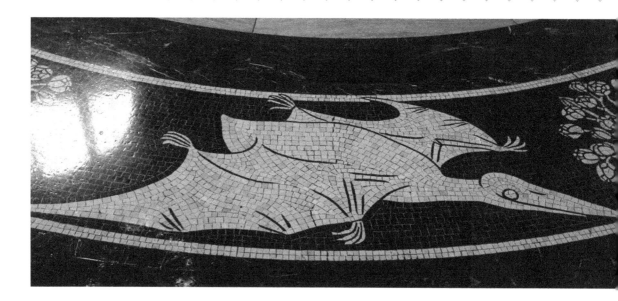

It is harder still to imagine how this land appeared in prehistoric days. It was a long, long time ago on that particular evening, when the tide went out for the very last time. It uncovered the seabed of the ancient ocean that created the state's limestone, one amoeba at a time; eons ago, on what would have once been the "Cornhusker Coast."

Inside, Hildreth Meière's mosaic images show us Alexander's Darwinian parade of primordial fish, dinosaurs, saber-toothed tigers, mastodons and pterodactyls that also once called this place home. Even though no human ever witnessed that last ebb tide, it surely happened. That ocean retreated and it formed the state's first fossil records and literally gave the state its original "history in stone."

# Bye Bye Bourgeoisie

Goodhue's aspirations for the Capitol were expressed in this early article, nearly a year prior to his death:

> It is Mr. Goodhue's conception that the adornment of a monumental building of the character of Nebraska's new capitol should be derived from two elements. First, the play of light and shade and the harmonious variation of geometrical form in the lines and planes of the building itself should be beautiful. Second, where ornament is applied, it should be significant and symbolic, and in particular it should center about such points as naturally seize and hold attention. It is with this conception in mind that the architect has capped the summit of the towering dome with the image of the *Sower,* thereby symbolizing the great industrial foundation of the life in the state in its grain fields. *Lincoln State Journal,* April 23, 1923.

To merely suggest that the Capitol is an unusual building is a gross understatement. It is the personification of symbolism: a broad base, that is flat much like the state it represents. The building stretches four hundred feet in a cruciform pattern, with courtyards in each of the squares of the outline. The tower, taller than any other

> The *Sower* thereby symbolizing the great industrial foundation of the life in the state in its grain fields."

structure in the city, soars an equal distance into the sky. The *Sower* himself, standing atop the tower, adds another thirty-two feet for an overall peak elevation of 432 feet. It is said that the tower represents the hopes and lofty ambitions of the people of Nebraska.

While the building's style may be classified by some as an example of the Beaux-Arts period, in actuality, it is more of a fusion of Beaux-Arts and Moderne. In retrospect, we now refer to the look as Art Deco, a term that wasn't even coined until a few years after Lawrie's death in January 1963.

According to David A. Hanks, an expert on the history of Art Deco, the earliest documented use of the term "Art Deco" didn't come along until some four decades after the fact, in 1966, when art critic/historian Hilary Gelson, in reviewing the 1925 Paris exhibition entitled "l'Exposition Internationale des Arts Decoratifs et Industriels Modernes," loosely translated it as the "Exhibition of Moderne Industrial Decorative Arts." The exposition had originally been scheduled for 1915, but was delayed by the Great War.

What sets this architectural wonder apart from many Art Deco treasures found across the United States and Europe is its condition. The building has been meticulously maintained and painstakingly restored, yielding a modern, well-utilized building, free of the damage caused by the elements, neglect, or the graffiti scourge that plagues most of our twenty-first-century American cities.

Art Deco was born out of multiple influences in Western Design. It followed Art Nouveau, but spun off the trappings of fine arts and realism to focus primarily on a "starkly elegant and geometrically designed aesthetic." Art Deco also shares its DNA with the German Bauhaus movement, which in turn gave rise to the International Style of architecture, prominent in the postwar architecture primarily found in Europe and the United States, but also in Australia and New Zealand.

In other words, the Bauhaus movement in Germany, which developed shortly after the end of WWI, could be classified as a protest movement against the perceived Bourgeoisie character of earlier architecture that was exemplified by decoration, which the Bauhaus crowd felt was a waste of resources.

Adolf Loos, author of the book *Ornament and Crime*, once suggested in an essay that decoration in architecture was wasteful, as it made it appear excessively dated. The students of Bauhaus had lived through the "modernized" Germany, which was largely aristocratic and imperialistic, both traits that they felt contributed to WWI. They felt that form should follow function and that any extraneous detail should be abandoned.

The modernization of architecture eventually led to a divorce of sorts between sculpture and architecture. For the most part, we don't find much engaged sculpture in it. Instead, the sculpture is generally separated from the building and may appear either in front of it or off in a courtyard. A prime example of this would be the Sheldon Memorial Art Gallery, also in Lincoln, Nebraska, which features a separate sculpture garden.

Other world events that helped shape Art Deco style were the discovery of King Tut's tomb, which set off a flurry of design influenced by Egyptian art, and the discovery of more Mayan and Aztec ruins in Central America, which led Alexander and Lawrie to incorporate some of these Mayan influences into several of their designs at the Capitol. These appear chiefly in the glyph-like designs of the buffalo on the front balustrades and the column capitals in the former House Chamber, which feature stylized human skulls.

Following the death and destruction of the Great War, society looked to industry and machines for inspiration to rebuild and for salvation itself. Machines represented not only industry, but also Consumerism. From telephones to vacuum cleaners, ocean liners to automobiles, zeppelins to planes, Art Deco was infused with streamlining—the concept of lopping off all that offered wind resistance, and speeding society into the future. Plus, it was functional. In essence, smoother was perceived as newer and better.

In design, Art Deco, Modernism, and Streamlining were all characteristic of the so-called Machine Age. But bear in mind that when the Capitol was being planned and designed, Goodhue and Lawrie were of about the same chronological age as many present-day Baby Boomers, like myself. When these men were coming of age, 90 percent of all labor, housework, laundry, farming, mining, or building railroads was still done by hand or with first generation horsepower. For most Americans, the Machine Age brought the first taste of an escape from the utter drudgery faced by people on a daily basis from primitive man to the present. It was no longer necessary to chop wood or haul coal in order to cook breakfast, lunch, and dinner.

At this point it is also probably worth mentioning that, despite its novelty, Art Deco, like the American movie icon James Dean, barely lived more than two and a half decades. If there were a death certificate for Art Deco, it would have had to include acute rejection as a cause of death.

Following World War II, the use of Art Deco plummeted rapidly, not just because of the development of the International style, but because psychologically, people associated it with the brutality of fascism. The simplistic Art Deco style was used heavily by the Nazis

and the Fascists, as well as in American WPA projects. These, in turn, brought back too many disturbing memories of the Great Depression with its multitudes of miseries.

According to his grandson, Peter Lawrie, Lawrie's son Archer was said to have once remarked that up until the International style emerged, "The artist and architect had walked hand in hand. Now, the engineer and the architect walk hand in hand."

## Wisdom, Justice, Power, and Mercy

The Capitol building is bisected into its two most basic components: the tower and the square. It is further subdivided into its physical sections, based largely in part on the interior elements for this seat of government. Alexander tells us that the circuit of the square is emblematic of the quarters of the earth and the historic past of man's experience.

Alexander said the tower serves as a gnomon, the shadow-casting point on a sundial, representing the Heavens. Others have commented that the tower represents man's aspirations, and that the broad width of the square is symbolic of the breadth of the state.

Alexander noted that the tower represents more abstract interpretations of life derived from man's historic experience. He then suggests that the combination of the power represented by the tower and the square symbolize action and thought—which in turn form the basis of all human life, socially as well as individually. He further suggests that the combination of the architecture with a decorative program together rise from the concrete (or truth) in our historical past, to the abstract and symbolic as the tower reaches towards the sky.

The square is comprised of several units: the North Portal, the South Pavilion, the Senate Façade, the House Façade, and the Terrace Circuit. Wrapping the building in a circuit is the series of eighteen panels called *The Spirit of Law as Shown in Its History*.

Alexander referred to the North Portal as the title of the building. Alexander also called the North Portal the Monumental Entrance, incorporating three elements: the stair, the doorway, and the pylon. *The Guardians of the Law* span the face of the pylon. The colossal figures represent the prerequisites for creating legislation, or law making, and for equitable enforcement of the law. The west side of the building was originally designated as the Senate Façade and carved upon its exterior are panels which represent the origins of law in the ancient world. The east side, or House Façade, symbolizes law in the modern and the new world up to the point in 1867, when Nebraska was admitted into the Union.

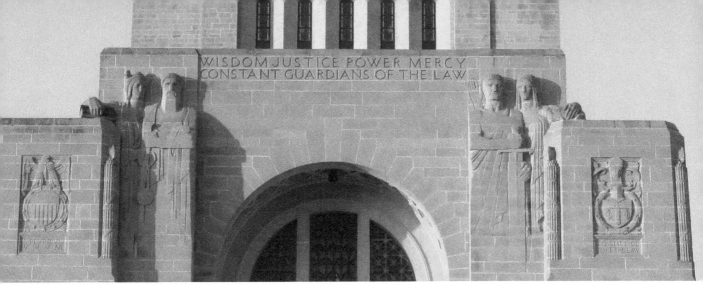

WISDOM JUSTICE POWER MERCY
CONSTANT GUARDIANS OF THE LAW

## "CONSTANT GUARDIANS OF THE LAW"

The South Pavilion typifies Western and Constitutional Law. The panels depicting the *History of Law* ring the terrace circuit, which also carries the names of Nebraska's ninety-three counties.

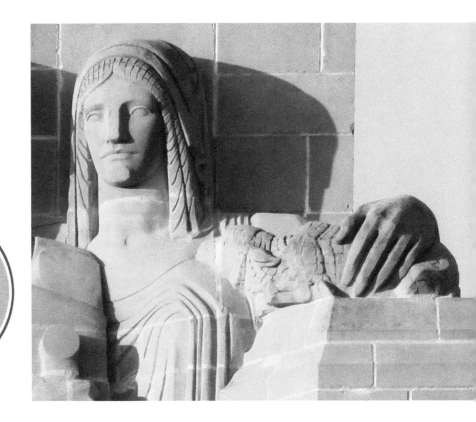

"Mercy had a little lamb..." The lamb was to symbolize that while the law is powerful, it must also be merciful; that gentility and compassion should be used when necessary. One must look very carefully to see the lamb from the ground level.

*Wisdom* stands with her wrist resting atop the book of law, wearing a crown that bears two flaming lamps. Next to her stands *Justice* holding his scales. To *Justice*'s left stands *Mercy*, demonstrating gentility with her arm around a lamb and her other hand raised against the sword of *Power*, whose sword is only partially drawn. The original clay models show the original design as Lawrie first envisioned it.

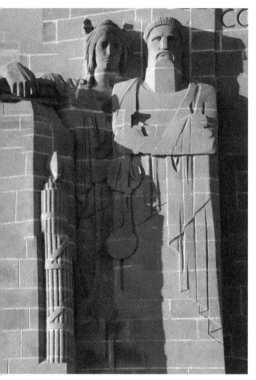

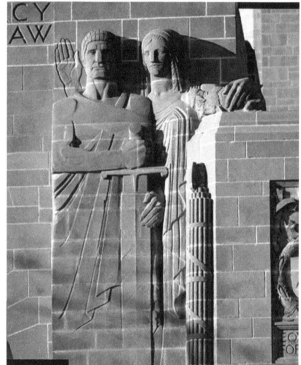

*Wisdom, Justice, Power,* and *Mercy.*

These photos from the Library of Congress's Manuscript Division have been pieced together. In later life, Lawrie had ripped up hundreds of photos of his work and was planning to burn them. Fortunately, his second wife Mildred interfered and saved the works for posterity. Most of the shards of these photos lack captions and almost none of them are dated.

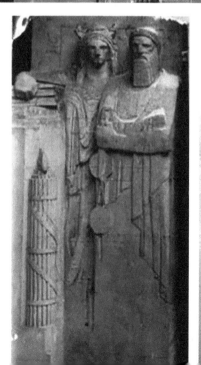

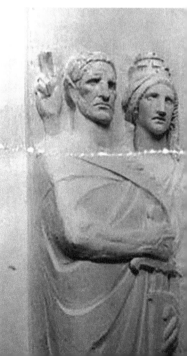

Original Maquettes for *Wisdom, Justice, Power,* and *Mercy.*
Photos courtesy of the Library of Congress.

Note the stylistic evolution between the original models, and the ones that Lawrie eventually used. They show a marked difference. The original maquettes were created in a classical, Greco-Roman style, but were gradually transformed into the Art Deco masterpieces that were eventually used. The details of Justice's hands, for example, go from a relatively natural appearance to looking very angular, and note that Mercy had headdress in the original maquette that was eliminated in her finished portrait.

Double life-size male and female figures for the exterior. Stone carver at right.

*Photo courtesy of the Nebraska State Historical Society.*

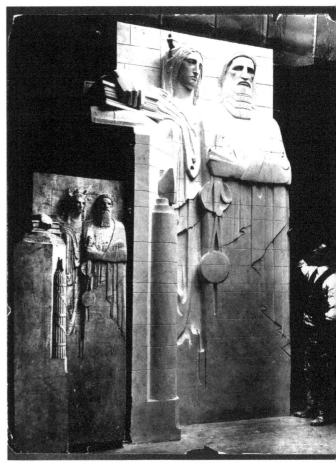

Furthermore, each of these figures has a deeper meaning, symbolic of the four great historical sources of civilized institutions brought to the state by the Pioneers. These are the Hebrew gift of the Wisdom of Law; the Philosophy of Justice from the Greeks; the Power and Majesty of Law from the Romans; and completing the Judeo-Christian component of the equation, the Christian ideal of Justice tempered with Mercy.

The caption says it all: "WISDOM, JUSTICE, POWER, MERCY: CONSTANT GUARDIANS OF THE LAW."

WISDOM JUSTICE·POWER MERCY
CONSTANT·GUARDIANS OF THE LAW

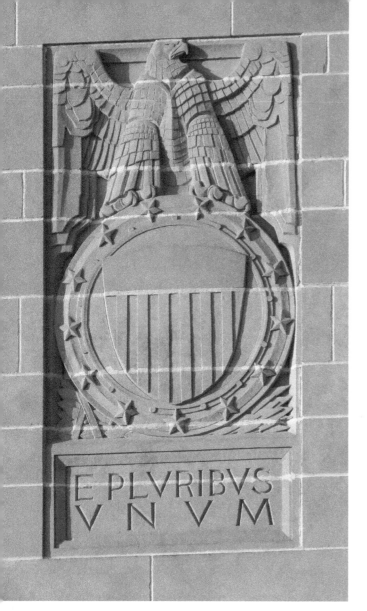

The pylon also contains the Seal of the United States as well as the proposed—but never adopted—seal of the State of Nebraska as envisioned by Lawrie.

Fasces, shown between the seals, were carried by Roman leaders and symbolized the power over life and death.

The ideal of law by and for the people is represented by the state's motto: "Equality before the Law." This also reinforces the sacred concept that no man is above the law in the United States—not even the President.

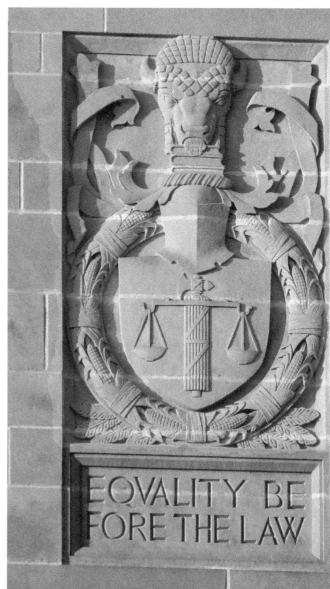

The Arms of the United States as well as the proposed, but never adopted, seal of the state of Nebraska as envisioned by Lawrie.

According to Merriam Webster, the fasces is a bundle of rods and among them an ax with projecting blade borne before ancient Roman magistrates as a badge of authority. In 1919 Benito Moussolini's Fascist Party was named after the fasces.

The sculpture of the Roman Fasces flanks the corner of the pylon and is situated between the sculpture of the Arms of the United States and the seal of the State of Nebraska.

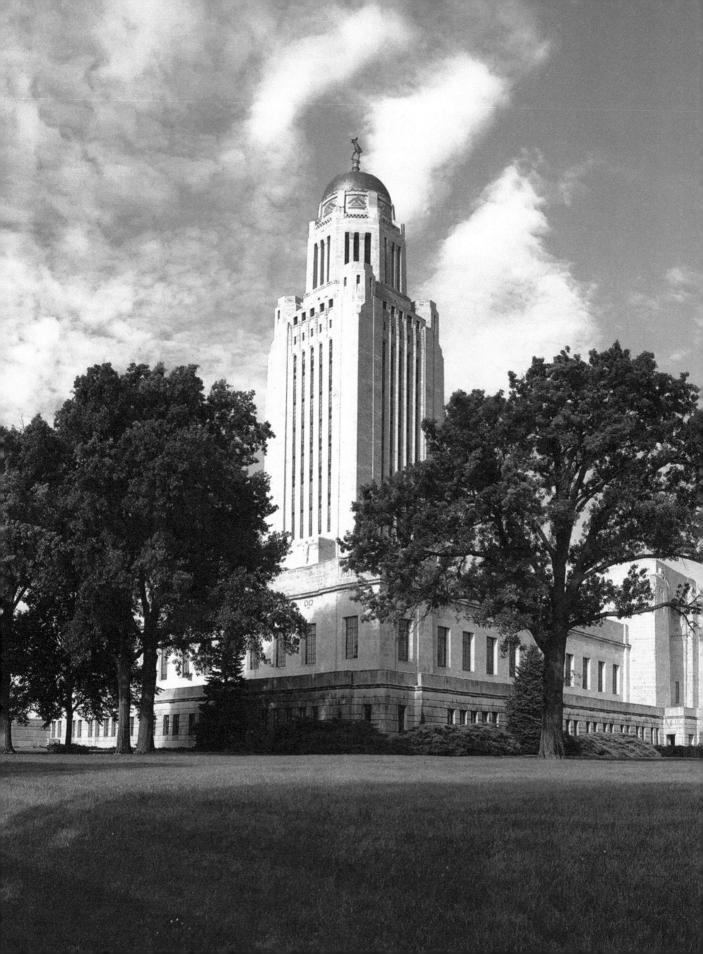

# 8

# SYMBOLS AND INSCRIPTIONS: WHAT DOES IT ALL MEAN?

ONCE ALEXANDER GOT INVOLVED IN THE PROJECT, HE provided the cohesion that Goodhue lacked to marry the Gothic elements of his résumé with Lawrie's vision into a unified and monumental government building. Goodhue's plans for the building were first conceived following the end of World War I.

Another central theme of the Capitol's design was to illustrate the institutions of government: to educate citizens about how we came to be a free society and to trace the development of democracy in the Western World. Clearly, Lawrie and Alexander were up to the challenge. With nearly the entire building as their palette, it was their task to identify and illustrate the stories of how American government was born.

Hartley Burr Alexander, standing under Hammurabi, facing southwest by the south center façade and showing the scale of the carving. Photo from Architectural Sculpture of the State Capitol at Lincoln, Nebraska, Press of the American Institute of Architects, New York, 1926.

One of the major objectives for building the Capitol was to serve as a memorial to those killed in World War I. As of 1919, a report in a Nebraska history publication had already compiled a list of 751 young men from Nebraska cities, towns, and farms who had died in World War I—either killed in action, from disease, or accidentally. Still hundreds more were casualties. It was a time of great international, political, and social upheaval, and people had a great desire to break free from the past and the traditions that led to the war.

One source puts the number of Americas killed in WW I at 116,516, which was greater than the population of Lincoln, Nebraska in those days. Nebraska's losses were surely felt in the countryside, small towns, and cities alike.

According to Newton's first law of physics, for every action there is an equal and opposite reaction. Culturally, World War I was such an action, generating many forms of reaction, where people not only tried to make sense of how it had happened, but also sought to learn what lessons they could from it so as to prevent a recurrence.

It is often said that WWI *industrialized* warfare. That was, after all, the Machine Age, and modern technology *mechanized* killing. It brought fourth warplanes, tanks, aerial bombing, improvements to the machine-gun, and a latently horrifying piece of equipment never before seen in combat—the gas mask. The romance of marching off to war was soon tempered by the new realities of the twentieth century. The War decisively ended the innocence of the nineteenth-century world.

Reaction to the War gave rise to movements of all sorts. Dadaism for example, originated in Zurich, Switzerland, as a cultural system of art and talking like a baby because traditional language was considered tired, old, and perhaps warlike. The innocence of a baby freed creativity, or so a bunch of Teutonic twenty-somethings thought.

Moreover, the post-war period was one of isolationism, and one can't get much more isolated from the rest of the world than being half a continent inland, in Lincoln, Nebraska, hundreds of miles away from any ocean.

But while creating this monument, Goodhue was also aware that the world was not stagnant. Prior to the development of the Capitol, the pre-eminent style of architecture

at the turn of the century was Beaux-Arts. French in origin, it had dominated American architecture for at least a generation. But with the Capitol, Goodhue broke with the past to create a new style that would establish itself as forward-thinking and futuristic. While architecture took a drastic turn in the years since World War II with the development of the International Style, as first exemplified by the Museum of Modern Art in New York City, Goodhue's style served as a *bridge* between the Beaux-Arts and the truly Moderne styles. Examples of Beaux-Arts styles found in Lincoln, Nebraska, include the old Post Office building at 9th and P streets and the old Burlington Depot in the Haymarket District.

Goodhue's original designs for the Capitol also contained elements of Spanish Colonial architecture, such as the mission-styled domes for the four turrets of the tower. But after his death, under the supervision of Goodhue's associate architect, William LeFevre Younkin, details were spun off as construction continued, and the project lost some of its initial momentum. When finished, the domes ended up on the cutting room floor as did other major sculptural elements and inscriptions that Alexander had originally intended to include on the building's exterior.

Younkin graduated in architecture from Columbia University in 1917, but had begun working for Goodhue in 1915—first intermittently as a draftsman, then permanently as an architect after graduation. He was as influential as any of Goodhue's associates in planning and designing the Capitol. Matt Hansen, a preservation architect who currently serves with the Nebraska Capitol Commission is an authority on Mr. Younkin.

Hansen noted that Goodhue so highly regarded him that as construction neared, he sent him out to Nebraska to oversee the work, and he remained on the job until its completion. Younkin eventually stayed on managing and taking care of it for years afterwards in one way or another until his death in 1946. Hansen also added that "the building became his life;" thus it is entirely appropriate that Younkin's epitaph reads "Capitolium Fecit." The inscription's translation from Latin is "He Made the Capitol," both "completely accurate and entirely deserved."

Architectural drawings from the mid-1920s still show examples of the thematic characters that were to continue the story of the heritage of the state, but these never materialized. The Great Depression hit several years before the Capitol's completion, so no doubt budgetary constraints helped trim the budget of the sculpture that had originally been planned for the Tower.

William LeFevre "Bill" Younkin.
*Photo courtesy of Matt Hansen.*

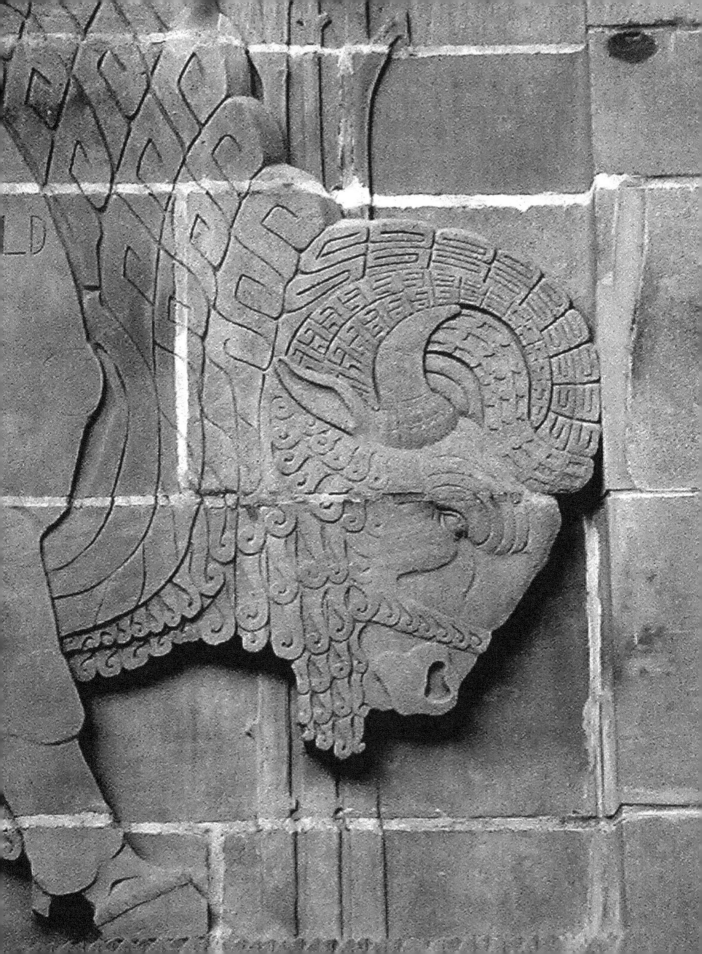

# THE RED MAN'S HERITAGE—HARMONY WITH NATURE

IT IS SAID THAT THE RED MAN FOLLOWED THE HUNT FROM Asia across a land bridge from Siberia and came through North America's back door and on to populate both continents of the Americas. As their settlements progressed over ten thousand years, they developed regional tribes across Europe and the Americas. While Western men viewed their existence as idyllic, they were not free from inter-tribal battles, like the wars that plague all civilizations.

But while their existence in the region lasted more than ten thousand years, it took less than three hundred years for them to be conquered by the Europeans, who shared with them Old World diseases such as smallpox and measles that nearly wiped out entire populations.

Almost from the start, the White Man's diseases wreaked havoc with the Native Americans. The early European fur traders introduced Old World diseases to their vulnerable societies, attacking any earlier immunities that might have saved these Native Americans from pandemics. For example, as early as 1725, villages along the Missouri River were decimated by no less than six major epidemics. And shortly after 1800, a major outbreak of smallpox and cholera nearly exterminated the Omahas, Poncas, and Iowa tribes. In subsequent years, similar outbreaks increased along the Missouri. Such epidemics decimated other tribes including the Arikara, Gros Ventre, Omahas, Mandan, Crowe, and Sioux along the Mississippi as well as the Kiowa, Pawnee, Wichita, and Caddo along the frontier.

Detail of the bison, West Balustrade.

Then came the so-called Indian Wars, where the native population was either forcibly relocated or killed off in order to make room for settlers from back east and to fulfill the nineteenth-century American dream of "Manifest Destiny."

Decades later, as wagon trains of settlers headed west across Native American country, they also brought scarlet fever, whooping cough, and other illnesses that killed the tribes. There was nothing the medicine men could do to help when these illnesses struck, and death was widespread. Often times when an epidemic struck, it affected entire villages, leaving no one alive to hunt, tend to the crops, or nurse the sick.

Finally, the coming of the Iron Horse and the resulting land grabs that allowed the post-Civil War Union Pacific and Burlington Railroads to acquire and redistribute the land also led to the demise of the Native American tribes in Nebraska. The land soon became populated with Northern European farmers—Czechs, Swedes, Germans, Danes, English, Scots, and Irish—who gradually created communities throughout Nebraska where many of their descendants still dwell.

The Indian Wars, which preceded and far outlasted the Civil War, employed a tactic of decimation of the buffalo or bison as a way to conquer the indigenous people. It was widely known that the buffalo was the chief source of sustenance for the Plains Indians, providing them with food, shelter, string, tools, and fur for warmth against the brutal winters of the Plains. The two most significant examples of conflicts between the American and the Indian nations—the Battle of the Little Bighorn, known also as Custer's Last Stand, and the retaliatory Battle (or massacre) of Wounded Knee—occurred when the state was still relatively young.

## Honoring Nebraska's Native American Culture

As fate would have it, as a youth, Black Elk was present and witnessed both Custer's Last Stand and the horrors of Wounded Knee.

It was Alexander's wish that these brave and noble people who once populated the Plains should not just be remembered, but honored as well.

Alexander was born in Lincoln and raised near Syracuse. As a boy growing up in the 1870s, he would have witnessed the last vestiges of Native Americans still roaming free in the area. Perhaps no other Anglo individual except maybe Nebraska's late poet laureate John G. Neihardt, the author of *Black Elk*

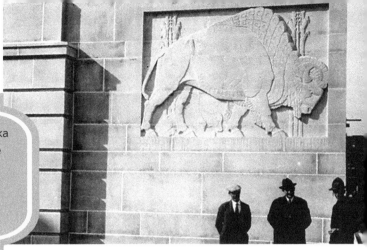

Three unidentified men standing in front of the buffalo carved in the north stairway buttress of the new Nebraska State Capitol Building, circa 1925. Although we may never *positively* identify the men pictured here, Lawrie and Younkin truly had strong, emotional connections to the Capitol. It makes perfect sense that they would strike a pose standing below Lawrie's newly-carved buffalo.

*Speaks* and other tales of Native American culture, knew as much about Native American culture and philosophy as Alexander. As fate would have it, as a youth, Black Elk was present and witnessed both Custer's Last Stand and the horrors of Wounded Knee.

Therefore, it was in his symbolism and inscriptions that Alexander identified the icons that he wanted Lawrie to incorporate into the designs used to honor Native American culture on the building. If you arrive at the Capitol from the north, among the first images you see on the building are the life-size effigies of bison that embellish the balustrades flanking either side of the magnificent stairway.

Alexander wanted to commemorate these people who once roamed the area. He called for the names of their tribes to be etched in stone as a permanent memorial to their existence.

On the buffalo panels, we see Lawrie's opening sentences of his sculptural style, mixing elements of Mayan influence with the contemporary fluidity of Art Deco, giving birth to an original "Prairie Deco" style. These buffalo roam over symmetrical and feathery blades of grass, among sleek geometric maize plants, replete with perfectly circular kernels. As you stand and look upon the mighty bison, you observe the geometric curves of fur across their front quarters. They are streamlined, with no evidence of any raggedy hair present on their bold and muscular forms.

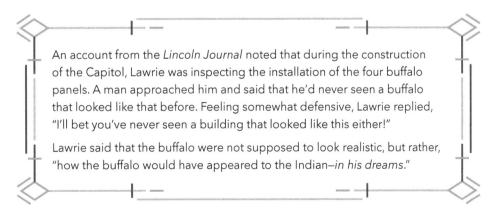

An account from the *Lincoln Journal* noted that during the construction of the Capitol, Lawrie was inspecting the installation of the four buffalo panels. A man approached him and said that he'd never seen a buffalo that looked like that before. Feeling somewhat defensive, Lawrie replied, "I'll bet you've never seen a building that looked like this either!"

Lawrie said that the buffalo were not supposed to look realistic, but rather, "how the buffalo would have appeared to the Indian—*in his dreams*."

No creature better symbolizes the connection between the Native American people and the land than the buffalo. In fact, in 2016 the American Bison was named as the National Mammal of the United States. They are truly the embodiment of solitude, strength, and magnificence. But despite their great numbers in the past, today, both the buffalo and the Native American are generally conspicuously absent from the state, save for a few small enclaves.

Originally, Goodhue wanted to put wings on the buffalo, but Alexander argued that there was no myth of winged buffalo in Native American cultural history, and eventually Goodhue conceded the point, and they were de-winged.

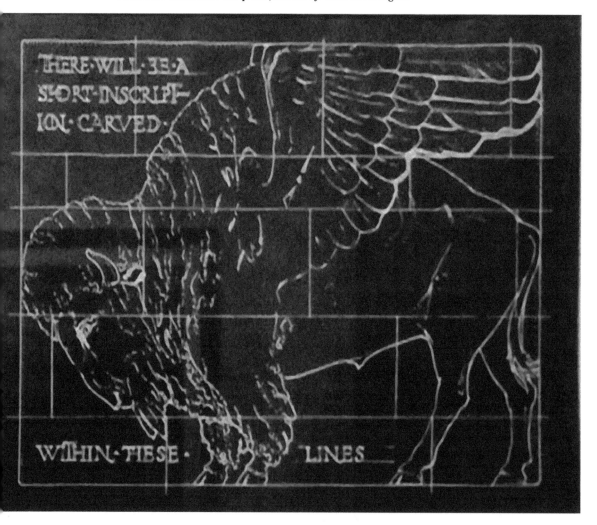

A design for a Winged Buffalo... soon abandoned.

KIOTA

11-1½

All joints ¼"

Horizontal joints figured to *bottom* of joint
Vertical " " " *center* " "

Lawrie's sketch plotting out the designs for a bison in the stone.

The clay models for the Bison. Photos, Lawrie's archives LOC.

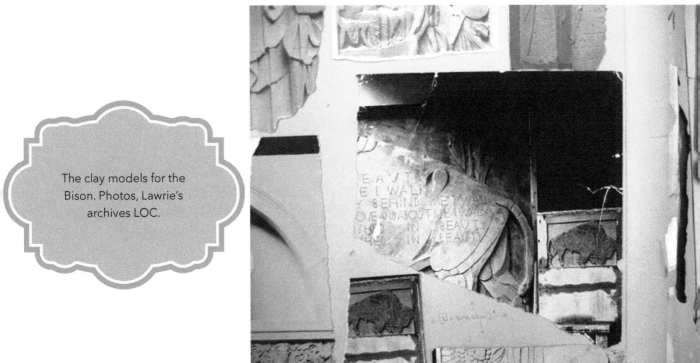

In tying together the Native American and Western Heritage, Alexander prescribed the following for the balustrades that flank the main north stairway.

Around the buffalo, we see listed these tribal societies, their names etched in stone: OMAHA, OTOE, PAWNEE, ARAPAHOE, and KIOWA appear on the west side of the eastern parapet, while across the stairs on the east side of the west parapet are engraved the names of the SIOUX, CHEYENNE, WINNEBAGO, PONKA and ARIKARA tribes.

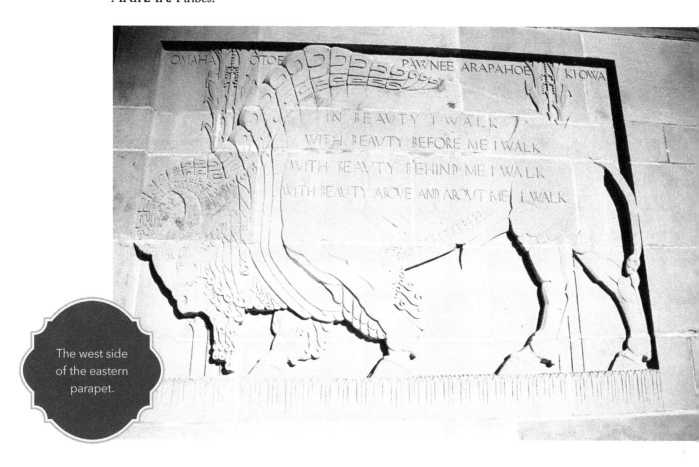

The west side of the eastern parapet.

A bison bull grazes.

"IN BEAUTY I WALK
WITH BEAUTY BEFORE ME I WALK
WITH BEAUTY BEHIND ME I WALK
WITH BEAUTY ABOVE AND ABOUT ME I WALK"

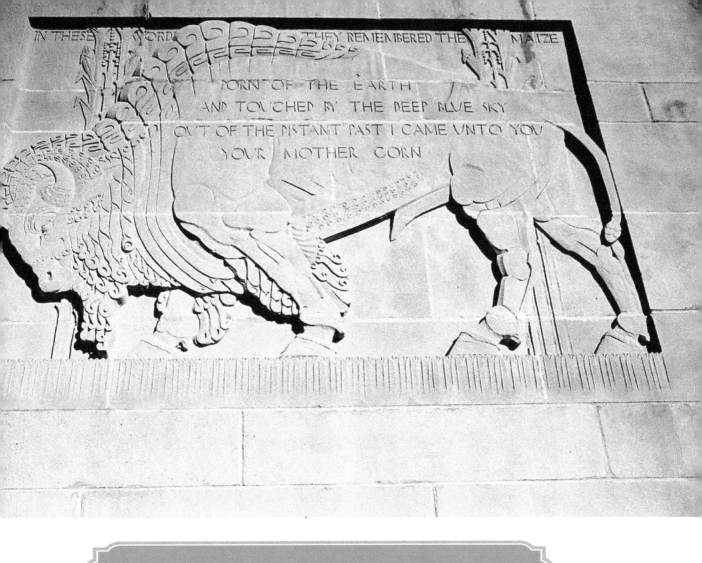

Text carved in stone within the relief:

IN THESE WORDS THEY REMEMBERED THE MAIZE

BORN OF THE EARTH
AND TOUCHED BY THE DEEP BLUE SKY
OUT OF THE DISTANT PAST I CAME UNTO YOU
YOUR MOTHER CORN

West side of west parapet.

From the Pawnee ritual of the Hako—a ceremony that celebrated the connections between father and son and between humanity and corn, which, along with the bison, provided sustenance as well as continuity to the Pawnee—the stone speaks of the gift of life through corn and children:

"BORN OF THE EARTH
AND TOUCHED BY THE DEEP BLUE SKY
OUT OF THE DISTANT PAST I CAME UNTO YOU
YOUR MOTHER CORN"

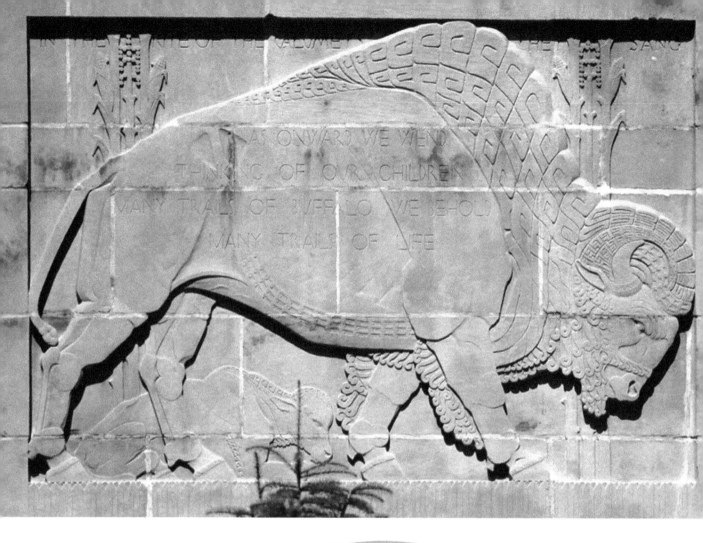

East side of the east parapet.

◇――◇――◇――◇――◇――◇――◇――◇――◇――◇――◇――◇――◇――◇――◇――◇――◇――◇――◇

Below the panel of a mother buffalo and her calf on the east side of east parapet, we read:

"AS ONWARD WE WEND
THINKING OF OUR CHILDREN
MANY TRAILS OF BUFFALO WE BEHOLD
MANY TRAILS OF LIFE"

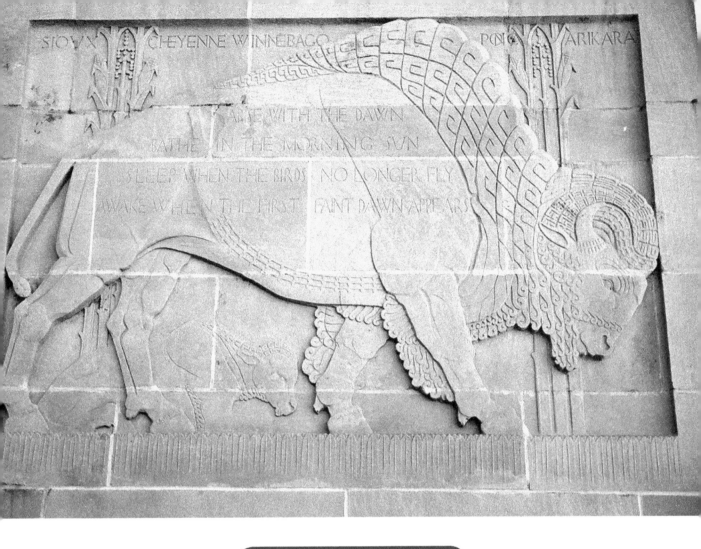

SIOVX  CHEYENNE WINNEBAGO  PONCA  ARIKARA

ARISE WITH THE DAWN
BATHE IN THE MORNING SUN
SLEEP WHEN THE BIRDS NO LONGER FLY
AWAKE WHEN THE FIRST FAINT DAWN APPEARS

East side of the west parapet.

A mother bison and her calf graze.

"ARISE WITH THE DAWN
BATHE IN THE MORNING SUN
SLEEP WHEN THE BIRDS NO LONGER FLY
AWAKE WHEN THE FIRST FAINT DAWN APPEARS"

THE·SALVATION
OF·THE·STATE·IS
WATCHFULNESS
IN·THE·CITIZEN

The top of the stairs in the north entrance is guarded by a bronze lacework of door screens, which mix icons of the Native American's life.

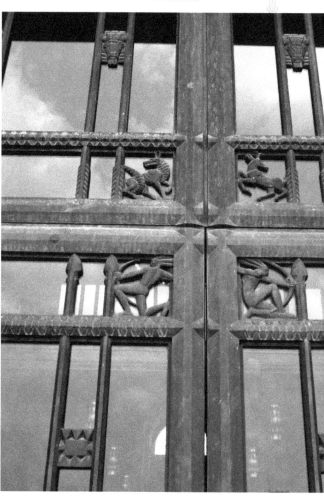

The Bronze Door Screens at the north entrance, depicting scenes from everyday life on the Plains. Lawrie frames his design with full-length arrows for the ribs of the doors.

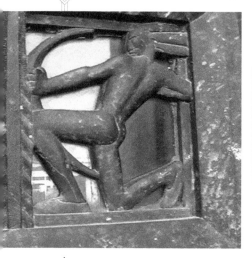

Crouched, and with their bows drawn and frozen in the hunt, we see a band of individual Native American braves taking aim on their prey. Here again, they are highly stylized figures which represent a graduation in design from Lawrie's earlier classical Gothic style into the Deco full of prairie iconography.

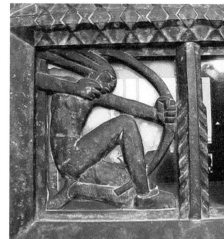

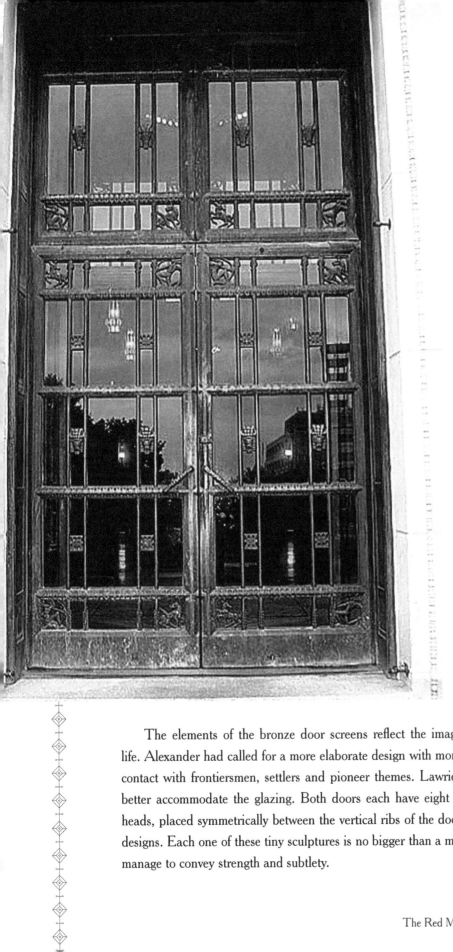

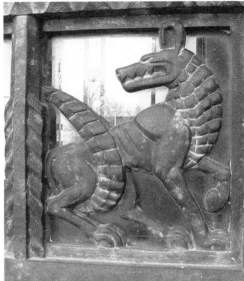

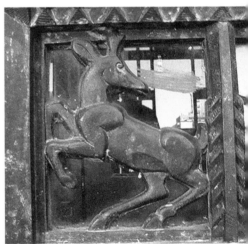

The elements of the bronze door screens reflect the imagery of Native American life. Alexander had called for a more elaborate design with more icons depicting the first contact with frontiersmen, settlers and pioneer themes. Lawrie simplified the design to better accommodate the glazing. Both doors each have eight of these identical buffalo heads, placed symmetrically between the vertical ribs of the door, employing giant arrow designs. Each one of these tiny sculptures is no bigger than a man's fist, and yet they still manage to convey strength and subtlety.

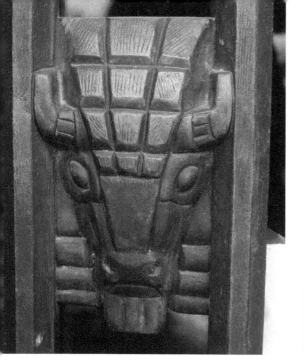

The bison heads face north, and appear nearly hieroglyphic in style.

There had been discussion of using pocket doors that would retract on either side into the walls. But Lawrie pointed out that this would mean that these doors would be hidden for eighteen hours per day, (as was the case of his decorative bronze doors featuring scientists, on the National Academy of Sciences Building in Washington, DC) so the present design won out.

For the Nebraska Cornhusker football fans out there, Lawrie designed several elements at Nebraska's Memorial Stadium. Unfortunately, these Bison Flagpole Sculptures never made it off the drawing board.

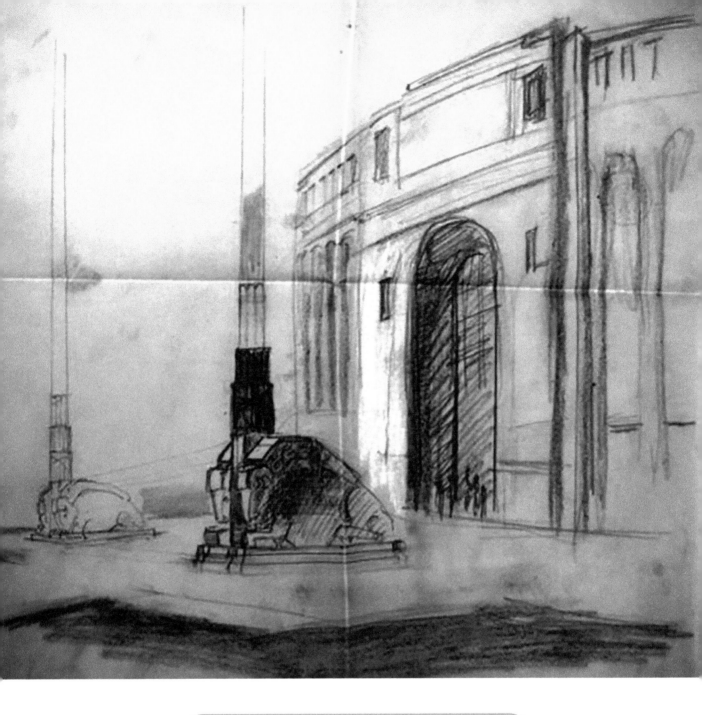

Picture taken of a sketch from Lawrie's archives.

*Photo courtesy of the Library of Congress.*

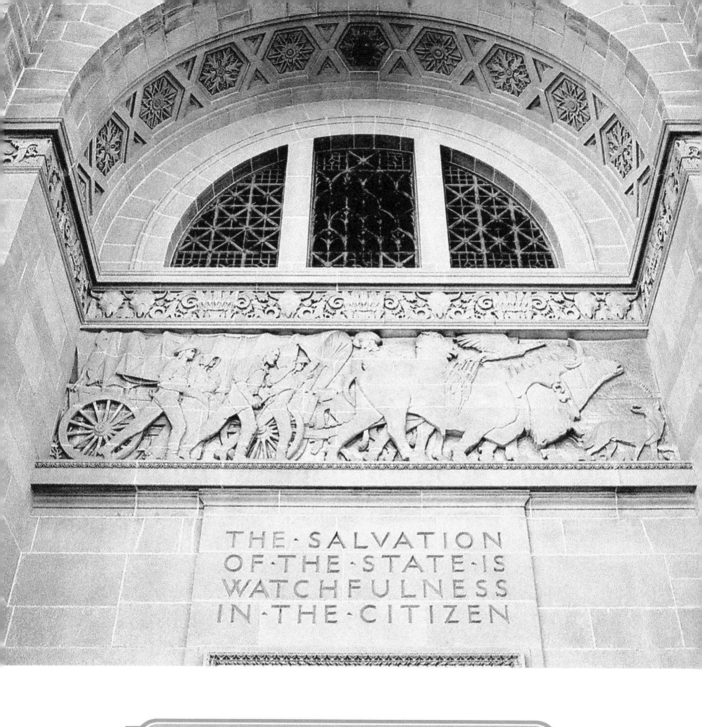

THE · SALVATION
OF · THE · STATE · IS
WATCHFULNESS
IN · THE · CITIZEN

*The Spirit of the Pioneers*, a.k.a. The Pioneer Panel.

# 10
# PIONEERS AND SODBUSTERS

## White Man Enters the Great Plains

WITHIN THE ARCHWAY ABOVE THE NORTH DOORS, WE find the Pioneer Panel depicting a Conestoga wagon—which was named after the Conestoga River in Pennsylvania—drawn by oxen, guided by a scout patterned after Buffalo Bill Cody and accompanied by a pioneer family. The family represents the four ages of life, including the old man with a divining rod, the youth with a basket of seed, as well as a baby and its Pioneer parents, which symbolizes the implanting of the whole life of man and a new land. Details also show the rising sun, a buffalo cranium, and the family dog.

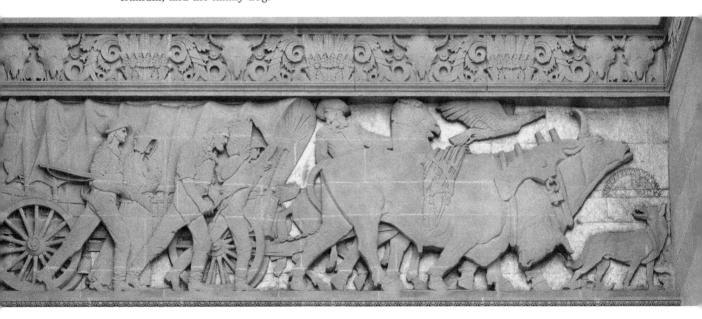

Detail of *The Spirit of the Pioneers.*

Typical of the cultural view of the 1920s, Buffalo Bill is depicted leading the family into the new land—however ironic it may be that the land was cleansed of buffalo by his labors, thereby starving the Native Americans into submission.

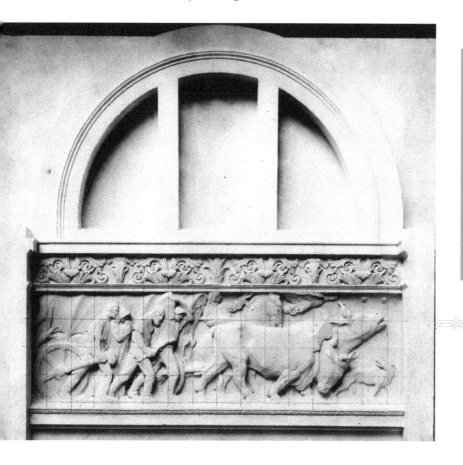

This is Lawrie's original maquette for the Pioneer Panel. Looking closely at this version, the most notable difference between this and the final one is that the man on horseback appears to be a Native American guide, as opposed to the figure of Buffalo Bill, which was how it was eventually carved.

*Photo courtesy of the Nebraska State Historical Society.*

The original maquette Lawrie created for what is commonly known as the Pioneer Panel—titled the Spirit of the Plains—contained the following distinct differences: first, instead of the figure on horseback resembling Buffalo Bill, guiding the Pioneer family westward, we see the original figure appears to be a Native American scout.

*Photo courtesy of the Nebraska State Historical Society*

Additionally, the second significant evolution in design is in the frieze above the sculptural depiction of the pioneer family moving westward. In the original maquette, we see a basic frieze, including a pair of bison skulls, a single ear of corn, and abstract depictions of the floral leaves of the acanthus plant.

But in the final design of the frieze, we see an elaborate Nebraska motif, featuring three baskets filled with corn, sunflowers, a half dozen symmetrically arranged bison skulls, some additional floral elements, and Lawrie's somewhat trademark decorative elements, the acanthus and arrowheads.

Finally, after the panel was completed, another highly-visible design element evolved. Lawrie and the architects concluded that, at a distance, it was difficult to see much detail in the panel, so the gold leaf was added to provide more visible contrast.

Centered above the bronze door screens depicting Native American life and below the Pioneer Panel, Alexander inserts an inscription, which he attributes to his father George Sherman Alexander—a minister, merchant, and sometimes journalist. In his book *Liberty and Democracy: and Other Essays in War-Time*, Alexander explains how his father taught this saying to his sons:

## "THE SALVATION OF THE STATE IS WATCHFULNESS IN THE CITIZEN"

In this quote, Alexander implores us to be vigilant about our government. This was written in the age of Populism (a political ideology that holds that virtuous citizens are mistreated by a small circle of elites, who can be overthrown if the people recognize the danger and work together)-dominated, Midwestern politics between the last decades of the nineteenth century and early ones of the twentieth century.

> Populism has been defined as a political ideology that holds that virtuous citizens are mistreated by a small circle of elites, who can be overthrown if the people recognize the danger and work together

A Detail showing Buffalo Bill.

Nowhere on the building do the words "Nebraska State Capitol" appear.

Rosettes featuring ears of corn over North Entrance Arch.

The arch above the Pioneer Panel is decorated with a frieze that includes alternating rosettes of wheat and corn ears along with baskets of maize ears interspersed with buffalo skulls. According to Alexander, this frieze represents the union of gifts of the old and new worlds.

The panel features a rising sun, a buffalo cranium—suggesting entry into the American West, and the family dog standing by a cactus, symbolizing the beginning of the West.

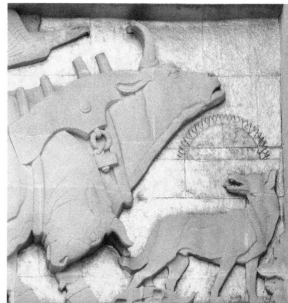

HONOVR TO
PIONEERS
WHO BROKE
THE SODS
THAT MEN
TO COME
MIGHT LIVE

HONOVR TO
CITIZENS
WHO BVILD
AN HOVSE
OF STATE
WHERE MEN
LIVE WELL

Alexander generated these poetic phrases to celebrate the
courage and tenacity of our Pioneer ancestors, who first settled the
state, and he continues the theme of Populism, that the electorate
will choose honest and noble legislators, where honorable
government will help grow and foster the "good life."

# *Carving a Legacy*

Is this unsigned lintel also Lawrie's handiwork? The curls in the buffalo's mane are nearly identical to his bison on the balustrades in Nebraska, and the ornate acanthus designs resemble many of Lawrie's other lintels, such as those at the National Academy of Sciences or the Los Angeles Public Library.

Although I cannot yet prove the connection, Ardolino also worked for Cross & Cross which provides another possible connection. Other elements on this same building, such as owls, cranes, wolves, and other Art Deco figures elsewhere all point to the hand of Lawrie.

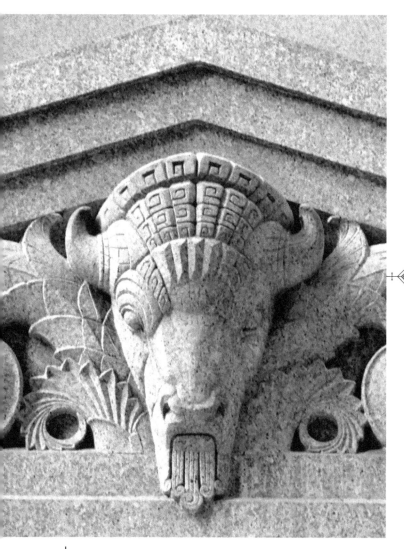

A bison found on the City Bank-Farmers Trust Building at 20 Exchange Place, a block south of the New York Stock Exchange in Lower Manhattan, 1931, Cross & Cross Architects.

*Photo courtesy of Chris Kralik, Danger Photography of New York.*

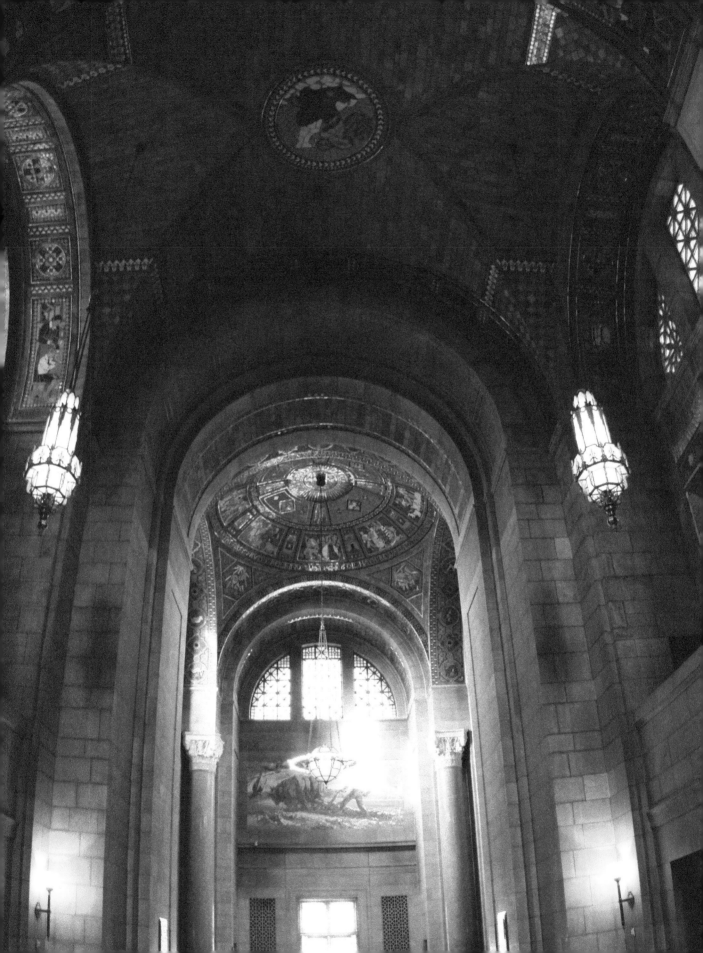

# 11

# MOVING INSIDE

HEN ONE ENTERS THE NORTH MAIN ENTRANCE, THE sense of magnificence is nearly overwhelming, like the sensation of entering a cathedral—solemn, majestic, and spiritual.

## Capitals

Among the first articles of Lawrie's works that we encounter indoors are his capitals on the massive columns.

Topping the columns in the foyer are the images of cattle and corn, the foods brought to the state by the pioneers that replaced the bison and maize of the Native Americans.

Cattle and Corn Capitals.

The vestibule and foyer.

There are four groups of six individual freestanding columns, and eight partial or hall-columns, flanking four curved walls in between the columns, each of which carries a capital of one of the two alternating designs used.

Again, we see how he skillfully adapts the regional, prairie symbolism into the very character of the building.

One can hardly imagine the amount of work that obviously went into creating all of these architectural details, while simultaneously working on all of the purely artistic bas-reliefs and other engaged sculpture present all over the structure.

Also significant is the fact that Lawrie created every one of the images used in the building—nothing is a copy of any work found anywhere else in the world. They are all unique works of art, each requiring its own individual creative design as Lawrie envisioned them.

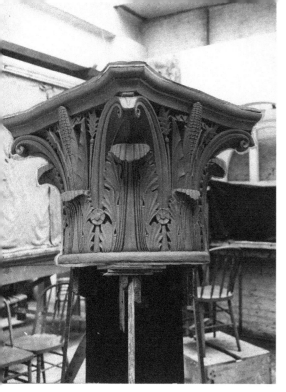

Studio model of pillar capital with ears of corn, sculpted by Lawrie.
*Photo courtesy of the Nebraska State Historical Society.*

Several stories up, and below the dome of the Rotunda, Lawrie tops capitals with alternating designs; the first showing ears of corn; the second comprised of sheaves of wheat, punctuated occasionally with sunflowers.

Again and again, the carvers reproduce the maquettes into the column capitals that line the upper rotunda balcony. Repetition then becomes pattern.

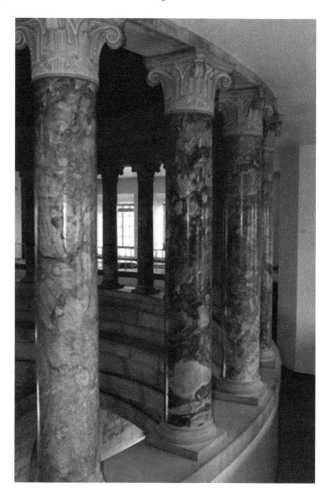

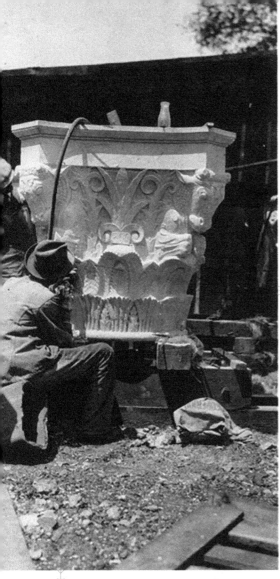

Two men carving a large capital for the column in the new Nebraska State Capitol in Lincoln.

*Photo courtesy of the Nebraska State Historical Society.*

Several stone carvers working on large capitals for the new Nebraska State Capitol Building.

*Photo courtesy of the Nebraska State Historical Society.*

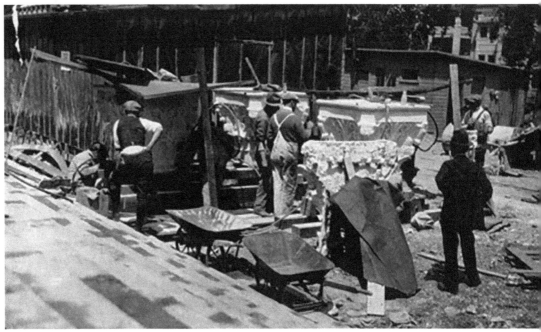

Lawrie's sketch for a buffalo column capital, never used.

Lawrie's original sketch as he developed the wheat and bison capitals.

These images illustrate the progression from a quick sketch on paper, to the plaster maquette used for the model, in turn used by the stone carvers to reproduce the work, making multiple exact copies of each of the individual models. The sketch then becomes physical in the form of the plaster maquettes for the corn capital.

The black and white photos of the capital maquettes were taken by R.V. Smutny from J.H. Jansen's 1936 book, *Sculpture* (by Lee Lawrie) and Frank Wright's 1931 book, *Architectural Forum*. These works appear at the bases of the arches in the Great Hall immediately north of the Rotunda.

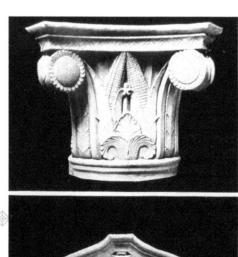

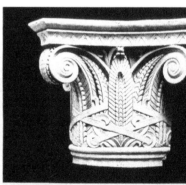

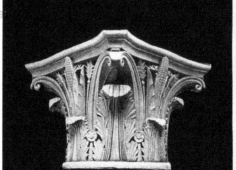

Capital designs.

*Photo from Architectural Sculpture of the Nebraska State Capitol Lincoln, Nebraska.*

Yet again, Lawrie draws on his perpetual fountain of creativity and imagination to create the capitals used for the various columns in the Rotunda and throughout the building.

Additional capital designs inspired by the geometric patterns of Native American beadwork.

# THE AGES OF MAN

Continuing toward the Rotunda, we pass through the Great Hall, where Lawrie created four reliefs found at the balcony level. Done in perhaps the purest example of Art Deco style in the building, the panels illustrate the four phases of life: *Childhood*, *Youth*, *Maturity*, and *Age*.

Two of these panels were featured in a 1931 article in *Architecture Review*, illustrating an assortment of Lawrie's then-recent works.

Like many of Lawrie's works in the building, you have to make the effort and look very closely to find them, even when they are in plain sight. The ages of man panels grace columns at balcony level in the Great Hall. Unfortunately, these panels are rather difficult to view, due to lighting issues. The area has some artificial light, but is still fairly dark.

Observe also the geometry present in each, as well as the minimal use of physical detail. Nothing is used beyond what is essential to convey the images.

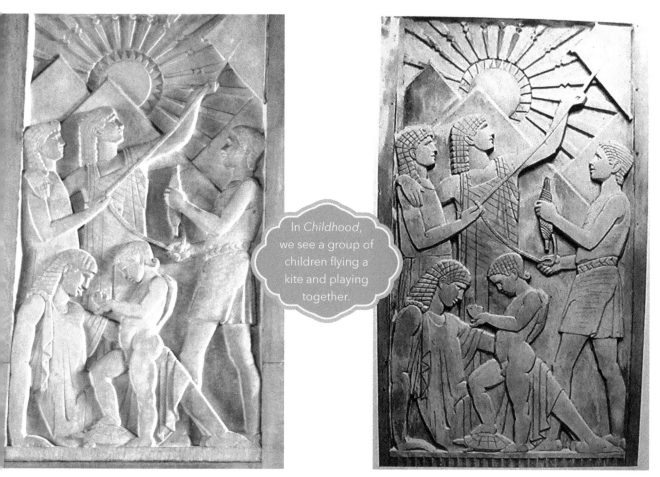

In *Childhood*, we see a group of children flying a kite and playing together.

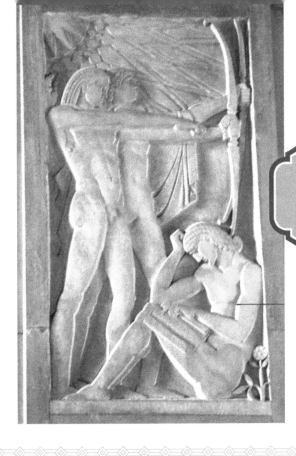

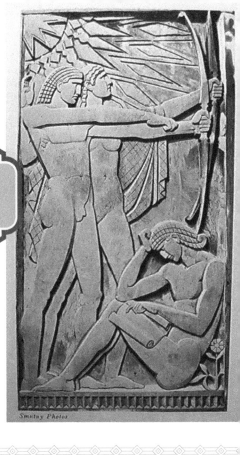

*Youth* depicts two archers while a third youth studies. Note the geometric pattern of the sun's rays in the background.

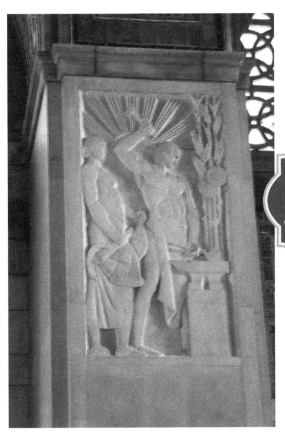

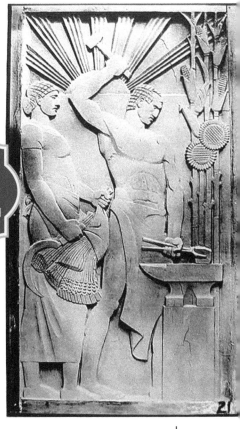

*Adulthood*, also called *Maturity*, shows a frontier blacksmith shaping iron while his wife clutches a sickle and a sheaf of grain in her apron.

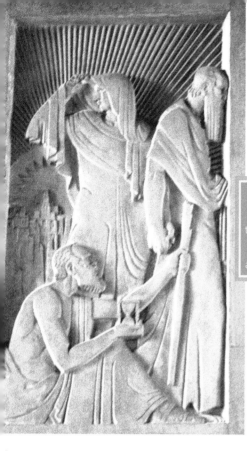

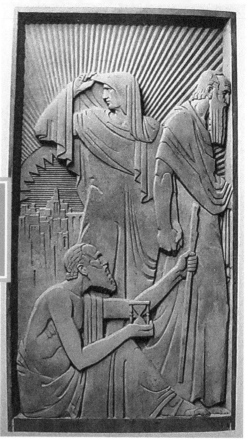

*Old Age* shows three men of significant age; one looking back to the past; the other looking forward; while the third, seated, holds a staff and his hourglass, marking the passage of time.

## The Rotunda

In the rotunda, Lawrie's next set of works are found on the railings of the balcony. Here we find decorations of corn, bison skulls, and the state bird, the Meadowlark. These onyx railings wrap around the balcony of the Rotunda.

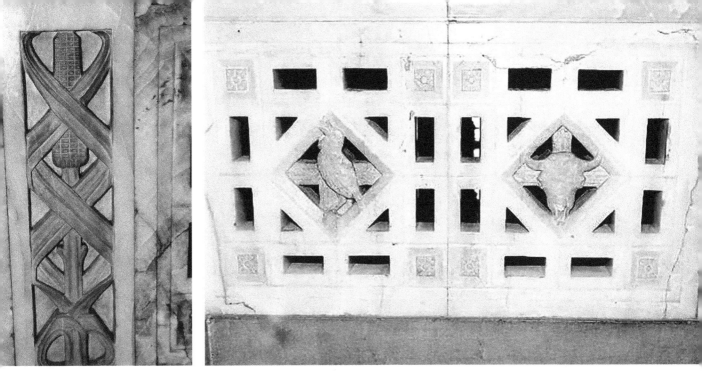

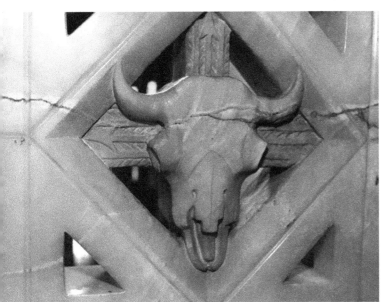

Carved from semi-translucent onyx, soft glowing sunlight often filters through the railings. In the center, the ever-present image of corn. The Meadowlark is the state bird of Nebraska.

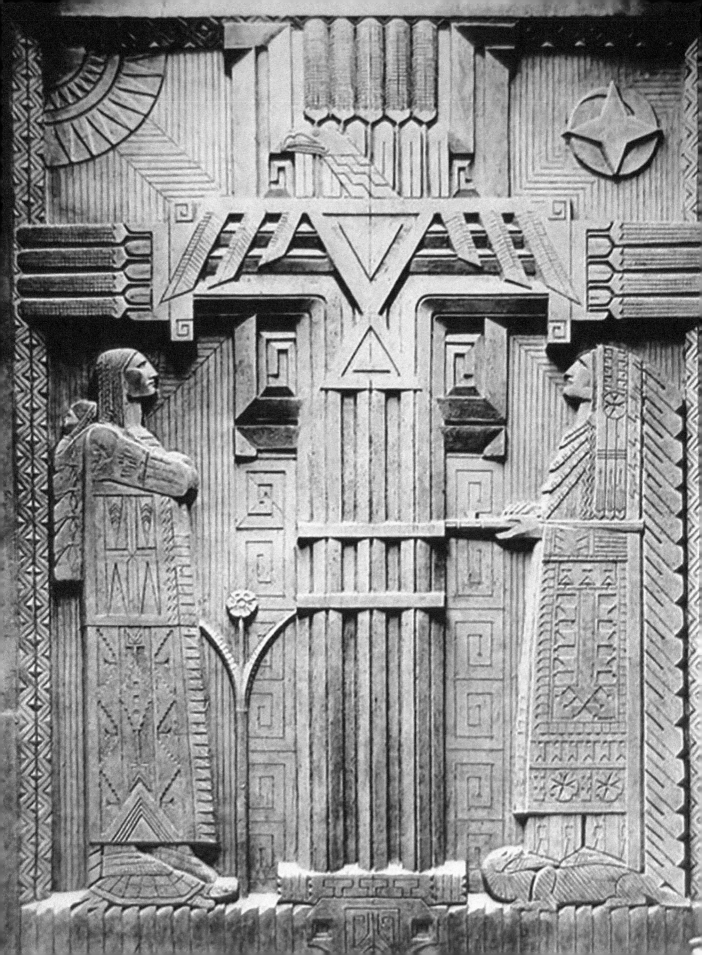

# 12
# THE BIRTH OF THE UNICAMERAL

### The Original House Chamber

WHEN CONSTRUCTION OF THE CAPITOL BEGAN IN APRIL 1922, Nebraska, like all other states, had a bicameral legislature; the Unicameral hadn't been invented yet. Chambers were built for both the State's House and Senate. The original and former House of Representatives' Hall is now known as the Warner Chamber.

The doors into what was to have been the House Chamber are constructed of Honduran mahogany, each weighing 750 pounds. Running the length and width of each door are fifteen massive internal bolts to prevent sagging, warping, or expanding.

*The Red Man's Tree of Life*, before it was polychromed. Photo from *Sculpture* by Lee Lawrie, 1936.

Lawrie's design for the doors was executed by the famed woodcarver Keats Lorenz, laboring three months on each door. The design features maize in the pattern of a cross underneath a thunderbird. A friend of Lorenz's tells that he worked on many additional buildings with Goodhue and Lawrie.

Today, the actual color has faded and dulled from the work's original varnish. This image has been saturated to bring out the work's original, true colors, as found in Plains Indian beadwork.

The thunderbird symbolizes the Native American masters who were ruling in the heavens, bringing the rains which made all life on the prairies possible. On the right door, an Native American chief holds a peace pipe while standing on an otter, symbolic of medicine. He worships the sun, which represents both the day and the god of war.

Across from him on the left door is an Native American woman with her baby on her back. She stands atop a turtle, symbolic of the productivity of life, and looks across to worship the star and the moon, signs of the night.

The color and designs in both figures' clothing were modeled on Native American beadwork. The handles of the doors show designs of corn and the locks have a sunflower motif, symbolic of productivity.

The Red Man's Tree of Life.

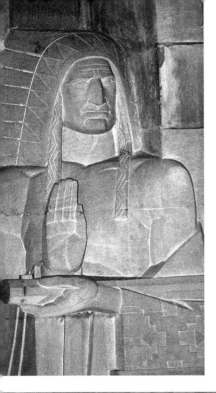

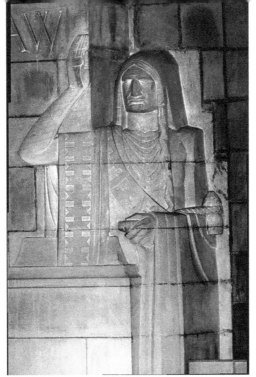

The Guide and The Counselor.

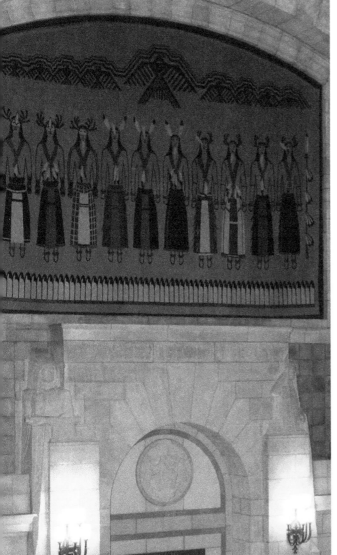

Detail of Lawrie's proposed, but never adopted seal for the State of Nebraska.

As one enters the original House chamber, Plains Indian symbols abound. On either side of the Speaker's Bay, we find *The Guide* and *The Counselor*, respectively. *The Guide* holds his peace pipe while *The Counselor* has a tomahawk resting on his forearm. Between these two figures sits a design Lawrie created for the state, consisting of two antelopes on either side of the state seal.

Capitol Commission historian and administrator Roxanne Smith noted that the Nebraska Legislature reviewed Lawrie's proposed new design for the state seal to decide whether or not to adopt it. When the vote was taken, one chamber voted in favor of adopting it; the other voted against it. Consequently, the tie killed the effort, and the success went to the status quo; thus, Lawrie's proposed design for a new state seal was defeated.

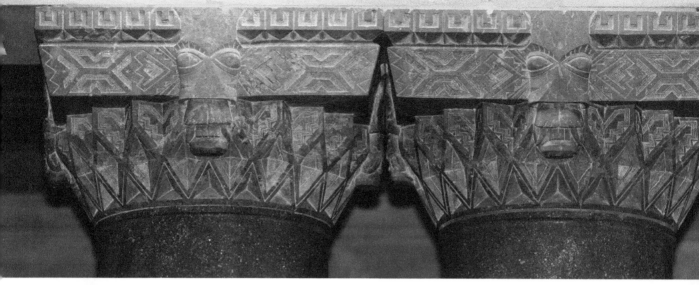

During the first two decades of the twentieth century, archeology was causing sensations with discoveries of Mayan and Aztec ruins in Mesoamerica. Consequently, Art Deco's and Lawrie's Moderne designs were highly influenced by these ancient, but newly-discovered styles. Note the skull-like faces on the capitals. While there is no suggestion here that Mayan culture ever flourished in Nebraska, it touched Lawrie, and he used its imagery in the creation of these columns.

The Native American motif is carried on by more arrow and beadwork inspired carvings on the gallery's hardwood benches and the legislators' desks. These elements may have also been carved by Keats Lorenz, but further study is needed to confirm this hypothesis, since, like Lawrie, much of his carving for Goodhue went unsigned.

Brass railings in the chamber were also
modeled after beadwork designs.

## The Former Senate Chamber

Today, Nebraska's Unicameral Legislature meets in the Chamber that Goodhue originally intended to be used by the Senate alone. The artwork of the Chamber symbolizes the influx of Western explorers and settlers into Nebraska.

Lawrie's figures in this chamber are limited to a pioneer family, represented in two works. The first figure is of a male pioneer, holding a shovel. The second, presumably his family, consists of a maternal *Prairie Madonna*, as she cradles her infant. Unless one walks up to the Speaker's platform, these engaged figures are easily overlooked.

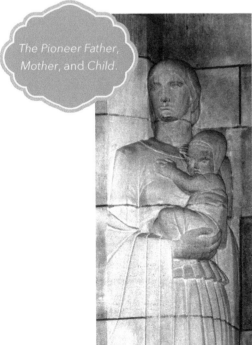

The Pioneer *Father*, *Mother*, and *Child*.

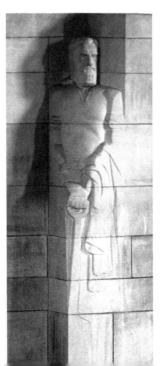

## Fireplace Mantles and Architectural Details

Prairie iconography and symbolism abound in the Governor's Suite. Yet again, the design features geometry and symmetry, born solely from Lawrie's vivid imagination.

The Governor's Suite includes the most dramatic of all the mantels in the Capitol. It is adorned with two identical bison heads, done in a heavily Art Deco style. Ears of corn dangle on either side of the buffalo heads, like giant earrings.

The central medallion is a design featuring the anvil, a symbol that represents the state of Nebraska and behind it, a blossoming ear of corn.

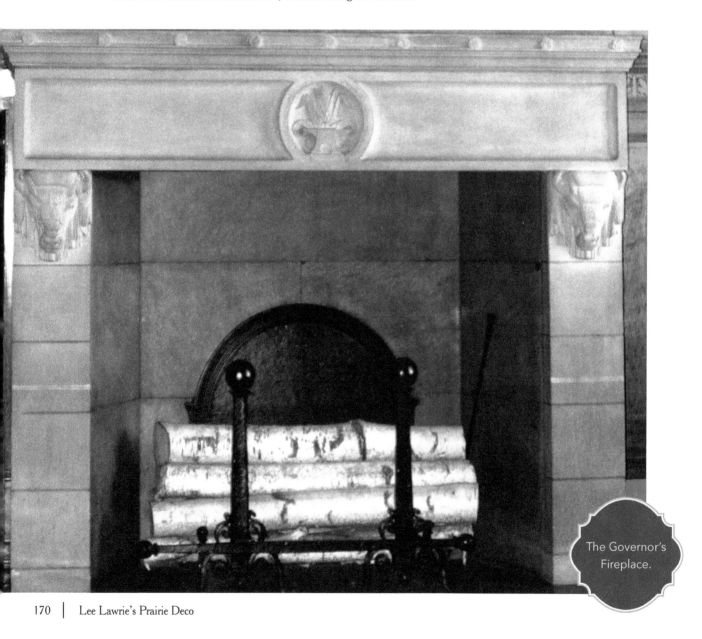

The Governor's Fireplace.

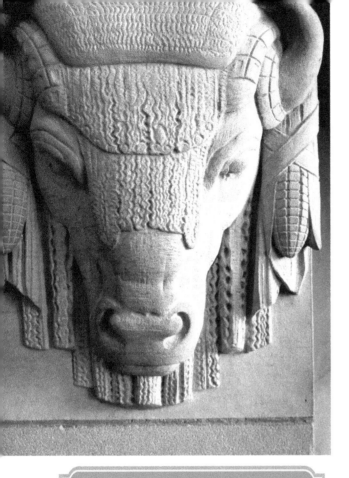

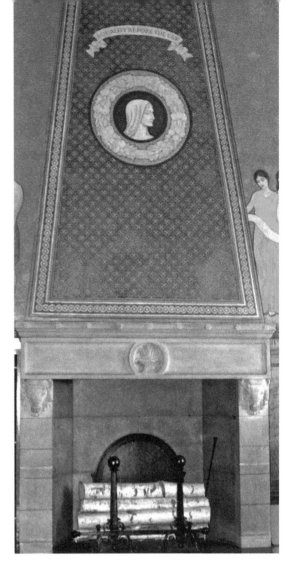

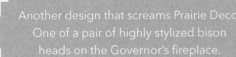
Another design that screams Prairie Deco. One of a pair of highly stylized bison heads on the Governor's fireplace.

There are also thirteen diminutive disks on this mantel lined side by side above the medallion. Each disk contains an emblem representing one of the original thirteen colonies that communicates the ideals of patriotism and national unity from a young state in the heartland.

During the previous decade, when I first began seriously researching Lawrie's work at the Capitol, it was known that these little disks represented the nation's first thirteen states, that had previously comprised the thirteen colonies. However, no one really knew the symbolism behind their designs.

The medallions' meanings were rediscovered by the Capitol Commission in 2008.

According to Roxanne Smith, Capitol Tourism Director, the medallions on the Governor's fireplace represent the thirteen original states. In the 1931 book, *Nebraska's Memorial Capitol*, the author, Leonard R. Nelson, an early Capitol tour guide, states, "Carved in the frieze of the fireplace mantel are symbols from the seals of the thirteen original States of the Union. The presence of these recognizes the basis of the law in Nebraska, just as the memory of pioneers recognizes the basis of life in Nebraska."

Like so many of Lawrie's other sculptures in the Capitol, you really have to look to see them all.

*Connecticut*, Grape leaves/ vines on State Seal.

*Delaware*, Shoreline and Delaware Bay.

*Georgia*, Three Pillars on State Seal.

*Maryland*, A Harlequin pattern on State Seal.

*Massachusetts*, Arm with Broadsword on State Seal.

*New Hampshire*, Ship on stocks on State Seal.

*New Jersey*, Plow on State Seal.

*New York*, Balance and Sword on State Seal.

*North Carolina*, Star on State Flag.

*Pennsylvania*, Nickname is the Keystone State.

*Rhode Island*, Anchor on State Seal.

*South Carolina*, a palm tree from its state flag.

*Virginia*, Smoky Mountains.

The thirteen disks, each representing one of the thirteen original colonies, that adorn the Governor's fireplace mantel.

# Hearing Room

Moving from the Governor's Suite to the Hearing Room, immediately to the west, is another fireplace—inside the room and back to back with his main fireplace. It features a single ear of corn on its face and the Roman Fasces and Scales of Justice on either side of the firebox, inscribed with the state motto, "EQUALITY BEFORE THE LAW". To either side of the fasces is the inscription, "PRIVATE HONOR, PUBLIC GOOD".

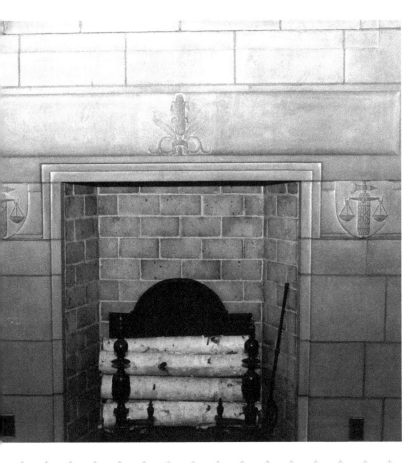

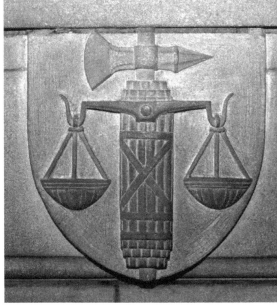

# West Senate Lounge

The West Senate Lounge contains a tall mantel, embellished with three Continental or Minutemen soldiers on either side.

In the center, a quote is inscribed from George Washington's Farewell Address:

"THE BASIS OF OUR POLITICAL SYSTEM IS THE RIGHT OF THE PEOPLE TO MAKE AND ALTER THEIR CONSTITUTIONS OF GOVERNMENT: THE CONSTITUTION WHICH AT ANY TIME EXISTS, TILL CHANGED BY AN EXPLICIT AND AUTHENTIC ACT OF THE WHOLE PEOPLE, IS SACREDLY OBLIGATORY UPON ALL: THE VERY IDEA OF THE POWER AND RIGHT OF THE PEOPLE TO ESTABLISH GOVERNMENT PRESUPPOSES THE DUTY OF EVERY INDIVIDUAL TO OBEY THE ESTABLISHED GOVERNMENT."

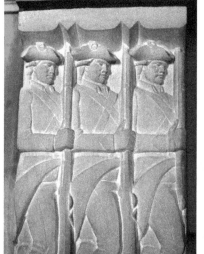
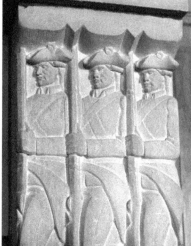

# East Senate Lounge

The East Senate Lounge Mantel is adorned with figures of a wolf baring his toothy upper jaw, and little feet curled up below it.

The upper walls and vaulted ceiling of the room are done in roughly-chipped slate from Vermont. At the base of the vaults are pendentives of Indiana limestone carved with more symbols according to Alexander's plan. Pendentives are the blocks supporting the arched vaults of the ceiling.

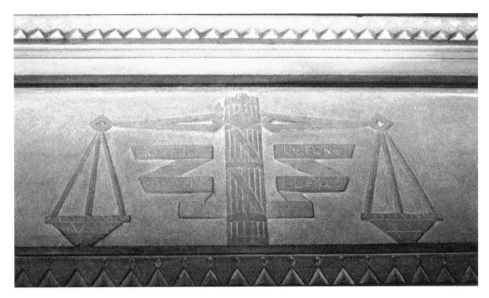

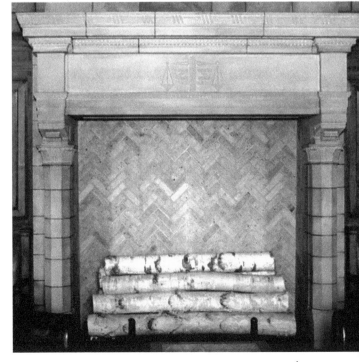

On the north is a sheaf of wheat.

On the south side is an ear of corn.

About fifteen feet above the ground, we see a bovine skull.

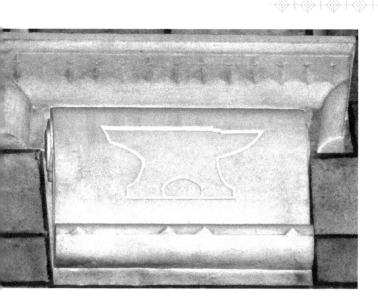

Also on the east side is the state symbol of the anvil.

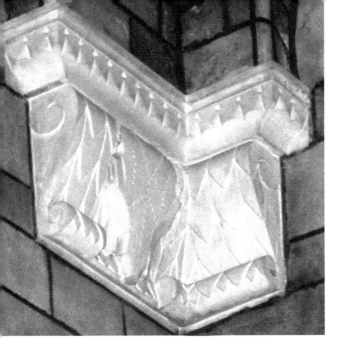

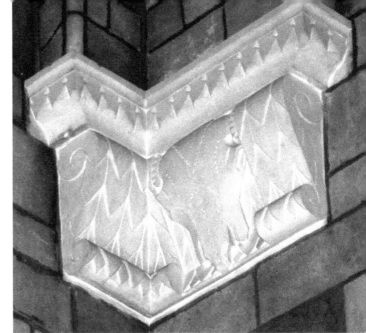

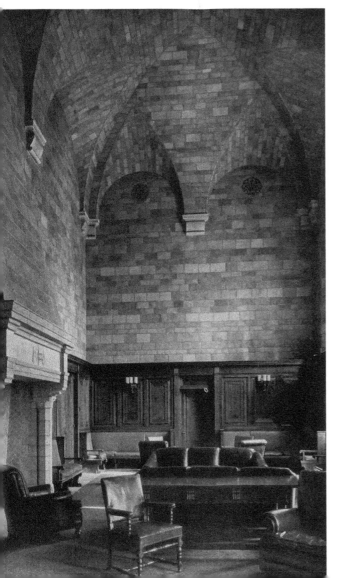

The remaining pendentives are decorated with bison skulls and the Roman Fasces.

Senate Lounge showing the fireplace and pendentives in context. *Architecture Magazine*, October, 1931.

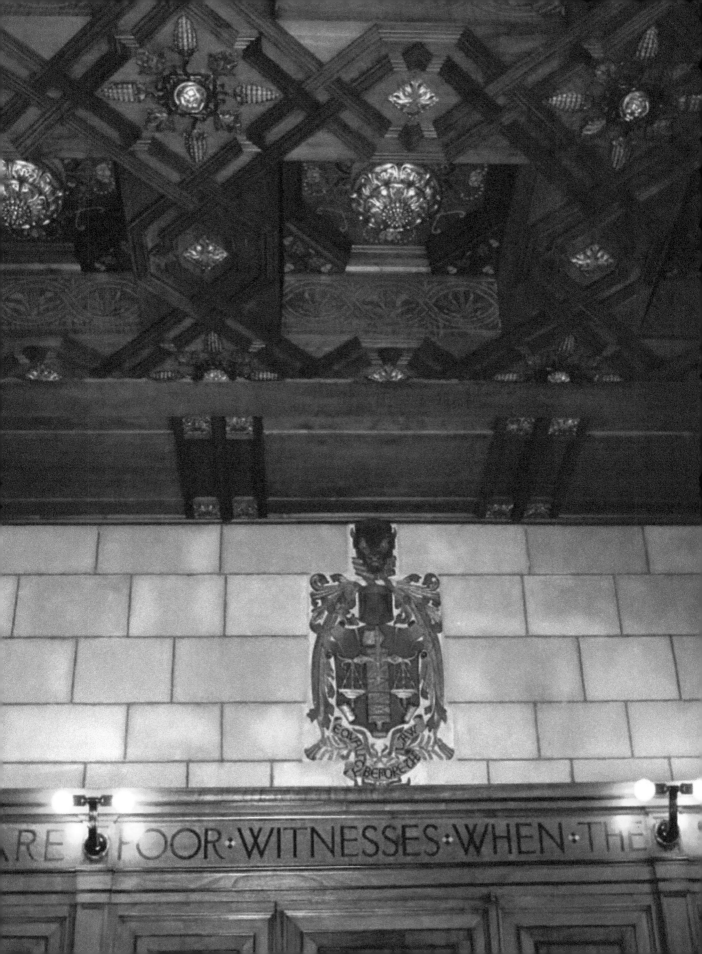

EQVAL BEFORE THE LAW

ARE POOR·WITNESSES·WHEN·THE

# 13

# NEBRASKA'S HALLS OF JUSTICE

ERE IN THE STATE'S HIGHEST COURTROOMS, WE SEE
several variations of Lawrie's proposed Seal for the State of Nebraska. In the main
chamber of the Nebraska Supreme Court, immediately behind the high court's bench,
the stone sculpture is polychromed. This is from Lawrie's 1936 monograph, *Sculpture*,
his original shown in black and white, but never adapted design for a new State Seal for
Nebraska. The fasces and scales of justice are also pictured on the shield. The whole
design represents and is inscribed with the state motto, "Equality Before the Law."

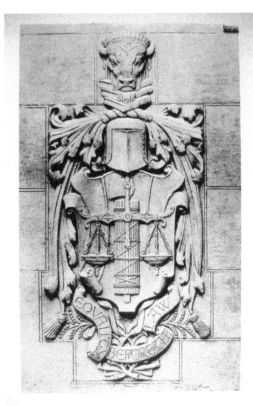

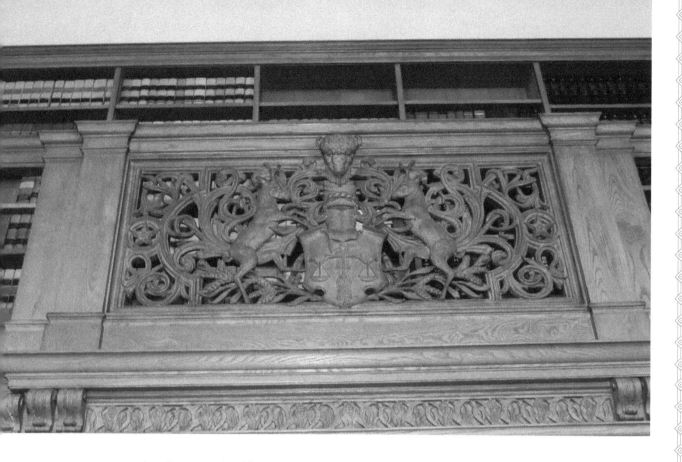

Another example of Lawrie's proposed State Seal is this pierced wood example on the balcony rail of the Law Library's reading room, located at the south end of the library. It is the largest of Lawrie's wood carvings in the building.

The sienna marble door lintels that lead out into the halls from the Supreme Courtroom.

Lawrie repeats the design of the Roman fasces, and Scales of Justice on these door grills.

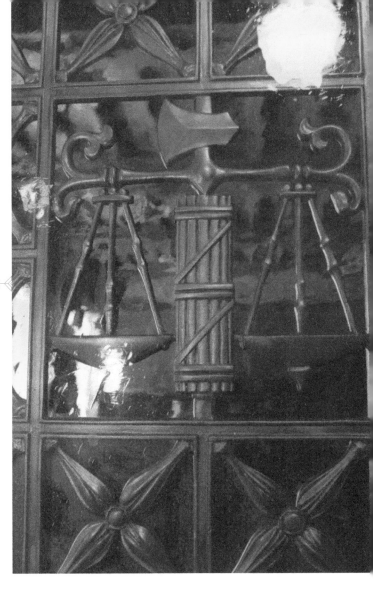

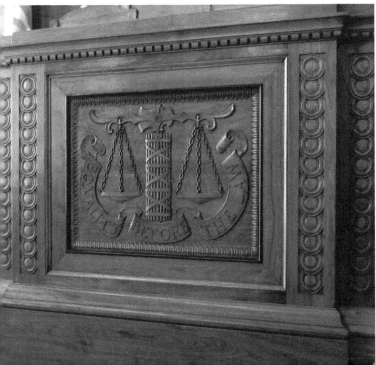

Entering the Court of Appeals, through the doors pictured above, we find a similar design featured, carved into the Judge's bench.

# Lawyers' Consultation Chamber

Lawrie also illustrated the ceiling of the Lawyers' Consultation Chamber. These designs are of plaster cast into the ceiling—a truly remarkable feat. He reinforces the prerequisites of the Law: *Justice, Courage, Wisdom,* and *Truth.*

The ceiling is graced with a medallion that portrays Poseidon on the north, inscribed "International Representation."

On the south ceiling is the image of Mercury with the caduceus and the fasces in front of the United States Capitol and the Nebraska Capitol building inscribed with, "Interstate Representation." Note the image of the Nebraska Capitol to the left, and the U.S. Capitol to the right, from the 1936 J. H. Jansen portfolio, *Sculpture* by Lee Lawrie.

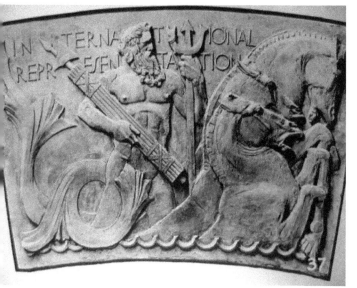

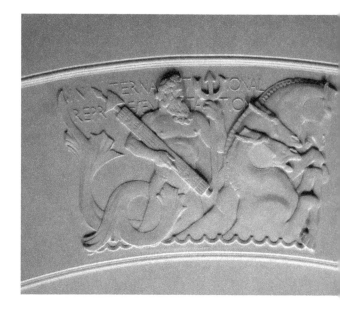

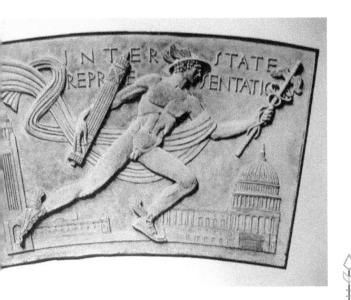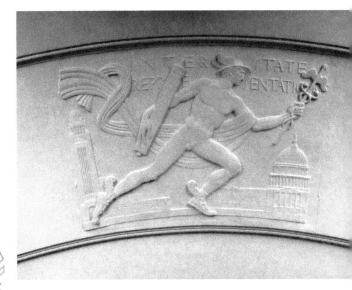

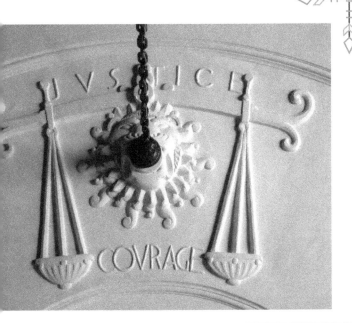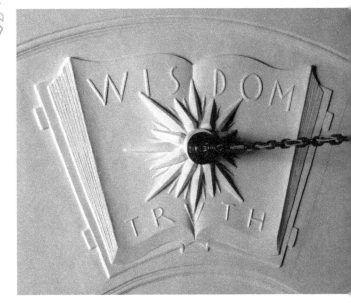

Additional reliefs depict the scales of justice with the symbols of a lion's head inscribed with "JUSTICE, COURAGE." Opposite the lion's head is an open book with stars and the description "WISDOM, TRUTH."

# 14
## DETAILS, DETAILS...

IN ADDITION TO ALL OF THE DEDICATED WORKS OF SCULPTURE, Lawrie created many of the structural design elements used in the building. While many of these are documented as genuine works by Lawrie, some of the lesser details may have been designed by others.

Tourism Director Smith also added that Goodhue and Lawrie would often look at catalogues and agree on a particular design, and then Lawrie would create it. This is true for hardware as well as many of the sconces and chandeliers that add luxurious touches throughout the building.

Goodhue died in 1924, long before the Tower was erected, so the latter details were added under the supervision of William Younkin, the architect in Goodhue's firm who took the helm after he passed.

The tower columns from the original design were modernized with a design based on wheat.

The chandelier from the Memorial Hall of the Tower, designed by Lawrie.

A sconce featuring a thunderbird motif.

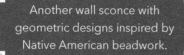

Another wall sconce with geometric designs inspired by Native American beadwork.

The thunderbirds surrounding the base of the dome, along with characteristic Art Deco zigzag patterns in the railings of the upper observation area (no longer accessible to the public).

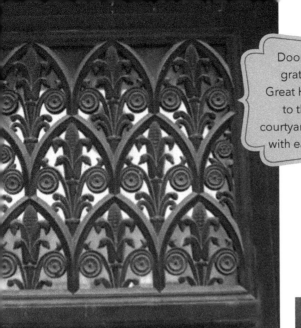

Door-window grates in the Great Hall leading to the north courtyards, adorned with ears of corn.

A handrail finial cast in the shape of a ram's head.

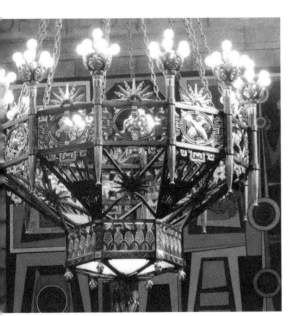

Lawrie's Rotunda Chandelier, featuring the signs of the Zodiac and corn.

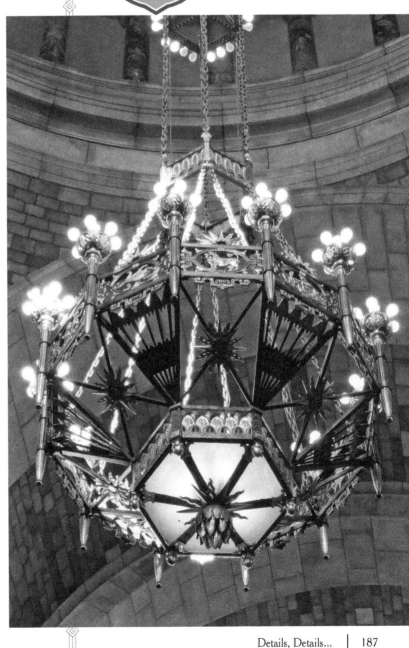

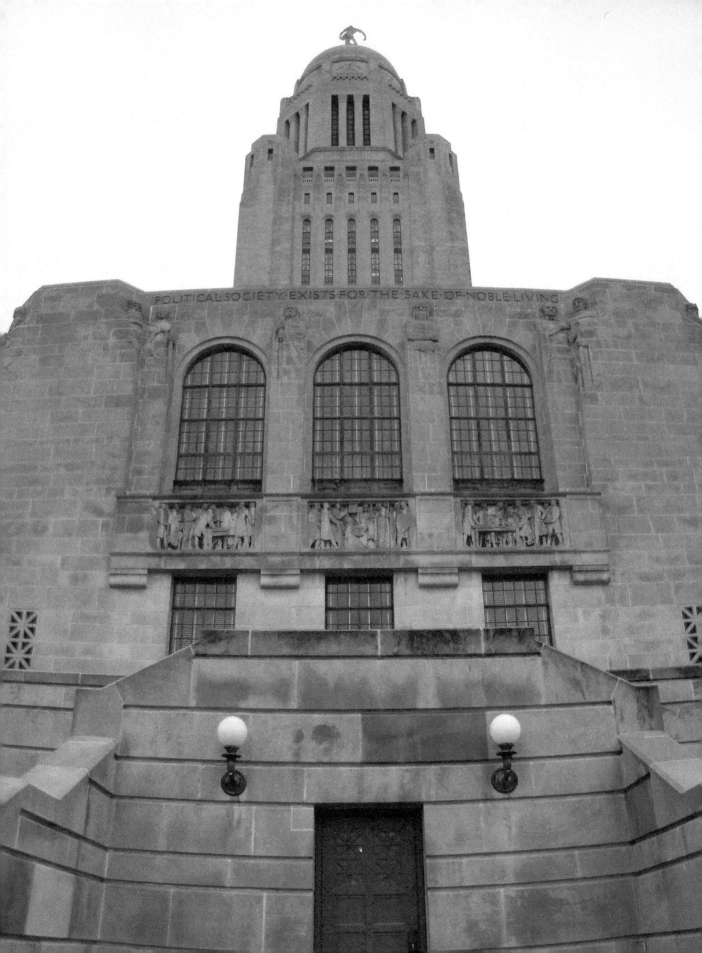

# 15

## CIVILIZATION'S GREAT LAWGIVERS AND NOBILITY

OVER THE CENTURIES, COURTS HAVE BEEN ESTABLISHED to carry out the laws of the nation, as well as the states and down to the local governmental level, including counties, water management districts, and even local school boards. But in the history of man, many centuries passed before laws came into existence, especially written laws. While early societies often had codes or customs in clans or tribes, written law is one of the institutions that helps differentiate us from other societies and countries. In the absence of laws and court systems, such as we have in the United States, societies may descend into chaos or war. One need only look at the nightly news to find examples of what life is like in the lawless parts of the globe.

### Returning to the Exterior

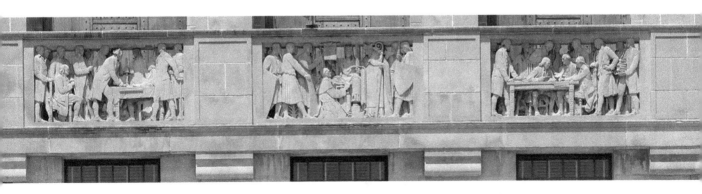

The South Façade features both the great *Lawgivers* and the *History of Law* panels, including the *Signing of the Declaration of Independence*, the *Magna Carta* and the *Drafting of the U.S. Constitution*.

Alexander chose to honor a series of the Great Legislators of the Western World, as appropriate symbols for the Capitol as a house of state and law making.

Eight out of the ten figures of kings and emperors appear on the South Façade. Two appear on the inner corners, above the two southern courtyards.

Across the South Façade, we see the figures of history's great legislators. These giants of law are pictured above the pierced stone panels depicting the segment in the *History of Law* scenes of the Declaration of Independence, the Magna Carta and the Drafting of the U.S. Constitution.

Inside the building, behind these works is the Law Library's reading room. Behind the windows below are the Supreme Court Chambers on the south side of the main floor. On the South Façade, above the figures of the great lawgivers, Alexander placed the words of Aristotle, "POLITICAL SOCIETY EXISTS FOR THE SAKE OF NOBLE LIVING"

## The Lawgivers

One of Lawrie's original maquettes for the lawgivers. The handwriting is from Bertram Grosvernor Goodhue, who wanted the sculpture changed.

*Photo courtesy of the Library of Congress.*

## Hammurabi

Hammurabi, the Babylonian King (1955-1913 B.C.), created one of the earliest known codes of law. A portion of his law is carved below his left hand in cuneiform script. The only known copy of the code is on display in the Louvre in Paris.

## Moses

Moses, who freed his people from slavery in Egypt, holds both tablets of the Ten Commandments and is situated on the South Façade.

## Akhnaton

To Moses's immediate left is Akhnaton,
(1410-1375 B.C) an Egyptian who was among
the first individuals ever chronicled in Western
History. This photo also shows a view of Moses
resting his hand on one of the tablets of the Ten
Commandments.

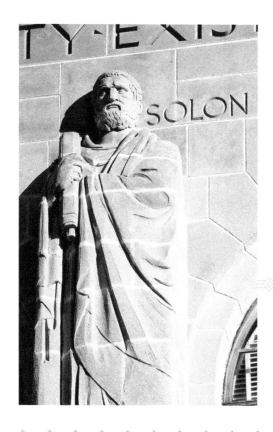

## Solon

Solon, the Athenian lawgiver (638-559 B.C.), also
appears in the *History of Law* series, giving Athens its
first constitution.

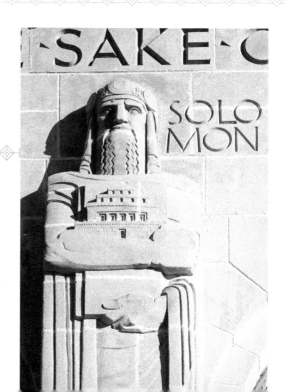

## Solomon

Solomon, the son of David, the Great King of the
pre-Christian era, (circa 1000 B.C.), holds the model of his
Temple. Note the economy of lines used in his arms, and the
geometric flow of his beard.

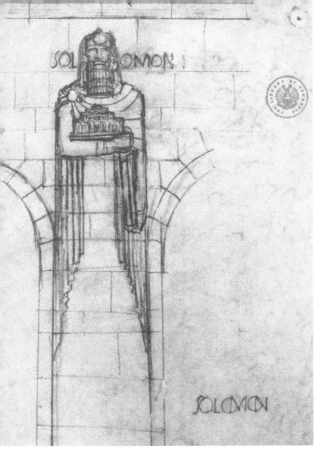

Lawrie's sketch of Solomon comes from the Library of Congress. Each work in this series of sculptures began with an idea sketched on paper. Lawrie created each of these images that would become this engaged sculpture.

Every piece had to be conceived, drawn on paper, sketched first in clay, then plaster for the maquette. Then the model was shipped halfway across the continent from Harlem to Nebraska for Ardolino's crews to carve in place. And this same process was repeated for each element that appears on the finished building; quite a feat in any era, and probably unmatched since then.

## Minos

Minos, was the mythical king of Crete and judge of the dead, for whom the Minoan Civilization was named (circa 1300 B.C.). Minos looks over the southwest courtyard.

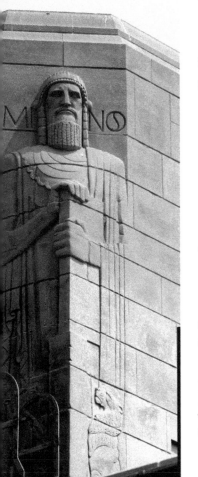

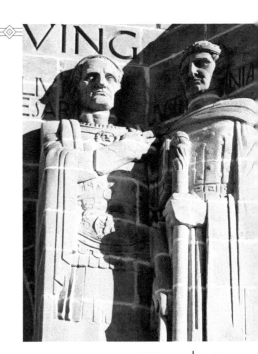

## The Caesars

Julius Caesar (100-44 B.C.) is symbolic of the spread of Roman law, and Justinian Caesar, the emperor of the East, and West (527-565 A.D.) who ruled the Roman Empire from his capital in Constantinople. Justinian is also featured in one of the *History of Law* panels.

## Charlemagne

Charlemagne (742-814 A.D.) was the founder of feudalism as well as the Holy Roman Empire. He faces southeast on the south buttresses.

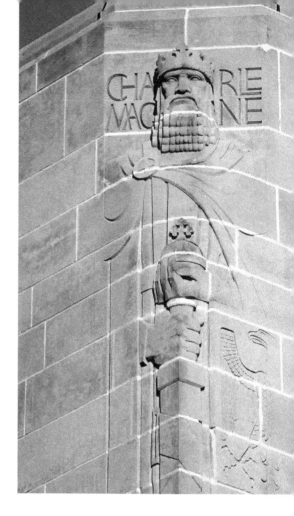

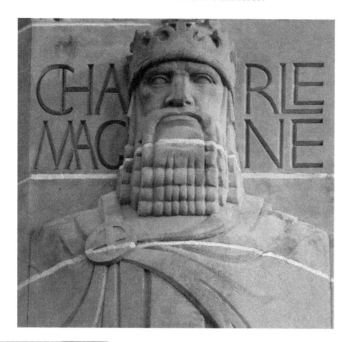

## Napoleon Bonaparte

Napoleon, who modernized European law, (1769-1821 A.D.) also appears as a bust in the *History of Law* panel for the Louisiana Purchase.

The Napoleonic Code was the basis for many laws of the states that emerged from parts of the Louisiana Purchase. The Napoleonic Code brought law into the new world and differed from the laws of the Spaniards and British. However, in lands that were formerly Spanish possessions, such as many of the Southwestern states, laws often retained elements of Spanish colonial law.

The United States acquired the land that would become Nebraska from the Louisiana Purchase of 1803. Prior to that, the land was a French territory.

You may recall Nebraska-born actor Marlon Brando as Stanley Kowalski in *A Streetcar Named Desire*, reciting the notion of community property to Blanche and Stella. In that scene, he points out that the idea of community property came from the Napoleonic Code, which governs the State of Louisiana.

# Alexander's Nobility of Civilization and Their Lost Inscriptions

Eight colossal figures representing the genius of human civilization, meant to convey the spiritual history of man's past, look out from the tower transepts—the intersections above the north/south and east/west corridors in the building—of the Capitol. The figures include the Egyptian scribe Pentaour, the Prophet Ezekiel, the philosopher Socrates, Emperor—philosopher Marcus Aurelius, John the Apostle, Louis IX or St. Louis of France, the Renaissance scientist Sir Isaac Newton, and finally the Great Emancipator, Abraham Lincoln, in his youth. The eight figures were installed on the tower transepts—but their inscriptions never were.

Correspondence from Lawrie's archives indicates that as of 1931, Alexander was anxious to see the inscriptions made. But here again, it is likely that the economic hardships of the Great Depression erased Alexander's hopes of the captions ever materializing.

The figures begin with Pentaour on the west side of the north transept, and progress chronologically around all four sides.

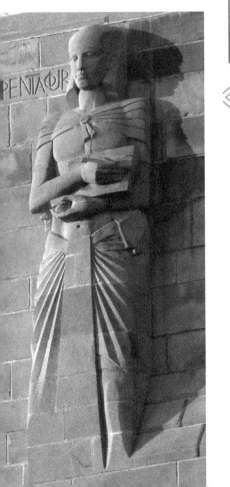

"Scaffolds are being built on four sides of the transept of the tower of the capitol for the use of carvers who are soon to begin the work of reproducing the gigantic figures modeled by Lee Lawrie, New York sculptor who designed the covered wagon and pioneers over the main entrance and other pieces around the capitol." The Lincoln State Journal, March 28, 1928.

## Pentaour

Pentaour, the world's first historian. His inscription was to have read,

"EVEN OF OLD MAN REMEMBERED HIS PAST
HE BETHOUGHT HIM OF LETTERS
HE RECORDED THE DEEDS OF HIS FATHERS"

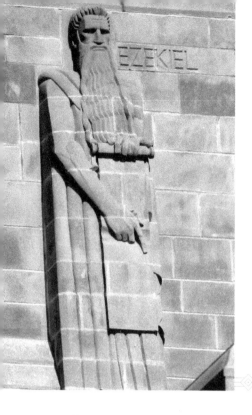

## Ezekiel

The Prophet Ezekiel represents the "Cosmic Tradition." Alexander described him as a "Semitic Seer, gifted with Apocalyptic Vision." His inscription would have read:

"HE TURNED HIS EYES UNTO THE HEAVENS
HE SAW THAT THEY WERE ONE
AND IN THAT ONE HE BEHELD THE IMAGE OF GOD."

Ezekiel faces south to the west of St. John. The carving made national news at the time of its installation when Biblical scholars debated whether or not he should be depicted wearing a beard.

## Socrates

Socrates represented "The Birth of Reason." His inscription was to have read:

"INTO THE HOUSES AND THE AFFAIRS OF MEN
HE BROUGHT UNDERSTANDING
BEFORE THEIR EYES HE SET THE PATTERN OF THE GOOD"

Socrates also appears in the panel where Plato writes his dialogue. On the Nebraska Capitol, he looks west, over the Lincoln Mall.

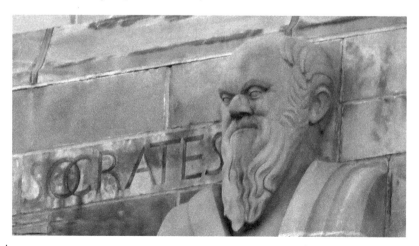

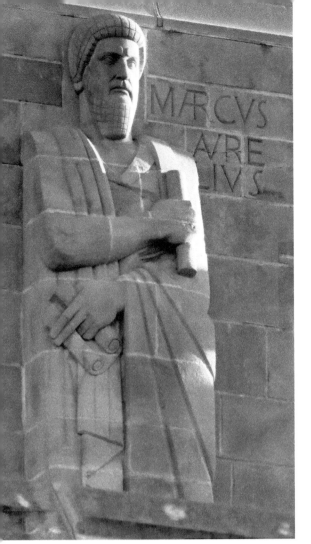

## Marcus Aurelius

He symbolized "The Reign of Law." His inscription was to have read:

> "HIS FORTRESS HE FOUNDED IN THE LAW
> HIS EMPIRE IN WISE ADMINISTRATION
> PERCEIVING THAT HE WHO WOULD RULE
> MUST ALSO SERVE."

Marcus is Socrates's neighbor, facing west.

## St. John

The Apostle John represents the "glorification of faith," according to Alexander. His inscription:

> "WITH THE EYE OF FAITH HE GAZED WITHIN
> HE SOUGHT OUT THE SPIRIT OF MAN
> HE PRAYED THAT IT MIGHT BE FOUND PURE"

St. John faces south, high above the south entrance.

### Sir Isaac Newton

Sir Isaac Newton represents the discovery of nature. His inscription was to have read:

> "WITH THE STARS FOR HIS TEACHERS
> WITH TRUTH FOR HIS GOAL HE ASKED OF NATURE
> WHAT IS POSSIBLE FOR MAN"

Newton is also often thought of as the ultimate Renaissance man. He pioneered the science of physics.

He faces the morning sun on the east side.

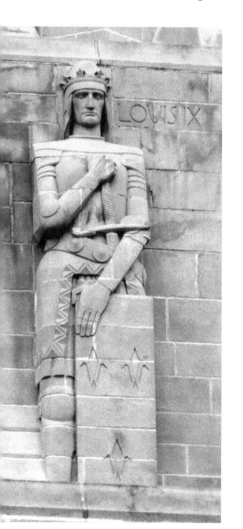

### St. Louis

Louis IX, commonly known as St. Louis of France, represents "The Age of Chivalry." His inscription was to have read:

> "HE SWORE WITH THE OATH OF HIS HONOUR
> TO BE COURAGEOUS BEFORE ALL PERIL
> TO ABHOR EVIL, TO BE MERCIFUL, TO BE GENTLE"

St. Louis is to the left of Sir Isaac Newton on the east side, when facing the building.

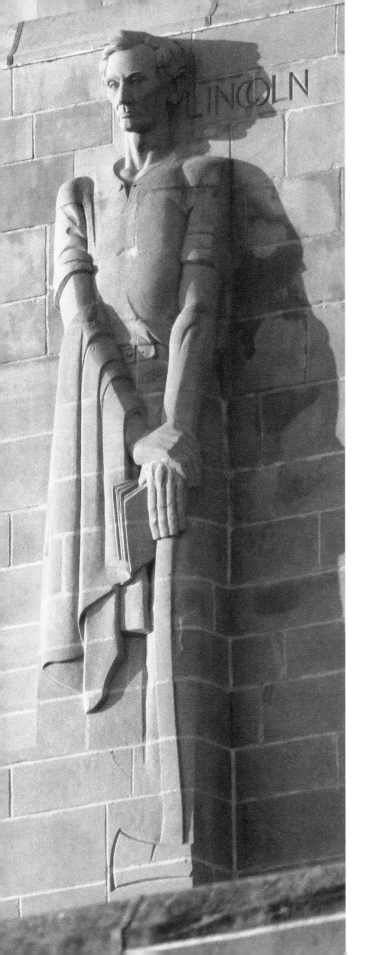

## Young Abraham Lincoln

Ending the series is the young Abraham Lincoln, symbolic of the "liberation of peoples." His inscription was to have read:

"STRONG IN THE LOVE OF LIBERTY HE DEMANDED FREEDOM FOR ALL MEN THAT HUMANITY MIGHT REIGN IN THEIR SOULS"

In his hands are his trademark axe and a law book from which he studied. In his youth he was known as "the Railsplitter." He looks north above the main entrance.

## The Ornaments of Democracy

Alexander also selected a series of ornaments to represent the symbols of democracy.

On the east side, originally conceived in the Senate Façade, the ornaments included a Phrygian cap as worn by peasants of the French Revolution. A laurel wreath, as worn by the ancient Romans was also proposed, but was lost. These icons represent political revolutions and the freeing of peoples from tyrannical governments.

Next are four balloting urns as used in ancient Rome where citizens voted by dropping either a light or dark pebble inside to cast their vote.

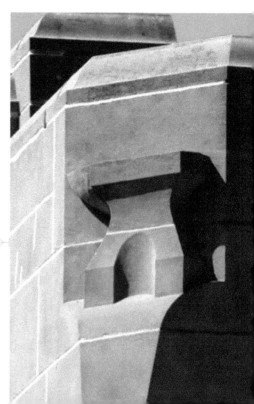

A buttress on the east side is crowned with the image of an anvil, a symbol representing the state of Nebraska.

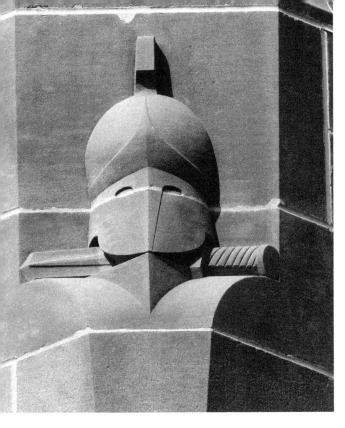

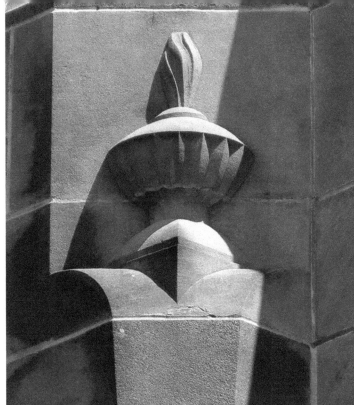

Above the western entrance, Alexander shows us more icons of democracy. First is the image of the Corinthian helmet and sword, symbolizing the active protection of the law. The Mural Crown, represented by a small castle tower, symbolizes the law as a wall of protection. The final ornament is a flaming lamp, which signifies the illumination of the law. Not pictured is a laurel wreath as worn by the Caesars, identified by Alexander, but somehow lost along the way.

Affirmed Dec 11th 1923
2.

This photo shows Goodhue's signature of approval on the photo of the model
on Lawrie's design for the first panel of *The History of Law* series.

*Photo courtesy of the Library of Congress, Lawrie's archives.*

# 16

# ALEXANDER'S HISTORY OF LAW

A
S THE TITLE OF THIS BOOK ALLUDES TO "HISTORY IN Stone," the words must be attributed to the late scholar Orville Zabel. He coined this phrase in his 1981 article in *Nebraska History Quarterly*, "History in Stone: The Story in Sculpture on the Exterior of the Nebraska Capitol."

Zabel was a professor of history at Creighton University in Omaha. In the 1980s, he took time to revisit, identify, and assemble Alexander's building blocks of democracy, and interpret them for us. He provides us with the framework for understanding the lessons of history that Alexander selected.

Lawrie, in turn, conceived these building blocks, molded them in clay, then made plaster maquettes of them for Ardolino, Beretta and the crews of carvers to sculpt them in situ, or in place. Zabel provides us insights into why we should care about these events that Alexander called *The History of Law*. Zabel wrote about who these people were, what events are shown and how they relate to law in the modern day.

Alexander chose "The History of Law in Civilization" as one of the themes for the Capitol. He illustrated how the law grew and developed from the earliest Hebrew law, through the Greek and Roman Empires, down through the Middle Ages, to the Pilgrim and Colonial eras, the Civil War and ending in 1867 with the admission of Nebraska into the Union as the thirty-seventh state. Alexander also refers to the series as "The Majesty of the Law" in archival documents.

The lessons Alexander chose provide a time capsule of Western Civilization and demonstrate how law has shaped our modern democracy. Again, Alexander creates the subject and Lawrie dreams up the designs and executes them.

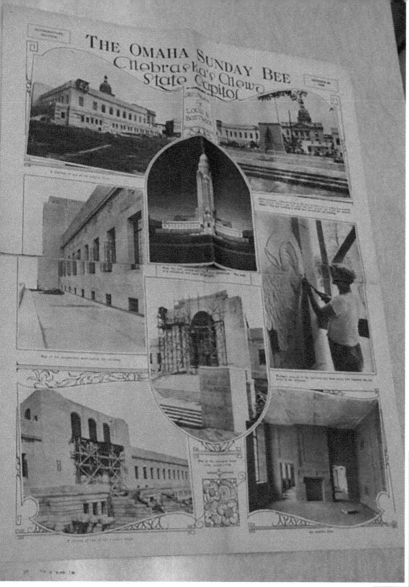

My research has led me to believe that Alexander hoped to show that we could learn from our history, and to help mankind avoid repeating the mistakes of the past as we chart our future.

The images for this *History of Law* theme represent the largest number of carvings on the building and were likely the most physically demanding to carve of all of the Capitol designs. Beginning at the Northwest corner, you can take a fifteen-minute, counter clockwise walk around the exterior. The Capitol's imagery takes us through the five thousand years it has taken for law to evolve to its current state.

Artisan Alessandro Beretta carving one of the Bison panels on the North Portal, 1927.
*Photos courtesy of the Durham Museum.*

It was Alexander's mission to create a living history book to tell the story of American constitutional government and to supply the seminal events that led us to the freedoms that we enjoy today. Throughout the centuries, many wars have been fought that allowed us to gain the freedoms that we hold so dearly today.

*The History of Law* is a procession of eighteen panels of Indiana Limestone that Alexander conceived, Lawrie designed, and Ardolino and his crews carved. Fifteen of the panels measure at five by nine feet, while those above the east entrance measure eight by ten feet.

Rome wasn't built in a day, nor was American Democracy, as Alexander points out. The development of Western Law took at least five thousand years, just like the development of Western Civilization. There are certain truths that we hold to be self-evident as the early American colonists later proclaimed. Life, liberty, and the pursuit of happiness are all ideals that were destined for a free society.

We are all familiar with the concepts of property rights, suffrage, jury trials, the writ of habeas corpus, meaning the right to hear charges against you. We know that the State has the legal authority to prosecute you, the common understanding that the laws work best when they are written down, and representative democracy reigns supreme, whether it is Tory, Whig, Democratic, Republican, or Libertarian. All of these concepts evolved from both reason and conflict throughout the ages. Nebraska's motto "Equality Before the Law," is in the same vein, meaning no one is above the law. This is yet another example of Alexander's rather prophetic idioms, made more salient than ever in the twenty-first century, when the balance of power among the three branches of government is once again under fire.

The founding fathers designed these three branches of government; the legislative, the judiciary (or court system), and the executive, to serve as a system of checks and balances to ensure domestic tranquility and prevent the abuse of power and anarchy. Our system of government has functioned for more than 230 years under this, the most appealing system of government, in the free world. Even so, the words taught to Alexander by his father, that "Salvation of the State is Watchfulness in the Citizen," still ring true today.

As the saying goes, every picture tells a story. So, when most people look at the Nebraska State Capitol and see a bunch of ancient-looking figures, men and women clothed in togas, robes and various other vestments that date their eras, they don't know the stories behind these figures. When you see these ancient figures, you may think you're

watching a foreign film, but without the subtitles. While many people may recognize the images of Abraham Lincoln, George Washington or Benjamin Franklin in these panels, we don't know the names of many of the other characters and there are no inscriptions to tell us their stories.

Alexander first proposed these designs in segments, beginning with the Terrace Circuit that wraps the horizontal portion of the structure. Beginning with ancient law, Alexander designed this as the Western or Senate Façade Group. It starts on the north-northwest corner of the building, running counter clockwise, from left to right, around the building. You will need your binoculars and your zoom lens to enable you to capture the detail on the faces of the scores of characters that Lawrie cast in each scene.

None of these images are reproductions of previous works of art—nearly all the characters are original designs from prior to the dawn of photography originated solely in Lawrie's imagination.

The west side of the building depicts ancient law, consisting of the Hebrew, Greek and Roman contributions. Alexander notes that early law was Theocratic or Kingly Law. Hebrew law is represented by a triad of panels: "Moses Bringing the Law from the Sinai", "Deborah Judges Israel" and "The Judgment of Solomon."

## The History of Law

The lessons Alexander chose provide a time capsule of Western Civilization and demonstrate how law has helped shape our modern democracy. Again, Alexander creates the subject and Lawrie designs and executes the sculpture that tells us the story of the most significant developments in political thought. This analysis is based upon the writings of Professor Zabel.

In the first panel, Moses brings the Ten Commandments, one of the first set of written laws, down from Mount Sinai. Christians and Jews believe that the Commandments were written by God Himself.

The Commandments were not exclusively religious, but were also designed to serve a civic purpose for establishing and maintaining order. The establishment of these laws in the thirteenth century B.C. created a significant degree of order among tribal societies of the ancient Middle Eastern world.

Recall also that Moses had wandered in the wilderness of Sinai, and this may have been the first attempt in history at what we now refer to as nation building. The deal was, if people kept the covenant, God or Yahweh would protect them. The idol of the Golden Calf appears in the upper right of the panel with wings but without gold.

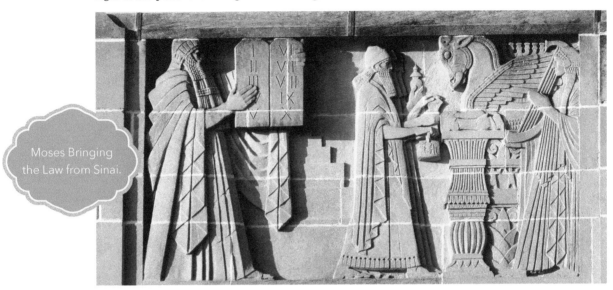

Moses Bringing the Law from Sinai.

These panels illustrate the influence of Assyrian art on Lawrie's style. As the panels progress around the building, Lawrie used different historic styles in the panels, going from Assyrian and Egyptian styling to classic Greco-Roman, and using a more naturalistic or what has been described as an architectonic style.

Before the development of monarchies, judges were charismatic Hebrew leaders who reviewed disputes and made decisions. Deborah was a great judge who encouraged the Hebrews as they sought liberation from the Canaanites' oppression. The panel shows the prophetess Deborah, sitting under the Palm of Deborah between Ramah and Bethel, judging Israel. According to Professor Zabel, this panel reinforces the Mosaic covenant—that God's will protects his chosen people—but only if they obey His law.

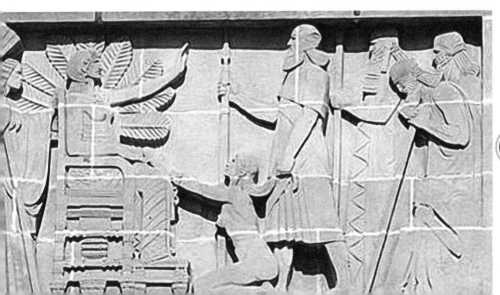

Deborah Judging Israel.

The third and final Hebrew panel features *The Judgment of Solomon*, showing us the importance of Wisdom as a guardian of the law. In roughly the tenth century B.C., the Hebrew people were first unified under King Saul. He was succeeded by Kings David and Solomon, who further extended Israel's control throughout the region. Jerusalem became the capital around this same time.

King Solomon was widely admired for his wisdom and for writing both Proverbs and Ecclesiastes in the Old Testament. The panel tells the old story of two women who both claimed to be the mother of the same child. To settle the dispute, Solomon ruled for the baby to be cut in half with a sword. The boy's real mother immediately relinquished her claim and forfeited the baby, rather than seeing it killed. In this act of maternal compassion, her actions to the truth spoke louder than her words, so Solomon determined that she was the baby's true mother. This panel was completed in the first half of 1934.

Like Moses, Solomon reappears among the Great Legislators series on the south side of the building.

*The Judgment of Solomon.*

Continuing around the west side of the Capitol, the next six panels feature classic developments in Greek and Roman law.

The three panels above the West entrance symbolize the legal founding of democracy and republicanism in Athens and Rome.

This scene celebrates the reforms of the Athenian archon, Solon. He was elected as the chief archon, during a socio-economic and political crisis during the sixth century B.C. He was given broad powers to enact reforms, bringing the law from a more idealistic state to one that could be administered more practically.

For example, debtors who fell behind in their payments could be enslaved, but under Solon, the practice was outlawed and they were freed. Other reforms he instituted dealt with trade regulations and land ownership, which influenced modern property rights. His reforms also led to the development of coinage as a form of currency.

Solon was instrumental as one of the founding fathers of Democracy. Athens had been dominated by the nobility, namely, the rich. He modified the government with the creation of the ecclesia, or popular assembly, of which all citizens were members and under which people had access to the people's court, or "heliaea" in Greek. So here is perhaps the birth of the bicameral legislative assembly, consisting of two houses, like the houses of Lords and of Commons that would become the English parliament and later evolve into the U.S. Senate and the House of Representatives. Perhaps Solon's most important achievement was his contribution to the new Constitution of Athens, which replaced the older, more Draconian set of laws.

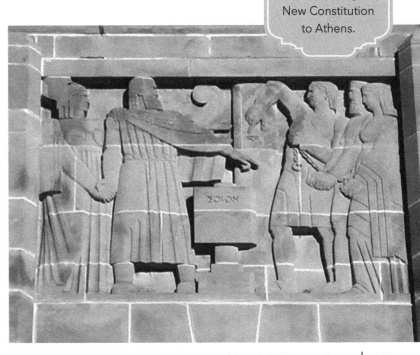

Solon Giving a New Constitution to Athens.

The panel shows Solon holding hands with Athena, the Greek goddess of war and protector of cities. She was also known as a goddess of agriculture and of various arts and crafts and is credited with introducing the olive to Greek agriculture and inventing the plow. She is shown together with the newly emancipated slaves who were returning to freedom, prosperity and a more politically stable Athens.

Carving of this panel was finished around the week of July 15, 1934, according to the Sunday *Lincoln Journal Star*.

From 450 B.C., *The Publishing of the Law of the Twelve Tables in Rome* shows a Centurion heralding the publication of the Twelve Tables. Common Roman citizens, shown in the characters of a mason with his trowel, a farmer with his sickle and a builder with his plumb bob as they come to inspect the new laws.

The panel represents the first codification of Roman law. The Twelve Tables were laws etched in stone, transforming the law from its previously secretive incarnation and translated into a form that people could easily see and read.

The Twelve Tables addressed civil and criminal law and were stern. They had never before been seen by the people or published. This development helped people obey the law.

The carving of this panel was finished in September 1934 and work on the Tribunate panel had begun. This carving would be completed in about ten weeks. (*Lincoln Journal Star*, September 24, 1934.)

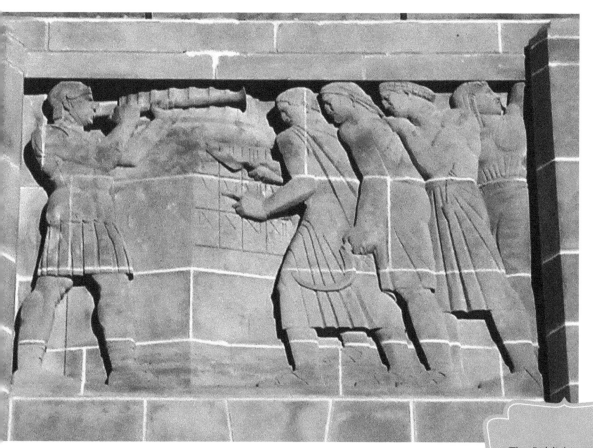

The Publishing of the Law of the Twelve Tables in Rome.

This panel depicts a rather melodramatic scene. The plebeians, or commoners of ancient Rome, had won recognition of an assembly to elect four Tribunes, who served to protect the people against the despotism of the patrician magistrates. The magistrates often abused their power but the Tribune could overrule their decisions. Eventually the Tribunate increased from four to ten men and served to protect citizens from encroachment by the state.

This panel shows Appius Claudius, one of ten Roman magistrates—known as decemviri—and the most hated of them all. He wanted to seize the plebeian girl, Virginia, as his love slave. Her father, Virginius, killed her rather than surrender her to him.

Claudius's abhorrent behavior and abuse of authority so outraged the public that it caused the plebeian revolution. This, in turn, resulted in the plebes' establishment of the Tribune to compensate for the power of the decemviri. Completed in November 1934, this panel culminated more than a decade of sculpting on the Capitol.

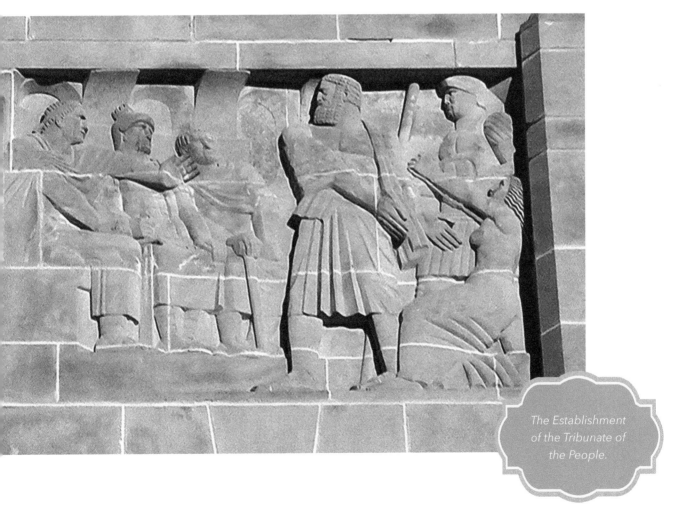

*The Establishment of the Tribunate of the People.*

Continuing the procession of the 18 panels making up *The History of Law*, we see Plato, who pioneered political philosophy. Plato was a student of Socrates and a teacher of Aristotle, both of whom are pictured in his forum. Plato is regarded as a giant among western philosophers. In his book *The Republic*, Plato discusses justice in an ideal Republic.

In Plato's Republic, only men with a sufficient understanding between good and evil were capable of governing and providing justice for all. He referred to them as the Philosopher-Kings. At the front of the class we see Socrates seated and listening to the lecture. Plato brought forth the idea that man is a political animal.

The Sunday *Lincoln Journal Star*, February 4, 1932, notes that Beretta was carving this panel at that time.

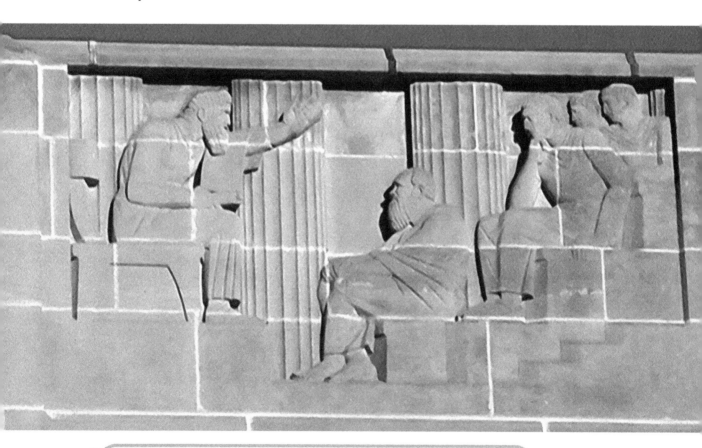

*Plato Writing his Dialogue of the Ideal Republic.*

Completing the Greek series is *Orestes before the Areopagites*. In the ancient play, *The Oresteia*, by Aeschylus, we see an example of violence begetting more violence in the House of Atreus. Orestes was on trial for killing his mother, Clytemnestra, because she had killed his father, Agamemnon. Back then, punishment for murder was left up to the victim's family.

Orestes was being tried by the Council of Areopagus, which was the council composed of the city elders of Athens. The Areopagus was split evenly until Athena decided Orestes should be free. Athena then created the Areopagites, which created a court to provide wisdom and leadership and to forever end the concept of blood feuds in justice.

What is symbolic about this is that blood revenge was replaced by enlightenment and the rule of law. In the panel, Athena is depicted wearing a helmet and holding a spear and carrying a shield emblazoned with an owl, symbolic of wisdom for the power of the mind. If not for the ideas brought forth in *The Oresteia*, we might never have developed jury trials.

*Orestes before the Areopagites.*

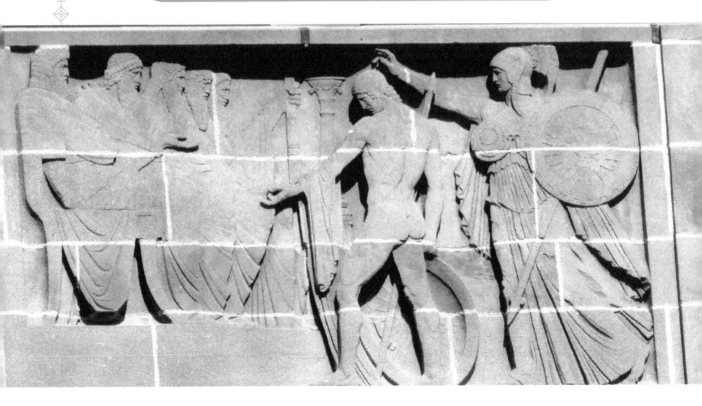

*The Codification of Roman Law Under Justinian* follows next. In this panel, Justinian and his wife, Theodora, receive the Corpus Juris Civilis from Roman scholars. This series of books was known as the body of Roman law. The emperor Justinian was more Byzantine and Christian than classical Roman and ruled his empire from Constantinople on the Bosporus.

Justinian was famous for reclaiming the Italian peninsula which had fallen to the Germans and for the construction of the sixth-century architectural wonder, the Hagia Sophia (meaning Holy Wisdom and pictured earlier in the book). Justinian also wrote the final chapter in a thousand-year story of Roman legal tradition. In the sixth century A.D., Justinian modernized the law, removing contradictory, repetitious and obsolete language through the creation of the Code of Justinian.

He also commissioned The Digest, or Pandects, commentary, written by the best legal minds of the Roman Empire. These, in turn, became the book, "The Institutes," and Justinian's laws were assembled and published in Greek as "The Novels."

Together, "The Code," "The Digest," "The Institutes" and "The Novels" became the body of civil law or the Corpus Juris Civilis, which then became the law of continental Europe and wherever Rome held influence. This work has been recognized as being nearly as influential as the Bible in the development of western law.

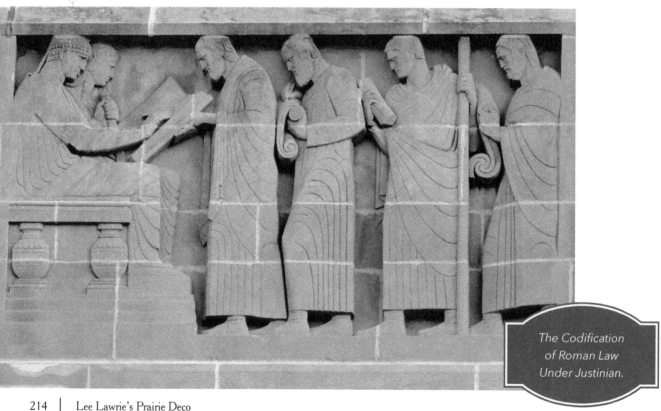

*The Codification of Roman Law Under Justinian.*

From here, we go to a special place on the South Façade with three pierced stone panels depicting perhaps the most important documents in the development of Western law; the Magna Carta, the Declaration of Independence, and the United States Constitution.

No other document in the history of modern law can compare to the magnitude of the Magna Carta, or Great Charter of 1215 A.D. But it didn't just happen. The Magna Carta was a feudal contract imposed upon King John of England by those he governed. His vassals viewed him as a tyrant. The Charter imposed many critical obligations upon him and it is regarded as the basis of modern government in Western Europe. Carving of the three pierced panels above the south entrance was completed by July 1924.

Although the Magna Carta was intended to ensure the rights of nobles rather than the commoners, it helped to lay the foundations for American Law. Some of its most important principles included: no taxation without representation; justice could not be sold, denied or delayed; no person should be deprived of life, liberty or property without due process of law. It also established the procedure whereby the lord who broke the feudal contract could legally be faced with rebellion. Most importantly, it established that no one, including the King, was above the Law.

According to Black's Law Dictionary, which has several various definitions for the multiple meanings of the term for the writ of "Habeas Corpus," perhaps the simplest is this: "An independent proceeding instituted to determine whether a defendant is being unlawfully deprived of his or her liberty."

This sacred, time-honored concept has been a central tenet of western law for nearly 800 years. Under this doctrine, every defendant is entitled to due process of law. In modern law, due process includes the right to confront one's accusers, to know the charges against him, and to have access to the evidence that is to be presented against him. Most modern legal scholars attribute the birth of habeas corpus to the Magna Carta.

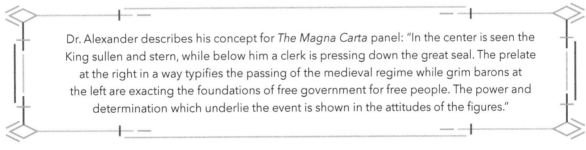

Dr. Alexander describes his concept for *The Magna Carta* panel: "In the center is seen the King sullen and stern, while below him a clerk is pressing down the great seal. The prelate at the right in a way typifies the passing of the medieval regime while grim barons at the left are exacting the foundations of free government for free people. The power and determination which underlie the event is shown in the attitudes of the figures."

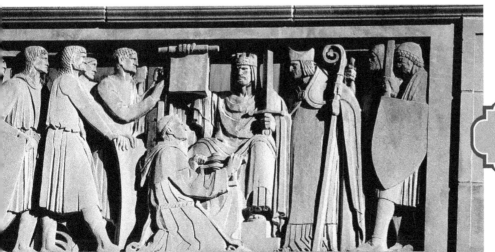

*The Magna Carta.*

In 1776, following more than a decade of controversy over rights in the American colonies, the Second Continental Congress adopted the Declaration of Independence. *The Declaration of Independence* panel appears to the left of the Magna Carta. Through this document, the founding fathers declared that abuses by one government forced upon another could justify a revolution.

The Declaration lists a number of complaints against King George of England and concludes that the united colonies—which would become the United States—were founded and intended to ensure human rights, with the expectation that they should be free and independent states.

The Declaration was proclaimed in 1776, during the Revolutionary War (1775-1783), but not confirmed until 1783 with the peace treaty which led to the birth of the United States. The figures depicted in this panel include Thomas Jefferson, John Quincy Adams, Benjamin Franklin, Roger Sherman, and Phillip Livingston. In 1924, Lawrie noted after completing this model that the 13 figures portrayed here would also serve a structural purpose as individual pillars supporting the lintel stones above. The remaining figures in this panel are Stephen Hopkins, Richard Henry Lee, Robert Morris, James Wilson, Samuel Adams, John Hancock, and Samuel Huntington.

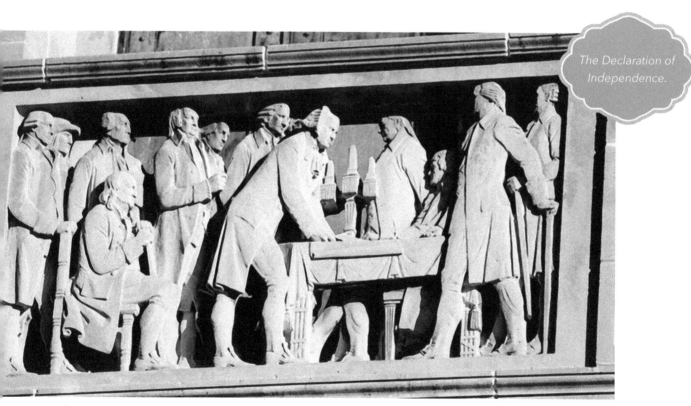

The Declaration of Independence.

Today, we often debate whether or not new laws are constitutional. That is, do they or don't they comply with the Constitution of the United States? The Constitutional Convention of 1787 drafted the U.S. Constitution, which was formalized in 1789. It delineated and divided authority between the states and the federal government and separated the powers of government among the executive, legislative and judicial branches. But most importantly it established the Bill of Rights after the first ten amendments were added in 1791.

What is more, the Constitution set forth the principle that the government would rule only with the consent of the governed. It is the ultimate social contract between a government and its citizens. Its roots hearken back not just to the Magna Carta, but rather, all the way back to the original Hebrew covenant in the form of the Ten Commandments.

In this panel, Lawrie shows thirteen figures (representing the thirteen original colonies) working around the central table. They are Franklin, Washington, Hamilton, Wilson, Madison, Gerry, Edmund Randolph, Pinckney Rufus King, and Gouverneur Morris. Zabel notes, however, that neither Elbridge Gerry nor Edmund Randolph actually signed the Constitution, though they were members of the Constitutional Convention.

*The Drafting of the United States Constitution.*

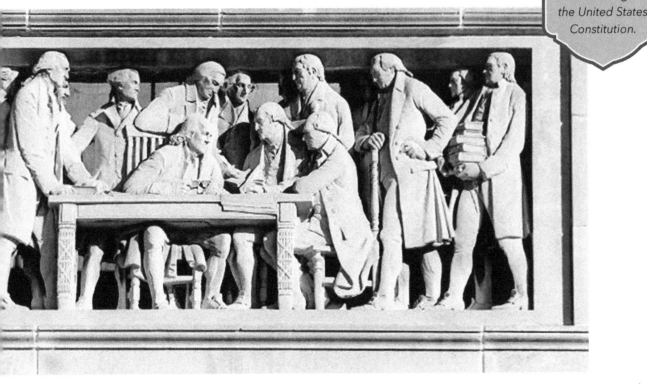

The next group of sculptures jumps back in time, returning to the sixth century A.D., and illustrates the codification of Anglo-Saxon law under Ethelbert. From the fourth to the eighth centuries A.D. the Roman Empire was invaded by Germanic tribes known as the Angles, the Saxons, and the Jutes, all of whom established small kingdoms across England. Ethelbert was the King of Canton, 562-616.

In 597, Ethelbert converted to Christianity under the Christian missionary Augustine and soon Christianity spread throughout Britain. Eventually, Ethelbert issued a code of Anglo-Saxon laws. Written entirely in German, this was the first written codification of law in northern Europe.

Augustine became the first Archbishop of Canterbury and may have played a role in the creation of the code, as it contained protection of Christianity and sought to limit the intertribal warfare that was prominent in this medieval era. An article in the Sunday *Lincoln Journal Star* of February 4, 1932 noted that Ethelbert's code was the oldest known document written in the English language.

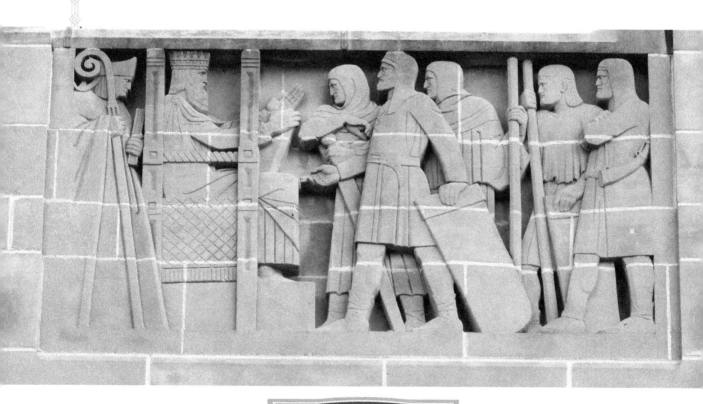

*The Codification of Anglo-Saxon Law under Ethelbert.*

The next two panels on the east side feature John Milton defending free speech and the rights of the colonists before Parliament. Milton, who had lived through the English Civil War and was familiar with governmental censorship, is best known as the author of *Paradise Lost*.

He argued that the press should be free and that in a democracy, informed people are capable of choosing truth over error. The Ethelbert and Milton panels were completed in 1928, according to the Sunday *Lincoln Journal Star* of February 4, 1932.

Milton Defending
Free Speech
before Cromwell.

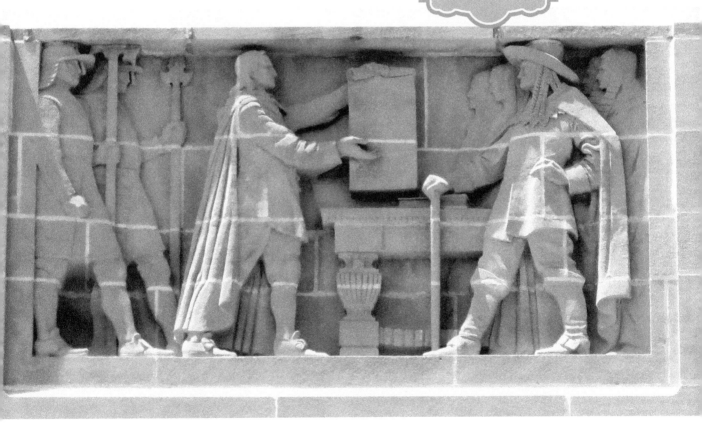

In this panel, Irish statesman Edmund Burke is shown arguing against the Coercive Acts imposed by Britain upon the American Colonies in 1774.

The American Colonists referred to the acts as the "Intolerable Acts." They would generate the friction that led to the first Continental Congress, which adopted the declaration of rights and grievances.

On March 22, 1775, Burke tried to persuade the House of Commons to repeal these acts aimed at the American Colonies, noting that they were being taxed without representation. He also argued the colonies were too remote to govern effectively and that the colonies were already contributing substantially to the crown.

He went on to say that the colonists were devoted to liberty and English ideals, and enacting English principles in oppressing them was a threat to the British liberties themselves.

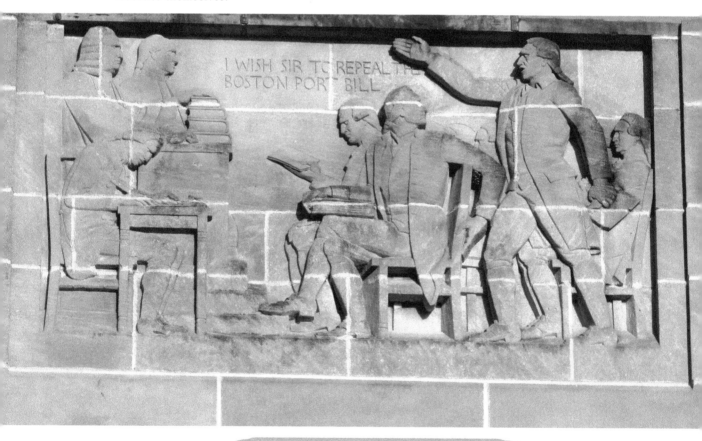

*Burke Defending America in Parliament.*

Over the east entrance are three panels depicting law in the New World. The panels above the east entrance each measure eight feet by ten feet, making them the largest in the eighteen-panel series of the *History of Law*. According to the Sunday *Lincoln Journal Star* on February 4, 1932, these had just been completed.

Five hundred years before La Raza Unida, a 1960s farmworkers' political movement led by César Chávez, a missionary named Bartolomé de las Casas was perhaps the first fighting young priest in the history of civil rights. The Spaniards owned sugar plantations in the Caribbean called encomiendas, and were oppressing the natives into slavery to work on them. Las Casas argued that the natives should have the same rights as Spanish citizens.

In the panel, he is shown as he pleads for their rights before Charles V—the Spanish King and Holy Roman Emperor—and his queen. In 1542, the encomiendas that he argued against were outlawed by what became known as the New Laws. While unenforceable, these were among the first civil rights laws passed in the New World.

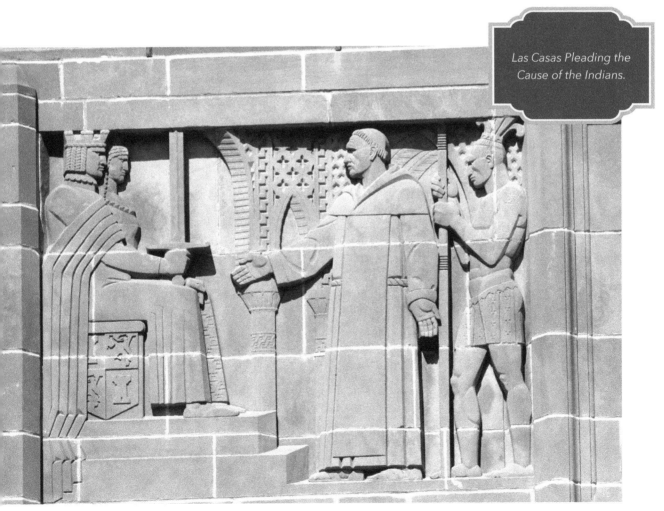

Las Casas Pleading the Cause of the Indians.

The second of these three panels is *The Signing of the Pilgrim Compact on the Mayflower*. During the winter of 1620, a group of English Separatists, known to us as the Pilgrims, were headed for Virginia, but through mistakes in navigation, ended up much further north along the formidable coast of New England.

If being hundreds of miles off their destination wasn't bad enough, matters were made even worse because they didn't have proper permissions to land there. Fearing chaos and mutiny, they drew up a pact pledging loyalty to the colony and signed it aboard their ship, the Mayflower.

In the Compact, they agreed to unite to form a civil body politic, adhering to the will of the colony. The adult males on board signed it before leaving the ship. This was the first law to be signed by Colonial Americans, and is a significant precursor to the Declaration of Independence.

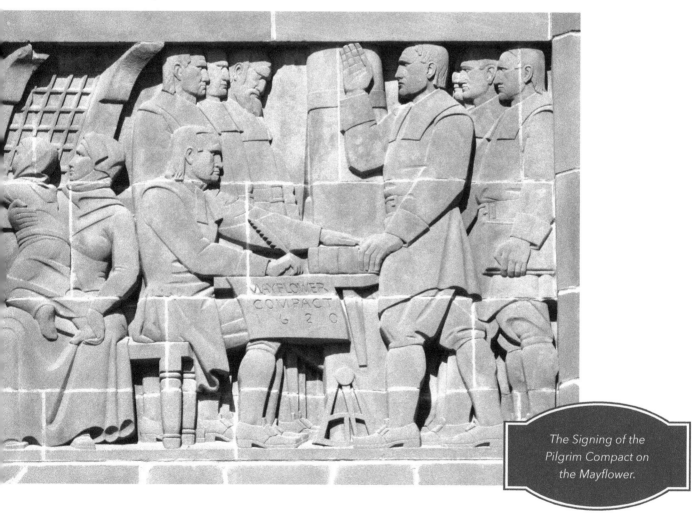

The Signing of the Pilgrim Compact on the Mayflower.

In the next panel, Abraham Lincoln is shown proclaiming the emancipation of the slaves in 1863. We see Lincoln addressing an audience of newly freed slaves, with their chains still dangling from their wrists. Secretary of State William H. Seward and Attorney General Edward Bates stand behind Lincoln. (In the 1920s, the term "negroes" was in the common vernacular, used by both black and white Americans.)

*The Emancipation Proclamation. (Originally titled Lincoln's Proclamation of the Emancipation of the Negroes.)*

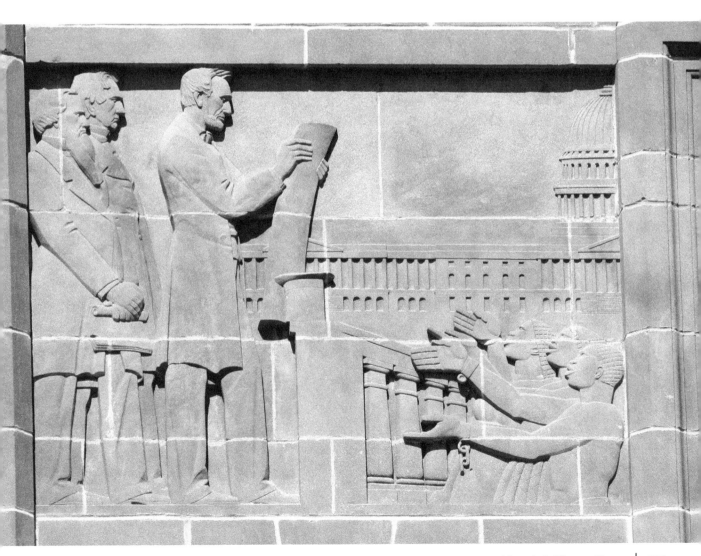

After Lincoln, we slip back in time, to the dawn of the nineteenth century, honoring *The Purchase of Louisiana from Napoleon.* In 1803, the United States bought a parcel of land consisting of roughly 800,000 square miles stretching from the Gulf of Mexico to the Canadian border for fifteen million dollars, doubling the land area of United States. Negotiations for the land were begun by Thomas Jefferson and conducted with Talleyrand and Barbe Marbois. At this time, Napoleon's empire was collapsing and he needed the money, so American diplomats Robert Livingston and James Monroe took advantage of his situation and got a great deal on the land.

The Louisiana Purchase included land extending from Louisiana and Texas north to the Canadian border, and from Montana east to Minnesota, a land area that became the central third of the nation. Nebraska was a part of this land area. With the purchase of land also came the adoption of the French law, the Napoleonic code, which has influenced civil law in the states up through the present.

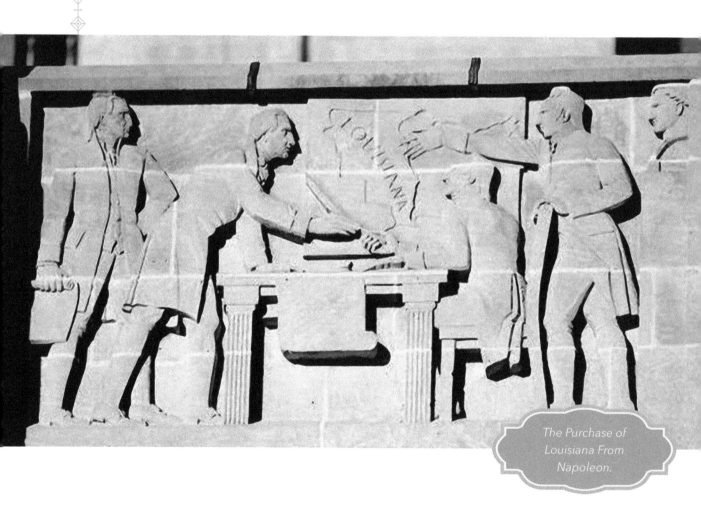

The Purchase of Louisiana From Napoleon.

The Kansas-Nebraska Bill of 1854. It passed and allowed these states to decide the question of whether they would permit slavery within their borders, and repealed the Missouri Compromise of 1820.

This panel depicts the heated debates over the Kansas-Nebraska Bill and includes Senator Charles E. Steward, Asbury Dickens, and William H. Seward, Secretary of State. The panel was completed January, 1931.

Stephen A. Douglas, known as the "Little Giant," is the figure in the center and to his left is President Franklin Pierce, standing with the bill's opponent, Charles Sumner. Also pictured are Andrew P. Butler, James Mason, Salmon P. Chase and Benjamin F. Wade.

The 18th and final panel in the *History of Law* series concludes with Nebraska's Statehood when it was admitted into the Union. In the territorial days, there had been three attempts to write a state constitution; of which efforts in 1860 and 1864 had both failed. A third attempt in 1866 was drafted, but only narrowly approved by a popular vote. Unfortunately, it contained a provision that limited voting rights only to free white males. Congress objected and the provision was stricken. Statehood for Nebraska became a reality on March 1, 1867.

The *Lincoln Journal Star*, May 5, 1931, notes that stone carver Alessandro Beretta completed the Statehood panel on that date. He then began carving Pentaour.

In the panel, we see the female figure of Columbia, representing the nation, seated in a chair adorned with an American Eagle and wearing a stylized Phrygian, or liberty cap. The nation's Capitol building is in the background. In her hand, she holds the papers of statehood and receives our star of statehood from a Civil War veteran. He stands next to a pioneer woman, shown wearing a farm woman's bonnet with a buffalo robe draped around her shoulder, representing the Territory of Nebraska. In her left arm, she holds a scepter made from corn. Early newspaper accounts about the panel described the woman as Miss Nebraska.

Behind her are soldiers of both the North and South, returning home from the war to start a new life. Nebraska entered the Union barely two years after the end of the Civil War, so it was a land that welcomed these veterans. They could live here, and start over, looking forward to the future, rather than living in the past. One veteran has a canteen and holds a bag of seeds while behind him is an older farmer with his plow. These veterans who settled the state were like most veterans of any war; ready to look forward to the promise of the future in a new land, instead of toward the hostilities of the past.

Maps of the Nebraska Territory dating to 1854, show land that extended from Kansas to the Canadian border, and as far west as present-day Idaho. If the original territory had become a state, it would have been comparable in size to the state of Texas.

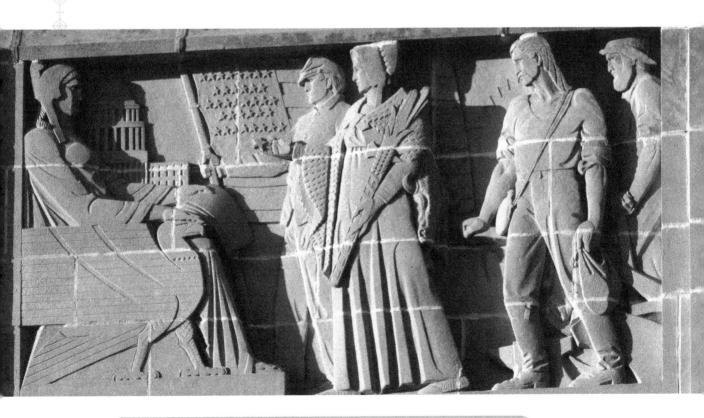

*The Admission of Nebraska as a State in the Union.*

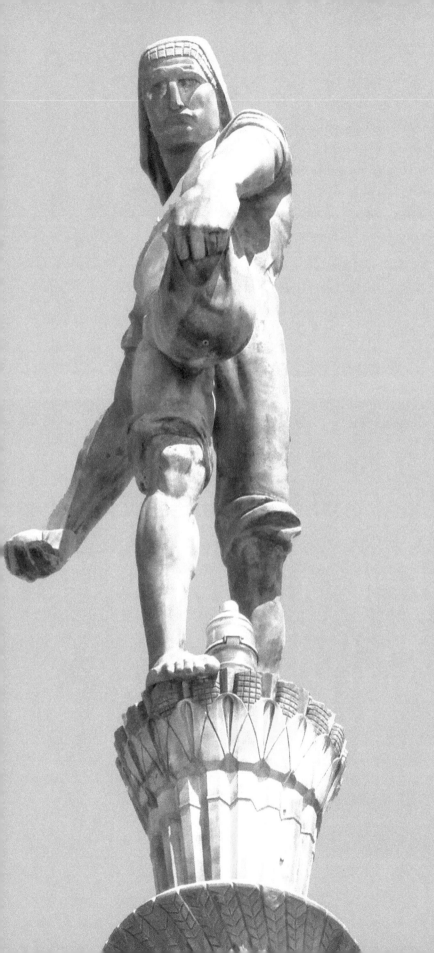

# 17

# THE SOWER

T*HE SOWER* IS PROBABLY THE MOST RECOGNIZABLE OF Lawrie's sculptures on the Nebraska Capitol. Alexander described the *Sower* as a symbol of the life of man in agriculture, and in the chief purpose of men forming societies to sow seeds for nobler living.

He is shown casting his seeds in the hope of a new crop to feed his family and others.

A description of Goodhue's original specifications for the sculpture follows, showing the first design for the *Sower*, and figures from the turrets of the Tower.

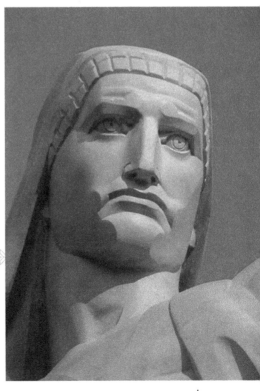

The brave and noble face of the *Sower* honors both agriculture and those who sow seeds for the hope of a brighter future. Photo courtesy of John Spence, used with permission of the Capitol Commission.

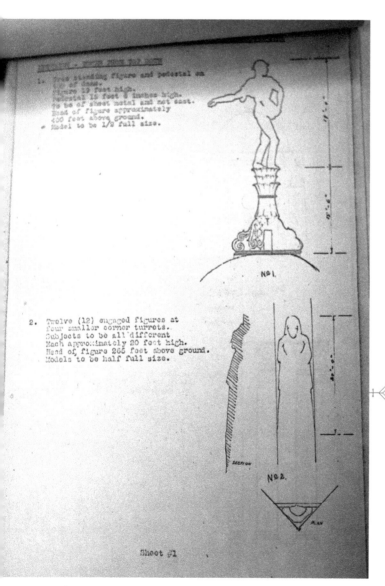

On his base, the *Sower* shows the four cardinal points of the compass, and cross, where a plumb bob was to have been suspended to ensure the statue was set correctly upright. Lawrie dated the piece in May 1930, but it was installed in April 1930.

The original design of the *Sower* was conceived as a weathervane, to carry its message in all directions and to sow to all the fields. In Goodhue's original drawings, the specifications called for the *Sower* "to be made of sheet metal and not cast," as he ultimately was.

We do not know whether the weathervane design was an inside joke between Goodhue and Lawrie.

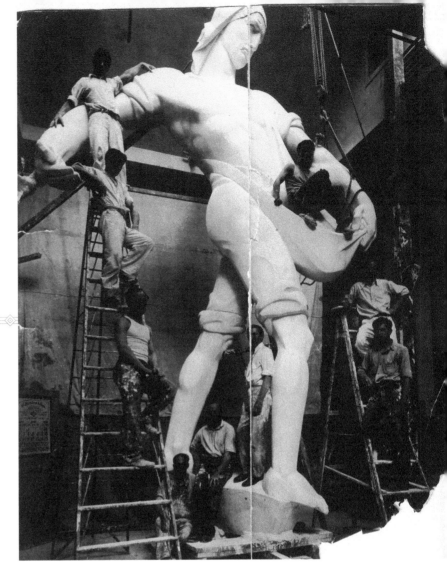

Lawrie stands by the right leg of the full-sized plaster model for the *Sower*.

*Photo courtesy of Mrs. Jean Ely.*

This original, eighty-year-old photograph was taken by Lawrie's usual photographer, R.V. Smutny, and is graciously shared with us by Mrs. Jean Ely, Lawrie's granddaughter.

The photograph is undated, but a calendar in the picture suggests this moment was immortalized in June 1929, just months before the October stock market crash that brought on the Great Depression.

Lawrie used the image of the *Sower* in his works at other sites, including a female sower at Rockefeller Center, in the seal of Scripps College and another at Michigan State University. He also used the design for a 1932 Society of Medalists commemorative medal, inscribed with the verse from Galatians 6:7, "Whatever a Man Soweth, That Shall He Also Reap."

The *Sower* was brought to the Capitol site by flatcar on railroad tracks built especially for use during its construction.

On April 24, 1930, the *Sower* was hoisted 400 feet into place before a crowd of thousands, according to newspaper reports.

A thirty-five-horsepower electric motor was used to raise it during the ten-minute trip up the four hundred-foot elevation, to its final resting place atop the Capitol's golden dome.

The papers of the day reported that the foreman in charge said to the crane operator, "Ladylike, Pete," meaning to be gentle with the load on the way up.

Again, Lawrie's distinctive use of cross-hatch lines and flattened planes show his use of the Deco elements and streamlined design, despite the fact that these features were not visible from the ground.

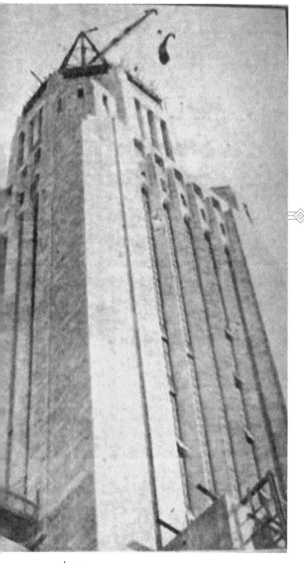

Photo from the *Lincoln Evening Journal* archives showing the *Sower* ascending.

A sculptural exhibit in Philadelphia in 1933 featured one of Lawrie's earlier models of the *Sower*, since by that time, the full-size *Sower* was already atop the Capitol. Unfortunately, there is no way to accurately judge the size of it, nor know what happened to it. The photo by E. Quigley comes from the public papers of Lawrie's archives at the Library of Congress. A similar photo appeared on the cover of *The Fine Arts Magazine* in 1933.

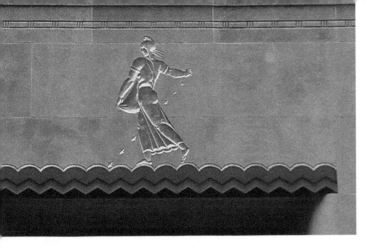

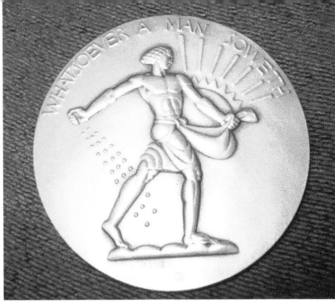

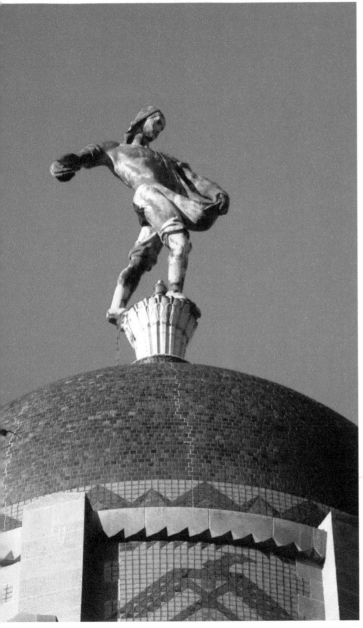

Lawrie's 1932 *Sower* for the Society of Medalists. At Rockefeller Center, Lawrie again draws the *Sower*, but in female form and in *intaglio*, a relief that goes inward, rather than above the surface.

The *Sower* faces northwest, the direction in which most of the state lies. He stands atop a thirteen-foot-high pedestal and his figure measures nineteen feet tall. He also serves as a lightning rod for the building. During the 2001 restoration, evidence of several lightning strikes was found.

The *Sower* pays homage to the agricultural roots of the state. He is as iconic to Nebraskans as the image of the Lone Star is to Texans.

And Nebraskans love their heritage as much as anyone anywhere else. It's just that kind of place.

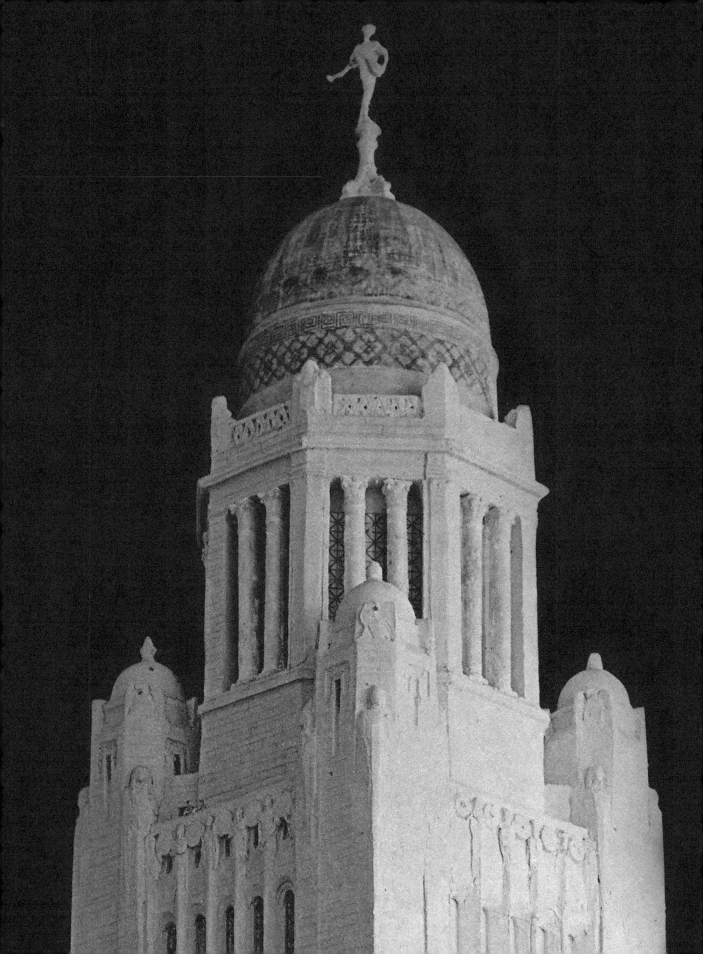

# 18

# ALEXANDER'S UNREALIZED DREAMS

SOME DREAMS NEVER COME TRUE. WHILE THE MAJORITY OF Alexander's plans for decoration and symbolism in the Nebraska Capitol building became reality, an enormous number of the works in his original schedule were lost somewhere along the way.

## The Lost Elements of the Bronze Door Screens

Alexander's original plan called for a substantially more detailed collection of figures on the bronze door screens at the north entrance. These were to have included not only the Native American elements, but also figures representing the white man's first explorations into the new country.

The bronze doors on this great building were not Lawrie's only use of these architectural elements. He designed bronze door screens for the National Academy of Sciences in Washington, DC, as well as at the Fidelity Mutual Life Insurance Building in Philadelphia, and the Education Building in Harrisburg, Pennsylvania.

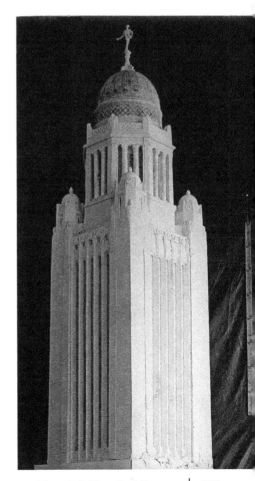

The dome and octagonal portion of the tower, as originally planned. These gave way to the more streamlined Art Deco design, that smoothed off the railings and added the thunderbirds below the dome.

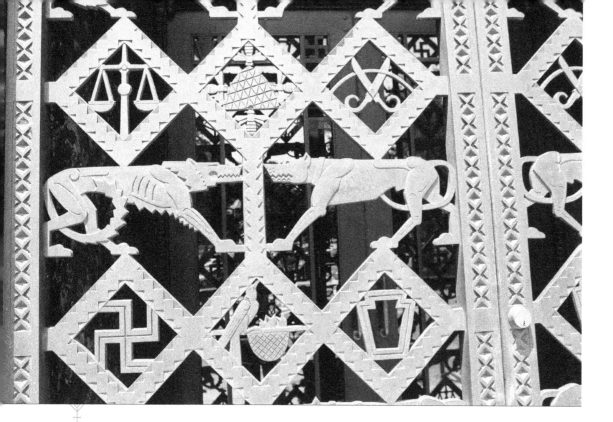

The doors at the former Fidelity Mutual Life Insurance Building in Philadelphia contain images representing life activities. There is a beehive representing industry, a set of snarling wolves representing adversity, swastikas representing good luck (more than a decade before the Nazis commandeered the icon), and Keystone shapes representing the state of Pennsylvania. The image of the owl, centered above the wolves, was one of Lawrie's favorite designs, and he used it on many buildings.

The most dramatic example of Lawrie's use of the bronze door screen motif can be found on the former Education Building, now the State Library of Pennsylvania in Harrisburg. The designs on these door screens illustrate Arts and Industries, and Lawrie completed them at the same time he worked on the Nebraska Capitol. There are figures of men engaged in various professions: firemen, doctors, linemen, machinists and masons represent the Industries.

The Arts are represented by dozens of theatrical characters from history: ringmasters, dancers, jugglers, lion tamers, and an Native American dancer wearing a buffalo head mask. There is even a witch flying her broom across a crescent and a Whirling Dervish. These doors are fine examples of Lawrie's Deco sensibilities. He used Alexander's concepts for symbolism on these buildings as well.

Lawrie wrote a letter to Alexander in 1923, suggesting that the proposed designs for Nebraska were perhaps a little too complex, and would have interfered with the placement of glass in the doors.

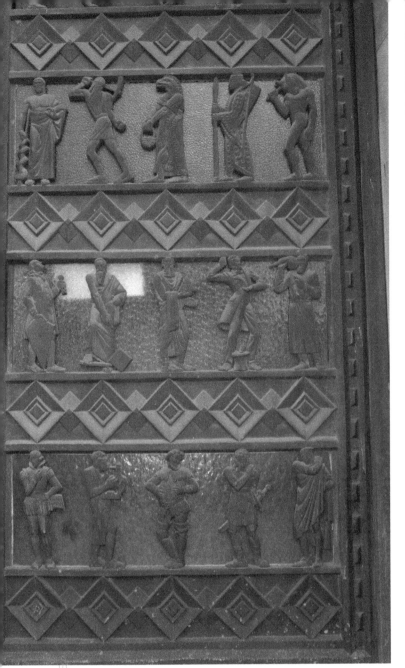

During this period of his life, Lawrie was extremely busy working on commissions from all over the country. He might just have been short of time. There is no real way to determine what factors influenced the simplification of the design, but nonetheless, the doors that were eventually created eliminated a great portion of Alexander's original concept. At first, I assumed that the simpler door designs were because the Legislature had cut the appropriation. But this change occurred in the mid to late twenties long before the economic belt-tightening that took place before the building was completed.

Alexander's original design plan included two doors: one on the east and one on the west. Taken together, the bronze screens were meant to symbolize the opening of the way of human life into Nebraska. The Eastern door would represent the old life of the Native Americans before the white man came, and the western door would represent the contact between the two races.

Each door would have had three columns of figures. In the first door, the left column was to include a maiden, a woman with a burden, and a woman as a mourner. Figures in the center column of the door were to include: a turtle representing the Native American symbol of life, the calumet or peace pipe ritual, a deer representing fruitfulness, a cornfield and an elk representing cosmic energy, and the buffalo hunt. The third column on the right was to include a figure of an Native American priest blessing a child, the lover, the hunter with game (an image which did survive), and a counselor or Native American.

The right column of the other door, which Alexander dubbed the west or "Indian-white door," "was to have shown the meeting of the two cultures. On the left, the first column would have shown an Indian story-teller, a warrior mounted on his horse, a medicine man or prophet, and a sign of friendship of Indian design."

The center column of the west door was to have a thunderbird (which Lawrie deemed a "war symbol") a scene of a ghost dance, a wolf (warrior), a battle, an owl (for wisdom) a scene of trading, and a beaver. The last column was to have been headed by a U.S. scout of Native American descent, a U.S. soldier as Native American fighter, a "Black Robe" as they called the missionaries, and finally a white trapper or trader.

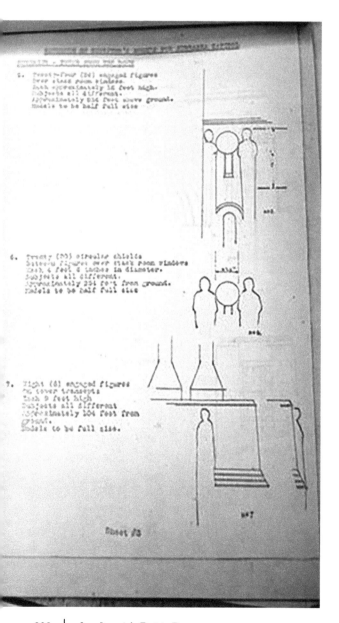

In these designs, Alexander suggested that the left and right doors respectively represented the woman's and man's life activities, while the center column represented tribal labors and rites. The doors were also to have included what Alexander termed minor emblems of peace pipes, hoes, and bows and arrows all of which signified peace.

Perhaps the largest array of Lawrie's symbolic figures that were never used were those for the Crown of the Tower. These included three divisions: capping the window piers, figures at the turret corners, and figures capping the turret piers. These would have wrapped around the building at the level of the observation windows.

We get a hint about the loss of these elements from a 1930's article by architectural critic and historian Walter Agard. He wrote: "They were abandoned because the three collaborators, (Goodhue, Alexander, and Lawrie) agreed that they would draw too much attention to themselves, marring the clean lines of the tower." However, it must be noted that Agard's comment was written long after Goodhue's demise.

Goodhue's original plan for placement of figures between the observation deck windows.

Alexander's original hopes for the tower were to have Lawrie illustrate each of the four sides, even with the present-day observation level, with iconography symbolizing the state's frontier days, the professions, agriculture, and craftsmen. Human figures representing these themes were slated to separate each observation window, along with shields or medallions. Also shown here are the Spanish Colonial-influenced domes on the towers, capped with massive carvings of eagles and three human figures on each corner turret.

Detail of the tower from Goodhue's plaster model.
*Photo courtesy of the Nebraska State Historial Society.*

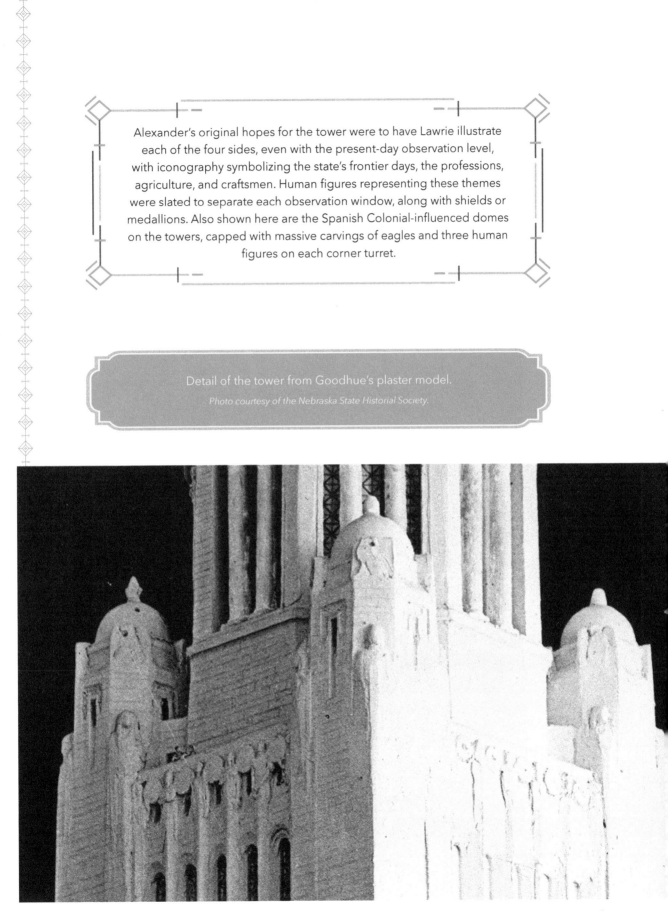

In the first designs, the caps of the window piers were to symbolize the industries of the state.

The sculpture on the North Façade was to symbolize the industries of frontier days. There would be a hunter carrying a rifle, a trapper with pelt, a cavalryman with a saber, a surveyor with a theodolite, a freighter with an ox-yoke, and a mail carrier with his pouch.

The sculpture on the South Façade was to represent the professions. Education would be represented by an academic costume and scroll, medicine by a mortar and pestle, law by the scales, a clergyman by the book and cross, commerce by weights, and transportation by a link and a pin.

The West Façade of the tower would have symbolized agriculture. There would be a rancher with a sombrero and lasso, a plowman with his plow, a harvester with the scythe, a thresher with a flail, haymaker with a fork, and the farm wife with a butter churn.

The East Façade was to symbolize labors and crafts. There would be a woodworker with his saw, a metal worker with horseshoes, a leather worker with his horse, a mason with his trowel, a printer with his case, and a woman seamstress with her sewing machine.

The engaged figures of the turret corners were to have been a Native American on each corner of the headdress representing the four winds.

Lawrie also designed figures representing the first explorers of Nebraska: Coronado, Sieur de Borgmond, Lewis and Clark, General Fremont and Manuel de Lisa, the territory's first Native American agent, Father De Smet, a Jesuit missionary and explorer, and finally George Catlin, an American artist and explorer.

He planned to cap the turret piers with thunderbirds done in Native American patterns showing native styles of the Sun, the Moon and the Morning Star. Alexander described them as the three most notable heavenly bodies in Plains Indian lore.

Note that the Spanish Colonial domes were also cut from the final turret design.

The pillars for Memorial Hall, located on the fourteenth floor of the Capitol, lost their original classic Roman flavor and acquired the Deco style. Early references to this portion of the building often referred to it as the Lantern, because it was to have remained brightly illuminated at night.

Note from the corner turrets up, how the design evolved as the construction continued.

Naturally, the Great Depression hit Nebraska as hard as any other state. Although the design for the corner turrets may have been simplified before the Depression, it is logical to assume that those hard times also contributed to simplifying the tower's design.

The building's design was changing—along with the rest of the world.

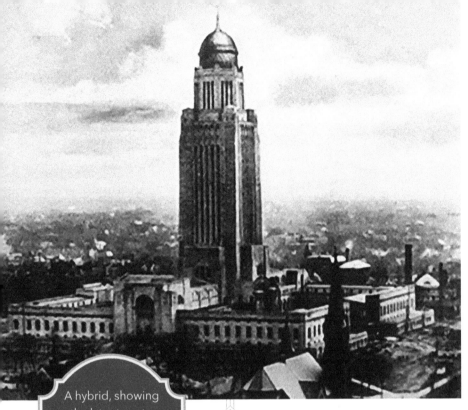

A hybrid, showing the later turrets, with the earlier Spanish-styled tower. (*Architecture Magazine*, June 1930.)

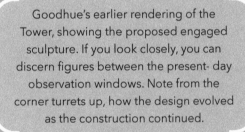

Goodhue's earlier rendering of the Tower, showing the proposed engaged sculpture. If you look closely, you can discern figures between the present-day observation windows. Note from the corner turrets up, how the design evolved as the construction continued.

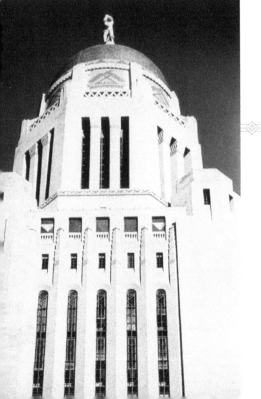

The Capitol as completed—without the original upper tower details.

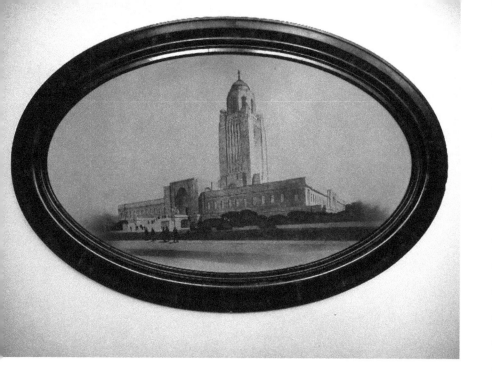

This undated rendering by Goodhue and Associates shows another lost idea for the tower. While the dome still exhibits the Spanish influence, the corner domes have been replaced with massive statues of buffalo, facing out in opposite directions. Judging from the rendering, these buffalo would have been as large as a modern motor home.

*Photo courtesy of New York artist Bruce Richards.*

Dr. H.B. Alexander
c/o Scripps College
Claremont, California

Dear Dr. Alexander:

In accordance with your request by letter addressed to Mr. Phillip, we are sending you under separate cover a blueprint of the revised tower drawing and some photostat prints of the preliminary studies for the new House Chamber. We had intended to invite your suggestions for the decorative scheme in this new House Chamber before making any further studies. This particular section of the construction we understand will go forward next year so that you will have ample time to consider the matter and give us your idea as to the symbolic scheme for this room.

We are particularly pleased to know that you like the new design for the tower and we can assure you that you need not worry about the terminals of the window piers. They will have considerable study on our part and they will also be modelled by Mr. Lawrie which, as we asked Mr. Younkin to tell the Commission, is the best possible form of "insurance". Your scheme of representing the four winds on the four corners of the tower where we had indicated eagles is very interesting. Mr. Lawrie had said that he expected to use "thunder birds". None of us here are familiar with that particular animal and wondered whether Mr. Lawrie was serious or speaking in jest. Of course, not wishing to display our ignorance, we dared not ask him. The four winds give us a fine opportunity to "get out" without displaying our limited zoological knowledge.

Thank you for your suggestions.

Very truly yours,

HPC/T

This undated letter is from Cunningham to Dr. Alexander, commenting on the re-design of the Capitol.

Since last publishing Prairie Deco in 2011, I came across another group of sculptures that Alexander had planned for the Capitol, that I had overlooked in his original Synopsis of Decoration and Inscriptions, where he originally developed all of the iconography that he wanted Lawrie to illustrate.

On the main ground level of the Great Hall, below where the four ages in the Life of Man series did materialize, Alexander had imagined a series of bas-relief sculptures carved in intaglio; a style of sculpture that is hollowed out and somewhat concave in nature, where the design is below the surface as opposed to being raised above it.

These were to have occupied the walls where now, there are niches holding busts of six great Nebraskans.

To celebrate what has since become known as "The Good Life," Alexander chose the themes of family, public education, recreation, reflection (contemplation), beauty, and a reverence for truth. These were all components that Alexander felt were essential to a civilized society. In twenty-first-century America, let us never forget his observation that, "Reverence for truth is the gateway to wisdom."

These are yet another example of Alexander's forgotten dreams, but some dreams are worth remembering.

Alexander's thirty-page, hand-typed "Synopsis of Decoration and Inscriptions." It provided Lawrie the inspiration and served as the roadmap for all of Lawrie's symbolic sculpture on the Capitol, drawn from the historic and cultural themes Alexander had assembled within it. It's as if Alexander's themes served as the building's lyrics, and Lawrie's sculpture created the melody; uniting to become the music of the Capitol.

Second section: E, "The Tree Planting," commemorating the tree-planting activities that followed the sod-breaking and house building. (Since "Arbor Day" has become a festival this appropriately falls in the recess devoted to "Recreation"). W, "The First Railroad," devoted to the opening of transportation, the beginnings of the definite mastery of the Plains for civilization.

Third section: E, "The Building of the Capitol," in the niche devoted to "The Sense of Beauty" (as a symbol of public taste and enthusiasm); W, "The Spirit of Nebraska," essentially symbolic, in the niche devoted to "Reverence for the Truth."

ii. Sculpture in bas-relief, viz.:

(1) Four panels at the springline of the arches, representing: NE, "Childhood"; NW, "Youth"; SE, "Maturity"; SW, "Age." These reliefs tie together the several sections of the Foyer, symbolizing the course of the Life of Man, to which in a historical sense the whole chamber is dedicated.

(2) Six panels in intaglio relief, resembling glyptic pictography or graffito decoration on the walls beneath the gallery rails and between each pair of doors (to replace the niches shown in the blue prints). The subjects should correspond to the themes of the several niches, viz.:

NE, "The Family," with inscription: THE HALE LIFE OF THE FAMILY IS THE HAPPINESS OF THE STATE

NW, "The School," with inscription: THE PUBLIC SCHOOLS ARE THE GUARDIANS OF CIVIC FREEDOM

E, "Recreation," with inscription: JOY IS THE BIRTHRIGHT OF MEN WHO ARE WELL BORN

W, "Reflection," with inscription: THE PURSUIT OF KNOWLEDGE ENLIGHTENS ACTION

SE, "The Sense of Beauty," with inscription: IN WORKS OF BEAUTY MEN GLORIFY THEIR HUMANITY

SW, "Reverence for Truth," with inscription: REVERENCE FOR TRUTH IS THE GATEWAY TO WISDOM

The inscriptions in this group are not to be borders, but intrinsic features of the reliefs themselves.

- 19 -

# *Carving a Legacy*

Hartley Burr Alexander and Lee Lawrie worked together on the Nebraska State Capitol, the Fidelity Mutual Life Insurance Building in Philadelphia, and the Los Angeles Public Library. Their friendship began around 1922 when the Capitol Commission brought Alexander in to help Goodhue develop the thematic program of the Nebraska Capitol. Lawrie and Alexander remained friends until the latter's death in 1939. While Alexander was buried in California instead of Nebraska, at one point, Alexander asked Lawrie to create a memorial to his parents. It is located in a cemetery in Syracuse, Nebraska, where Alexander spent his formative years, reading and learning about Native American Culture.

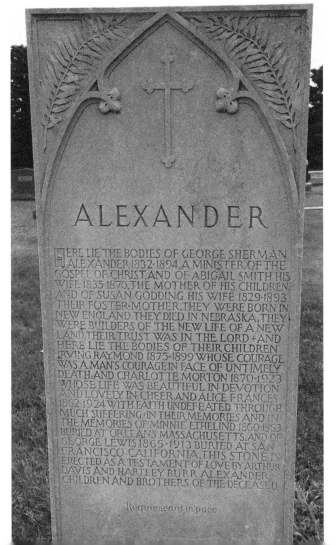

This memorial is at Park Hill Cemetery in Syracuse. I visited it in July 2014. The stone faces west.

# 19

# THE MOST POIGNANT DISCOVERY

A TRUE HIGHLIGHT OF MY RESEARCH OVER THE PAST decade and a half, was meeting and interviewing retired sculpture professor Tylden Streett—assistant to Lee Lawrie more than a half-century ago—on Saturday, September 6, 2015 at his home in Richmond, California.

In 2013, through tedious research—poking around on the website of the National Sculpture Society, of which Lawrie had been a member—I had the great fortune to learn that Mr. Tylden Streett was once a studio assistant to Lee Lawrie. I was even more thrilled when he granted me a telephone interview! Mr. Streett was then ninety-one years old and a wonderful conversationalist.

Streett is also a philanthropist dedicated to helping young sculptors get a start in life!

Mr. Streett taught sculpture at the Maryland Institute College of Art for fifty-three years and just recently created a scholarship for students who choose to study for careers in creating figurative sculpture. This particular form follows the classic Greek and Roman forms of sculpture, where the human body comes first, *then* the clothing is applied later, which provides a more realistic work of art.

Streett is one of the finest artists I've ever met. In discussing sculpture, he stressed that sculpture was different from other arts—at least bronze sculpture, the medium in which he did a great deal of work over the years. While a painter can reach a point where he or she looks at the painting and knows it's done, it doesn't work that way for sculpture.

Often times, sculpture is commissioned, and as such, those who commission it have certain expectations that the work must satisfy the customer or patron. This may involve

a series of meetings, until the artist and its audience reach a harmonious place where all principles agree on the work, before it is even started.

Then, either working in clay, Plasticine, or plaster, the sculptor works up the model. Perhaps it is one that is a scale model that needs to be enlarged, which brings in additional assistance of others. Then the process of making a mold takes place. The piece is then poured, but when it is removed from the mold, it requires more finishing, commonly called "chasing," whereby any traces of extra metal that don't belong are removed, and the piece is buffed to remove traces of these leftover bits of material. There can also be instances where the piece requires more finishing, coating or polishing before it is eventually installed, and whether it requires a pedestal or other form of mounting surface.

Streett cares a great deal about his art, but he mentioned that too often, sculpture does not receive the same respect that other arts do. For example, he said, people may vandalize a sculpture, painting it or otherwise defacing it. He then explained that most people wouldn't dream of going up to a painting in a museum, and spray painting or cutting it. But sculpture is often outdoors and away from the scrutiny of security guards. He expressed a blend of both disappointment and frustration when such events occur.

Mr. Streett informed me that he worked in Mr. Lawrie's Studio at Locust Lane Farm in rural Easton, Maryland, from about 1955 until Mr. Lawrie's death in January 1963. At times, he lived there at the farm, in makeshift quarters that had been converted from a chicken house to a temporary dorm room.

I had read earlier accounts of Lawrie's life written by other colleagues and former assistants, and I had been informed that Lawrie worked right up until he passed away. In a sense this was true, but Lawrie was ill for some time prior to when he was taken to the hospital during the last eight days of his life.

Nevertheless, Lawrie was working on several pieces of sculpture at the end of his life. These included works at West Point, where Lawrie had periodically and incrementally done various works since 1908, as well as a portrait-bust of the founder of Chicago's Hull House, Jane Addams, and a bust of Albert Schweitzer. The last of these two were done for Riverside Church in New York City. Streett assisted in creating the series Women of the Old and New Testament, which graces the main entrance doors to the Shrine of the Basilica of the Immaculate Conception at the Catholic University in Washington, DC.

Streett shared an anecdote that Lawrie was working on this series of panels when he first began assisting him in the mid-to-late-1950s. Lawrie mentioned that he had to drive into town to pick up some supplies, and he assigned Streett to complete one of the panels. In particular, Lawrie assigned him what he, Lawrie, felt was a minor task of modeling a woman's foot protruding out from the hem of her gown. Lawrie said that he wanted it done by the time he got back from running his errands.

Streett accepted the assignment, but then asked where—or, more specifically, who—would be the model for the foot. Lawrie responded brusquely:

"Do you mean to tell me that you teach sculpture at the University, and you can't even model a woman's foot?!?! There *is no model!*" Lawrie barked. Then he got a little nasty, and asked, "What are you, a *little girl?*" Obviously, Lawrie was goading him into either creating the work—or getting fired.

In the end, Streett said, he took off his shoe and used his own foot as the model for the woman's foot, and completed it, and did so to Lawrie's satisfaction. Streett also pointed out one particular panel that both men worked on together; however, in viewing the image, the two styles of how the women's garments are draped reveal that they were done in different styles, within the same panel.

Mr. Streett shared some interesting anecdotes that Mr. Lawrie had shared with him over their time spent working together.

Lawrie told Streett that at their studio in Harlem, formerly at 1923 Lexington Avenue (pictured in Chapter 3), now the site of a grade school, a former urban parking structure that was big enough to hold scores, if not hundreds of autos was where Lawrie's studio was located. This was in the 1920s and 1930s. During that time, Lawrie had a problem with men showing up and playing craps in the entrance to the building, (which I can only assume, was cut into the building and provided some shelter from the elements.)

Lawrie had called the cops to help keep these guys out of the entryway because it was bad for business, and it impeded his employees from coming and going to work.

As expected, the cops did nothing. At some point, the Mafia got wind of this and somehow entered the picture. Accordingly, they apparently "persuaded" Lawrie to show them his books, in order to determine how much they could "wet their beak" from his income, but not bleed him dry.

So, they started "working with" Lawrie, or as it is commonly known, charging him for protection. Suddenly, the crap games disappeared. Moreover, Lawrie let them know that vandals kept breaking windows in his building. That came to a stop, too, shortly thereafter.

Mr. Streett said that Lawrie noted that while he was none-too-thrilled with paying for protection, that the Mafia protected his shop better than the cops ever had, and so he was grateful for their help anyway.

In September 2015, I had the pleasure of meeting and interviewing Mr. Streett at his home in Richmond, California, just across the bay from San Francisco.

Perhaps the most interesting comment that Streett shared with me came when I asked him about how Lawrie felt about his own work; in other words, did he have a particular piece that he was especially proud of, or was there a work that was his favorite, during his seventy years as a s sculptor.

Having spent a decade and a half trying to learn all I could about Lawrie, here I was with perhaps the last living human being who had worked for Lawrie. Streett is almost like a human version of the *Rosetta Stone*, a living character from history, who worked for him off and on from about 1955 until Lawrie's death in January 1963. In as much as most modern artists flirt with celebrity, or with luck, even emerge as celebrities over time, I expected that Lawrie's body of work would be a source of infinite pride.

But to the contrary, Streett surprised me—or perhaps I should say flabbergasted me—when he responded. "Lawrie didn't talk much about himself, and at times, he could be rather gruff," Streett said. But he said that Lawrie never mentioned that he had any remarkable degree of pride in any of his works.

"These were just *jobs* to him!" Streett proclaimed. "Just like the carpenters that built this house we're standing in (his home) they finished and moved on to the next job! They didn't hang around after the work was over, they moved on."

To a degree, I was crushed, due to my own hero-worship, and admiration for Lawrie's work. I found it astounding that he never spoke of having a favorite piece of work. Apparently, from what Streett indicated, Lawrie never considered *any* particular piece of his work to be his masterpiece. Not even the mighty *Atlas* at Rockefeller Center, which is probably his most recognizable piece.

So, I credit Mr. Streett most of all, for helping ground my perspectives of Lawrie and his work, that he was just as human as the rest of us, but one who had an extraordinary talent for designing memorable and original sculpture.

# CONCLUSION: LESSONS LEARNED

I HOPE THE READER HAS GAINED A BETTER UNDERSTANDING of who Lawrie was, where he came from, how he was educated, what he accomplished in Nebraska, and that he deserves far more recognition that he ever received during his lifetime; as well as the relationship between Goodhue and Alexander, and the challenges they faced in the years that the building went from being Goodhue's dream to an internationally recognized work of art.

I hope I have illustrated that the building serves as a living history to Nebraskans and the world. I hope that readers will see how Lawrie's designs tell the story of how our American Democracy developed, based on values shared by pioneers to the state. In summary, here is what *Prairie Deco* has shared about Lawrie:

- His birth name was Hugo Belling.

- He was a German-American immigrant who rose from very humble beginnings to prominence in the art world.

- He was shy and never touted his achievements, which were indeed numerous.

- The majority of Lawrie's work was done in service to architectural firms and performed anonymously.

- Several hundred examples of his works must exist in different places across the country, but he sought neither credit nor recognition for many of them.

- Since the Nebraska State Capitol contains the largest single collection of Lawrie's works in the world, I feel it is fair to classify it as "Prairie Deco" based upon its regional interpretation of a historic, international form of Art Deco design. Consequently, this collection deserves recognition as a premier destination for tourism and for connoisseurs of Art Deco.

Here are some things *Prairie Deco* has shared about the Nebraska State Capitol:

- It was judged the fourth most beautiful building in the world by a panel of the American Institute of Architects in 1948.

- In 2007, the building's popularity still ranked in the upper half of the nation's favorite 150 buildings.

- One of the chief purposes in building the Capitol was as a war memorial to the 751 Nebraskans killed in World War I.

- It also serves as the State House where all Nebraska state laws originate.

- It originally housed state departments.

- The Nebraska Capitol Building pays homage to the Native American culture that once dominated the state, as well as the pioneer heritage of the state.

- The building serves as a bridge between Beaux-Arts architecture and the birth of the International style of architecture.

- The building illustrates scenes of the founding of American democracy, with its roots dating back more than five thousand years.

- Laws foundations began with Hammurabi and in Mosaic, Theocratic or kingly law, the Greek and Roman civilizations, medieval English common law, American colonial law, and nineteenth-century law created during the nation's westward expansion.

- *The History of Law* scenes illustrate significant landmarks in states' rights and personal freedoms. It includes the inventions of nation building, constitutions, the bicameral legislature, political voting, political theory, judicial remedies that negated the tradition of blood revenge, property rights, habeas corpus, civil rights, national independence, the United States Constitution—which guaranteed all Americans the freedoms granted by the Bill of Rights and

established the system of checks and balances between the three principal branches of government, the abolition of slavery, the Napoleonic Code, the Union's victory confirming the superiority of federal over states' rights, and that democracy is alive and well in the twenty-first century.

- The 1897 sculpture of Father McIncrow was his first independent commission.

- That Dr. Hartley Alexander also served as a thematic consultant for many notable buildings including the Los Angeles Public Library, the Finance Building on the Capitol campus in Harrisburg, Pennsylvania, and Rockefeller Center.

- That Alexander honored Native American culture by identifying their literature in the tradition of oral history and their symbolism representative of their religion and culture.

- That one should love, honor, and take pride in the place of their birth.

Since this book was originally published in 2008, I discovered a *New York Times* article dated November 25, 1934, which noted that the approximate date of the sculptures' carving completion had occurred that week. The article also dated the birth of the Unicameral as beginning that week.

In promoting an appreciation for Lawrie and his legacy, I have discovered an additional twenty examples of Lawrie's sculpture and added them to the Smithsonian Institute's Art Inventories Catalog of American Painting and Sculpture.

Finally, I have to answer a nagging question that bothered me while I was researching the information for this book. How in the world did Nebraska manage to get this world-class sculptor? As I mentioned earlier, Lawrie had gone on later to do his most famous work at Rockefeller Center I found it puzzling that such a renowned sculptor who had done so much work in Nebraska and would later achieve such cosmopolitan recognition of the arts.

After more than a decade of research, I finally learned the secret of this connection. But to get there, you have to follow time—backwards.

Many people know that Raymond Hood was the architect of Rockefeller Center. Before that, he won a design competition for the Chicago Tribune Building. Goodhue had also entered that competition. And before that, Hood designed the famous American Radiator Building in New York.

But years earlier, before Hood designed any of these three buildings, he worked for Goodhue and Associates, where surely, he would have known Lawrie and his work personally. So, it was likely Hood who brought Lawrie on board as one of the sculptors for Rockefeller Center.

Lawrie and Hood also collaborated on the 1933 Chicago Century of Progress Exposition, where Lawrie designed pylons for the "Water Gate" at the electrical group buildings that Hood designed.

It's more than likely that Hood would have also been the logical connection that brought Dr. Alexander and Hildreth Meière into the Rockefeller project as well—especially since he would have had to have been familiar with his philosophical skills and her mosaics at the Capitol.

So, Hood had known both of these artisans for more than a decade when he drew his plans for Rockefeller Center and knew they could add dazzling contributions to the project.

And he was right.

The Nebraska Capitol sculpture covered ten years and was the largest commission that came to Lee Lawrie. The complete book of human liberation is depicted on its walls. It would require more time than we have to show more of the Nebraska sculpture. Perhaps we should see the

24    Sower finial atop the tower. It looks small from the ground but its base and the figure are 32 feet.

25    And these capitals for columns, original and refreshing, they have been described---composed of native elements of the state--corn, wheat, sunflower, cattle---instead of the Greek acanthus used on state house columns for years and years. Lee Lawrie's sculpture on the Capitol in this way: "a new kind of building enriched and intensified not by egg and dart, guttae and

26    And the famous buffaloes, the Cow with Calf

27    And the Buffalo Bull   frets but by original sculpture." These express life on the prairies when Nebraskans

Lewis Mumford, writing about Goodhue in the New Republic, mentions

were Indians.

# APPENDIX

| A Partial List of Buildings For Which Lawrie Created Scultpure While Working on the Nebraska Capitol | | |
|---|---|---|
| BUILDING | YEAR | LOCATION |
| Harkness Memorial Tower, Yale University | 1921 | New Haven, CT |
| Kansas City Liberty Memorial Competition (not won) | 1921 | Kansas City, MO |
| Nebraska Memorial Stadium | 1923 | Lincoln, NE |
| Trinity English Lutheran Church | 1923 | Fort Wayne, IN |
| Memorial Flagpole (with Goodhue) | 1924 | Pasadena, CA |
| National Academy of Sciences | 1924 | Washington, DC |
| Los Angeles Public Library | 1926 | Los Angeles, CA |
| St. Mary the Virgin and Christ, statues | 1926 | New York, NY |
| Fidelity Mutual Life Insurance Building | 1927 | Philadelphia, PA |
| Rockefeller Chapel, University of Chicago | 1928 | Chicago, IL |
| Beaumont Tower, Michigan State University | 1928 | East Lansing, MI |
| Bok Carillon Tower | 1929 | Lake Wales, FL |
| Church of the Heavenly Rest | 1929 | Manhattan, NY |
| Education Building | 1931 | Harrisburg, PA |
| Hale Observatory, Caltech | 1931 | Pasadena, CA |
| Sterling Memorial Library, Yale University | 1931 | New Haven, CT |
| Louisiana State Capitol | 1932 | Baton Rouge, LA |
| Ramsey County Courthouse | 1932 | St. Paul, MN |

# INDEX

# ACKNOWLEDGMENTS

WANT TO EXPRESS MY SINCERE APPRECIATION TO:
Former Lincolnite and lifelong friend, Russ Dantzler of New York City, without whom I might never have located Lawrie's many works in Manhattan;

Ms. Christine Roussel, who shared many insights with me about Rockefeller Center;

Dr. Dale Gibbs, retired university professor of Architecture, Lincoln, Nebraska, who provided cohesion for my work;

Dick Hill, the 1960s architectural grad student, and now-recently-retired architect, who gave me fresh details of the maquettes project and his Nebraska roots;

Architect Kim Clawson, who provided me with great insights into the building's architecture and its European influences;

Robert Ripley, Administrator at the Nebraska State Capitol, who told me much of the story of how Alexander tied the history and philosophy to the building;

Roxanne Smith, who facilitated liberal access to photograph the works;

Karen Wagner, Archivist of the Capitol, who helped pave the path of my research on Lawrie, Goodhue, and Alexander;

Ms. Jennifer Rowe, who helped with early editing of the manuscript;

Ms. Mary Lou Gibson, who read my work and provided invaluable advice;

My friend Bill Stoughton, who supplied photos of the Lawyer's Consultation Room;

Bruce Richards, who supplied the early watercolor rendering of the Capitol;

Alexandra Witze, for the photo of Lawrie's grave;

Jeff Kanipe, for his publishing advice;

Bryan Wheeler, for technical advice;

Lisa Wheeler, for helping me provide structure to the book;

Richard Cain Harm, my older brother, who provided invaluable feedback;

Richard Von Hatten, who helped me with earlier editing;

Chris Kralik, who answered an ad on Craigslist and took pictures for a total stranger—half a continent away;

Jill Edwards, who helped immensely with early editing and copying;

Nebraska State Senator Lydia Brasch, who helped me with promotional creativity;

My grad school professor, the late Dale Hardin, who taught me legal theory and research methodology;

My graphics designer of the 2011 edition, Hunt Wellborn;

Paul W. Engel of the Commonwealth Fund for graciously granting us access to photograph the Harkness Mausoleum; Susan Olsen of Woodlawn Cemetery for driving us to it, and the Straus Memorial in the Cemetery's golf cart;

The entire Concierge Marketing and Publishing Services staff, Lisa Pelto, President; Rachel Moore, Art Director; Ellie Godwin, Marketing Director; Sarah Knight, Editor; all of whom have helped me so tremendously in producing this latest book. I'm eternally grateful for their help.

Alastair Duncan, an established authority on Art Nouveau, Art Deco, and a member of the Art Deco Society of New York, who is deeply familiar with Lawrie's work, for his encouragement to continue my research, writing, and photography of Lawrie's as-yet-unrecognized legacy;

My wife Susanne, who shares photography credits throughout the book, for editing my manuscript, and for immeasurable patience and encouragement;

My late mother Margaret C. Harm, who worked at the Capitol when it was still a brand-new building.

Finally, to my late father, Dr. Charles Dale Harm, D.D.S., who taught me to work hard and to stand up for noble principles.

# ABOUT THE AUTHOR

GREG HARM WAS BORN AND RAISED IN LINCOLN, NEBRASKA, and lived there until he graduated from college at age thirty-eight and moved to Austin, Texas. Harm holds a Bachelor's in Political Science from the University of Nebraska-Lincoln and a Master's in Legal Studies and Administration from Texas State University.

He has been a lifelong lover of art, music, history, and politics. He lives and works in Austin, Texas.

He has finished writing and illustrating his second book, *Passing Torches: Lee Lawrie's Art Deco Sculpture at the Los Angeles Public Library*, presently in production. The Library was created by the same crew who worked on the Nebraska State Capitol: designed by Architect Goodhue and adorned with Lawrie's mystical sculpture, as programmed by Hartley Burr Alexander. Alexander designed it to be a temple of learning and knowledge.

Harm has also begun working on his third book, *Oblivion: The Forgotten Sculptural Legacy of America's Machine-Age Michelangelo*, which delves further into the art and life of Lee Lawrie across America. The book will be an encyclopedia, sharing nearly two decades of study on America's most obscure and never recognized genius.

# BIBLIOGRAPHY

_____. Meière, Hildreth, "Mural Painter," *American Artist*, Volume 6, Number 7, September 1941.

Agard, Walter Raymond, *The New Architectural Sculpture*, Oxford University Press, New York, 1935, p. 35.

Alexander, Hartley Burr, "Nebraska State Capitol; Synopsis of Decorations and Inscriptions." p 19.

Alexander, Dr. Hartley Burr, "Symbolism and Inscriptions," *American Architect*, October 1934, p. 24-28.

*American Architect*, October 1931.

American Institute of Architects Press, *Bertram Grosvenor Goodhue: Architect and Master of Many Arts*, New York, New York, 1926.

AskART Biography for Lawrie, Lee. http://www.askart.com/Biography.asp, visited February 21, 2003.

Barbarossa, Theodore, "Lee Lawrie, Art and the Church," speech to The National Catholic Building Convention and Exposition, delivered in Chicago, Illinois, July 1, 1948.

Batts Grover, 1962, Beverly, Brann, 1970, Matheson, David, 1987 expanded Ernst, Nan Thompson, 2012, *Lee Lawrie Papers: (1908-1990;) A Finding Aid to the Collection in the Library of Congress, Manuscript Division*, biographical notes, Library of Congress Washington, D.C. 2012.

Bok, Edward W., Medary, Milton Bennett, Lawrie, Lee, *America's Taj Mahal—The Singing Tower of Florida*, Georgia Marble Company, Publisher c. 1929; 2nd Edition, 1989.

Breeze, Carla, *American Art Deco*, W.W. Norton, New York, New York, 2003.

Brown, Eleanor L., *Architectural Wonder of the World: Nebraska's State Capitol Building*, State of Nebraska State Building Division, Lincoln, Nebraska, 1978, p. 152.

Cunningham, Harry F., "A Record of Successful Experiments," *American Architect*, October 1934, p. 35.

Fazio, Beverly. Editor, Brooklyn Museum of Art, *The Machine Age in America: 1918-1941*, Harry F. Abrams, New York, New York, 1986.

Fine Arts Publications, Society Incorporated, *The Fine Arts Magazine*, New York, New York, August, 1933.

Fowler, Charles F., *Building a Landmark: The Capitol of Nebraska*, Nebraska State Building Division, 1981.

Garvey, Timothy, "Strength and Stability on the Middle Border: Lee Lawrie's Sculpture for the Nebraska State Capitol," *Nebraska History Quarterly*, Volume 65, Number 2, Summer 1984.

Garvey, Timothy, "Lee Lawrie: Classicism and American Culture, 1919-1954," doctoral thesis, 1980.

Gebhard, David, *The National Trust Guide to Art Deco, in America*, John Wiley & Sons, New York, 1996.

Gruney, George, *Sculpture and the Federal Triangle*, Smithsonian Institution Press, Washington, DC 1985.

Hanks, David A. and Hoy, Anne, "Streamlining and Art Deco in American Industrial Design," Magazine Antiques, The, October 2004, Brant Publications, Inc., New York, (p. 116-7, 123).

Hartmann, George E., Cigliano, Jan, "Twelfth Night, in Mr. Goodhue's Office," *Pencil Points Reader: A Journal for the Drafting Room*, 1920-1943,. 2004 p 50.

Hill, Richard T., "Lee Lawrie's Maquettes (Plaster Study Models for Capitol Sculpture)," monograph, Spring 1965.

Hitchcock, Henry–Russell, and Seale, Willie M., "How Nebraska acquired a State Capitol Like No Other," *Journal of the American Institute of Architects*, 65, (October 1976). Page 57-61.

Hoak, Edward Warren, and Church, Humphrey, *Masterpieces in American Architecture*, Dover Publications, Mineola, New York, 2002, reprint of Scribner, 1930.

http://en.wikipedia.org/wiki/Adolf_Loos, "Ornament and Crime," 1906. visited November 25, 2006.

http://en.wikipedia.org/wiki/Thomas_Rogers_Kimball, visited November 25, 2006.

Kent, Norman, "Lee Lawrie: Dean of American Architectural Sculptors," *American Artist*, April 1956, Watson-Guptil Publications, Volume 20, Number 4, Issue 194, P. 44.

Kiselewski, Joseph, "My Four Years with Lee Lawrie," *National Sculpture Review*, Summer Edition, 1963. P. 7, 26-27.

Kubly, Vincent F., *The Louisiana State Capitol: Its Art and Architecture*, Pelican Publishing Company, Gretna, Louisiana, 1955

Larson, Erik, *Devil in the White City*, Random House, New York, New York, 1995.

Lawrie, Lee, "The Sculpture of Lee Lawrie: With a Forward by the Sculptor," J. H. Jansen, Publisher, Cleveland, Ohio 1936.

Library of Congress: Lee Lawrie: a register of his papers in the Library of Congress, Grover Batts 1962. Beverly Brann and 1970, and David Matheson 1987.

Luebke, Frederick C., *A Harmony of the Arts: the Nebraska State Capitol*, University of Nebraska Press, Lincoln and London, 1990, pp19-12, 16.

Masters, Margaret Dale, *Hartley Burr Alexander: Writer in Stone*, Jacob North Printing Co., Lincoln, Nebraska, 1992. p. 64.

McCready, Eric Scott, "The Nebraska State Capitol: Its Design, Background and Influence.," Nebraska History, Nebraska State Historical Society, Volume 55, No. 3, Fall 1974, p. 377.

Mirabella, Stephen, "Lee Lawrie: Sculptor of Ideas," *American Arts Quarterly*, Summer/Fall 2000, p. 14, 16.

Nebraska State Building Division, "Guide to Exterior Art and Symbolism: Nebraska State Capitol: Lincoln," 1995.

Nelson, Leonard R., *Nebraska's Memorial Capitol*, 1931.

Okrent, Daniel, *Great Fortune: The Epic of Rockefeller Center*, Viking Press, New York, New York, 2003.

Oliver, Richard, *Bertram Grosvenor Goodhue*, The Architectural History Foundation of New York, the MIT Press Cambridge, Massachusetts and London, England, 1980, p. 6, 12, 13.

PBS American Masters Website, visited July 13, 2002, http://www.pbs.org/wnet/americanmasters/database/saint-gaudens_a.html

Prince, Sue Ann, *The Old Guard and Avant-Garde: Modernism in Chicago*, University of Chicago Press, Chicago, Illinois, 1990.

Shand-Tucci, Paul Douglas, *Ralph Adams Cram: An Architect's Four Quests*, University of Massachusetts Press, 2005.

The Nebraska Capitol Commission, and Cunningham, Harry Francis, "The Capitol," pamphlet, 1926.

University of Georgia Press, *Lee Lawrie*, American Sculpture Series, 1955.

Wakeman, Robert C., "The Lawrie I Knew," *National Sculpture Review*, Summer Edition, 1963. P. 8.

Whitaker, Charles, Harris, *The Story of Architecture: Ramses to Rockefeller*, Halcyon House, New York, New York, 1935.

Whitaker, Charles, Harris, and Alexander, Hartley Burr, *The Architectural Sculpture of the State Capitol at Lincoln Nebraska*, Press of the American Institute of Architects, Inc., New York New York, 1926

White, Norval & Willensky, Elliot, *AIA Guide to New York City*, Fourth Edition, Three Rivers Press, New York, New York, 2000.

Wishart, David J., *An Unspeakable Sadness: the Disposition of Nebraska Indians*, University of Nebraska Press, Lincoln, Nebraska, and London, 1994.

Wolcott, Anne Lawrie, 1990, Recollection, personal letters.

Wylie, Romy, *Caltech's Architectural Heritage: From Spanish Tile to Modern Stone*, Balcony, Press, Los Angeles, California, 2000.

Zabel, Orville H. "History in Stone: The Story in Sculpture on the Exterior of the Nebraska Capitol," Nebraska History Quarterly, Fall 1981, p. 330

Zaczek, Iain, *Essential Art Deco*, Paragon Publishing, 2002, (p. 6, 7).

CPSIA information can be obtained
at www.ICGtesting.com
Printed in the USA
BVHW062124070420
576852BV00001B/1

9 780983 903093